"WHICH OF MY PHOTOGRAPHS IS MY FAVORITE?

THE ONE I'M GOING TO TAKE TOMORROW."

– *Imogen Cunningham*

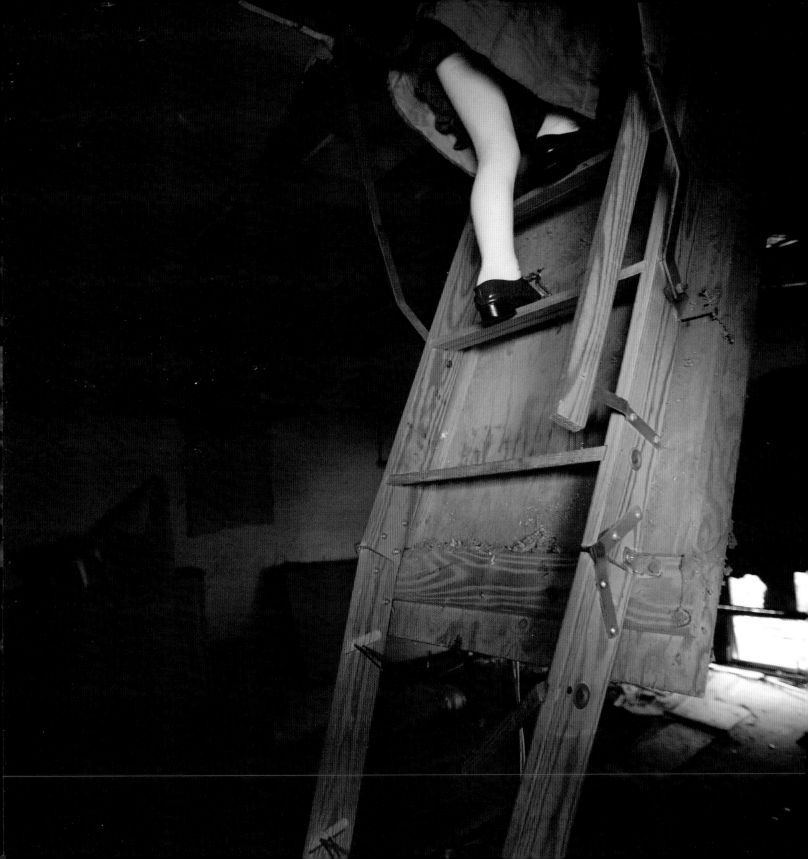

PHOTOGRAPHING CHILDHOOD

the image & the memory

LANOLA KATHLEEN STONE

ELSEVIER

Amsterdam • Boston • Heidelberg • London • New York
Oxford • Paris • San Diego • San Francisco • Singapore
Sydney • Tokyo
Focal Press is an imprint of Elsevier

Focal Press is an imprint of Elsevier

225 Wyman Street, Waltham, MA 02451, USA

The Boulevard, Langford Lane, Kidlington, Oxford, OX5 1GB, UK

Notices

Knowledge and best practice in this field are constantly changing. As new research and experience broaden our understanding, changes in research methods, professional practices, or medical treatment may become necessary.

Practitioners and researchers must always rely on their own experience and knowledge in evaluating and using any information, methods, compounds, or experiments described herein. In using such information or methods they should be mindful of their own safety and the safety of others, including parties for whom they have a professional responsibility.

To the fullest extent of the law, neither the Publisher nor the authors, contributors, or editors, assume any liability for any injury and/or damage to persons or property as a matter of products liability, negligence or otherwise, or from any use or operation of any methods, products, instructions, or ideas contained in the material herein.

Library of Congress Cataloging-in-Publication Data

Application submitted

British Library Cataloging-in-Publication Data

A catalogue record for this book is available from the British Library.

ISBN: 978-0-240-81818-4

For information on all Focal Press publications visit our website at www.elsevierdirect.com

11 12 13 14 5 4 3 2 1

Printed in China

Working together to grow
libraries in developing countries

www.elsevier.com | www.bookaid.org | www.sabre.org

ELSEVIER BOOK AID International Sabre Foundation

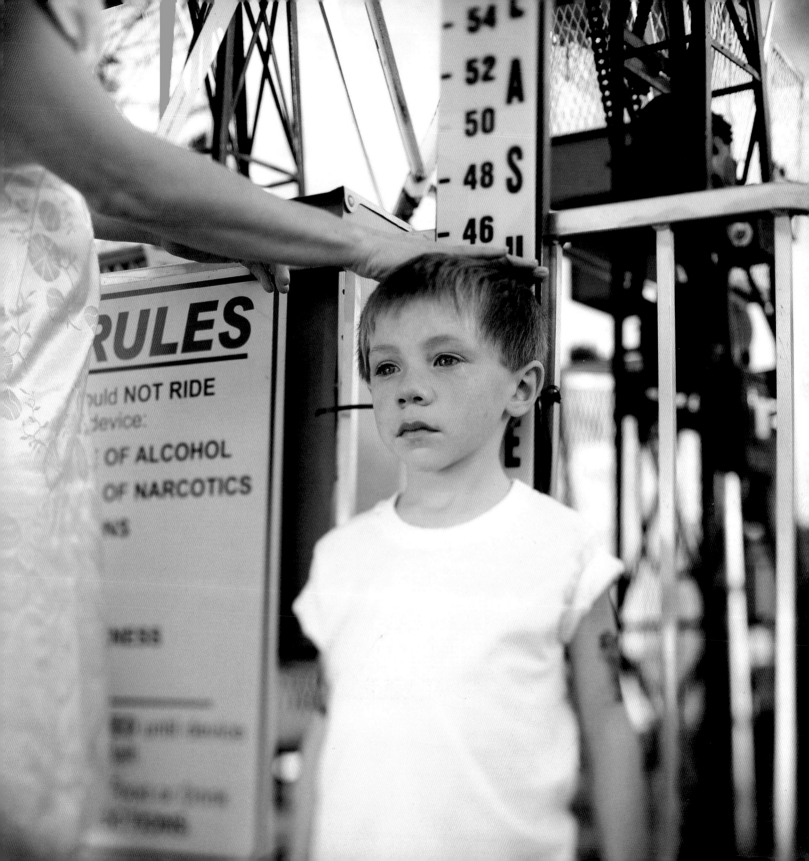

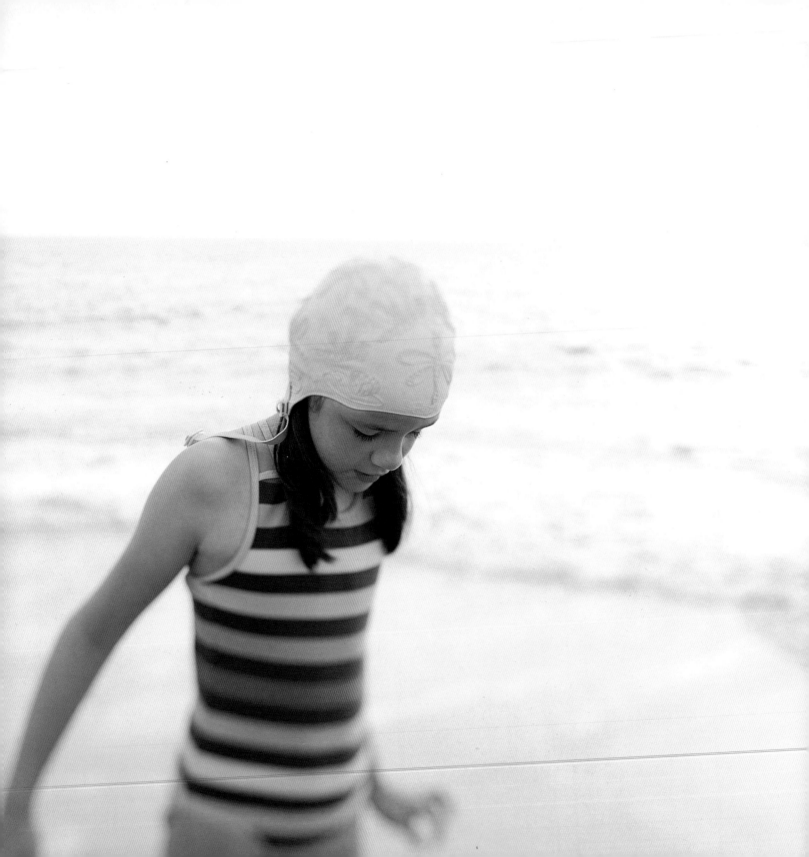

CONTENTS

INTRODUCTION

Every experience, every person, and every perspective is unique. It is not easy to duplicate, with exactness, the life, look or philosophy of another, nor should we try.

As adults, when we see something we like or admire, we tend to covet. Children do not naturally do this.

Rather, they are great examples of fresh learning. When children observe the actions and results of others, they seem to absorb the whole experience and, naturally seek to discover new insights from the encounter. Rather than seeking to simply imitate, they incorporate the ideas, thus making the experience authentic and their own. As we photograph children in their world, we can learn a lot from their approach—namely, to take in the entire experience, inform our vision with its insights, and add a certain je ne sais quoi, an indescribable personal attribute, that makes the new creation our own.

Grown-ups take more photographs of children than any other subject. There is a familiarity in childhood that attracts our lens, yet far too often we still manage to miss the authenticity of the moments we try to capture.

Childhood is wonderful, lively, unpredictable, and not easily deceived. The time spent with a child is exactly as it is represented to be. This authenticity is something that many of us grow out of as we are influenced by the perspectives, emotions, and opinions of others. However, until the time that potent sincerity becomes extinct, we lived in the unique naivety that is childhood.

In childhood the world is new and large, emotions are fresh, and experiences are innovative. It's these precious firsts that make childhood so charming and nostalgic to those who remember our own experiences from childhood. The reoccurring cycle of childhood becomes a playground for the photographer who is prepared to witness these experiences again through the eyes of the child before their lens.

It is said that luck is when preparation meets the right opportunity, and by this definition, photographing childhood definitely takes luck! This book is meant to aid preparation, not only with facts and techniques but also inspiration and insights into the potential of childhood photography. Preparation can open our eyes to new and available opportunities, while experience and insight help us create our own luck as we interact with our child subject.

With full-hearted sincerity, I wish you the best of luck! The image is there. Prepare for it, open your eyes and mind to see it, and confidently make the capture.

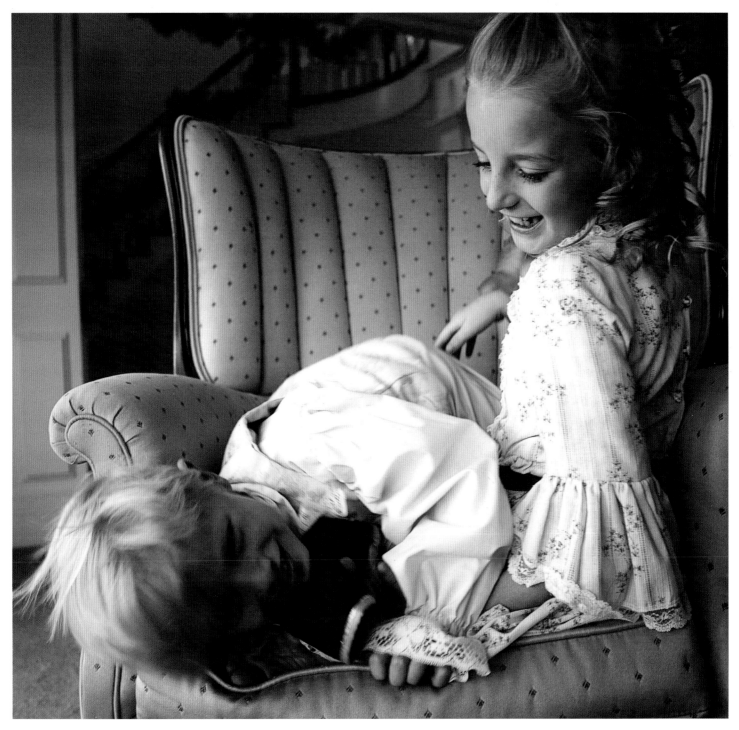

"*You have your way.
I have my way. As
for the right way,
the correct way,
and the only way,
it does not exist.*"

— Friedrich Nietzsche

A STAGE
LaNola Stone, 2002

THE AUTHENTIC THE IDYLLIC & THE FANTASTIC

WHAT'S THE OBJECTIVE?

When I was little and had a quandary I would often go to my father for help. No matter the question, his reply was always the same, "What is your objective?" My father knew that it wasn't necessarily an answer I needed from him (answers often live inside us). Rather, what I required was a platform for understanding my question. Having an objective often clears a path for decision-making and lays a foundation for what we'll choose to communicate; what will we emphasize, what will we minimize, and what will we leave out all together? These are the elemental decisions that literally frame our photography, but before we make them, we must answer: What's the objective?

EXPLORING INTENT
Why we do what we do

I can't help but wonder why we do anything. Is it because we were preordained to a certain lifestyle, purpose, or involvement? Is it because we were influenced through training or circumstance? Only the individual can answer these questions. Our answers will provide valuable insights as we dare to ask.

Why are our cameras drawn to childhood? Is it the authenticity of their little lives, their spontaneous ways and the plain nostalgic beauty of a time we've all left behind? Perhaps, and with no disrespect intended to the intrigue of the individual child, it could be that they are just there, willing participants to a world of make-believe and show for the camera.

Each of us is drawn to this segment of life for our own reasons. But though childhood is multifaceted and as diverse as the photographers who capture it, the draw of its images is almost as universal as the experience of childhood itself.

Childhood has a lot to teach the artist-photographer who is willing to put in the time and effort to advance their work within the subject. It has been said that everything we need for a successful life we learned in kindergarten, and so it is in the photography of childhood. Working with children will teach the receptive photographer valuable lessons of interaction, respect, and agility. The patience and skill required to shoot children well will support all photographic endeavors.

To photograph a child we must be flexible and prepared. We need to make decisions instinctively and not bog ourselves down with deliberation. Childhood also requires respect and kindness if we want to elicit cooperation or at least avoid flat-out rejection. We require participation from not only the child, but also those who care for and look after them. In the time we will spend with the child, we must also intend to care and look after their needs as well. We cannot demand and dictate to a child and expect cooperation and ease; we must earn it. At the risk of sounding too reverential, this interaction involves a sacred trust of which we must never take advantage. Forever remember that we are charged to create a safe and protective stage for their world; and in doing so our ability to create honest, sincere, and authentic images, whether on set or location, will flourish.

Before I introduce the general categories of possible objectives in our images, I want to suggest that these

segments of photography are intertwined. Although it is perfectly acceptable to do so, we need not feel pressure to choose and focus on just one category throughout our career. Many will focus and specialize. However, our niche might be the subject, rather then the objective or approach. Edward Steichen (p. 54) never bound himself to a certain style or genre. He simply followed his heart and interests and his strong results spanned the gamut of methods. In the final analysis, it's about you and where your inner compass takes you.

The purpose of this chapter is to help us clarify our personal objective for each shoot. This will determine the approach, equipment, and preparation required. Generally, the objective of all images fall into one of three categories;

The Authentic: Candid and journalistic images showing life as it is.

The Idealistic: Formal portraiture and staged scenarios, depicting life in its "Sunday Best."

The Fantastic: Conceptual and imaginative images that explore concepts in a world a little left of reality.

Each one of these is enhanced by the categories before it. Idealized images, like portraits, are aided by a splash of the candid. Fantastic images combine the strengths and requirements of both the authentic and the ideal and saturate them with concepts, production, and personal vision. So, who are you? What are your strengths? What is available to you because of your background and current circumstances? How will you share your perspective? How will you expand it? Artistic perspectives can have roots in all these categories.

When utilized authentically, these objectives are vehicles for your perspective and offer a serendipitous connection between you and the viewer of your work. We mustn't

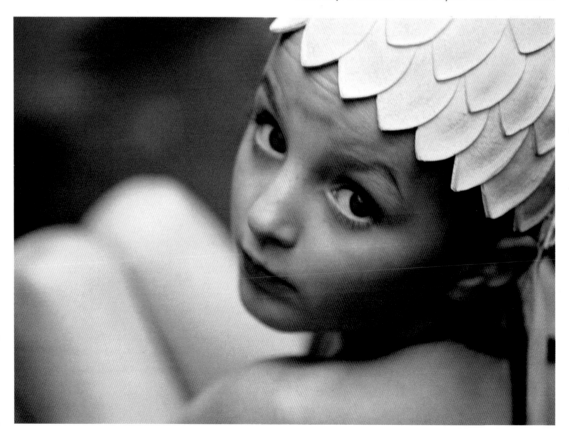

image 1.2
When working with children, the primary objective should be to "give," and offer something of the experience to the child; not just "take" the photograph.

Shutter Speed: 125
F-Stop: f/2.8
ISO: Kodak 160NC (film)
Camera: 35mm SLR
Lens: 200mm
Light: Diffused: overcast, fill card

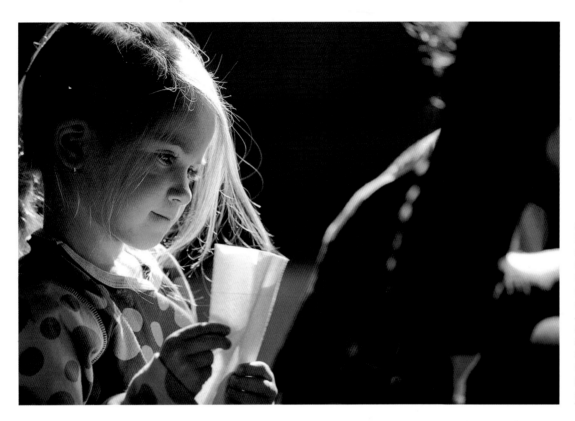

image 1.3
Even when you are in the middle of the action, children quickly forget about the presence of the camera and photographer as they focus on other projects and activities.

Shutter Speed: 200
F-Stop: f/4.5
ISO: 800
Camera: 1/1.7 in. sensor: Canon G11
Lens: 9.78mm
Light: direct window sidelight

worry about manufacturing that connection; as we make authentic work, the connection will come naturally to those ready to receive it. Plot your objective, but allow the work to flow organically *through* that objective. One of the many beautiful things about photographing childhood is that it tends to lead us away from concerns about merely pleasing an audience and allows us to focus on the subject and our objective. Before every shoot, clarify for yourself: What is the objective?

THE AUTHENTIC
A candid image

The objectives within "The Authentic" image are foundational for photographs of all types. Although it holds its own category in the classifications presented here, it often defines the "success" of all images because of the subtle power in candid gestures, expressions, and poise. The authentic is what we do when no one is looking.

It provides our viewers with a window into the everyday, not barred by self-concern or show. Authentic elements ground images and allow for a connection with the viewer to our work simply because it honors, at least in a small way, real life and provides new insights into the everyday.

When we photograph things as they are, rather than a manufactured scene, we approach image-making through the role of a detective. It is up to us to discern what moments before us are essential to capture. Rather then getting overly involved, the authentic requires that we step back and observe! Observation is the hallmark of this objective.

The same questions we asked ourselves to determine our own personal objectives in photography can now be placed in the scene before us. A candid and authentic photograph is frank, honest, truthful, and sincere. It is the foundation of journalistic photography. The best images will be backed by a story, the life before the lens.

Who is the child? What are his or her strengths in gesture and interaction? What is the child's background and current circumstance? Can we tell just by looking? How will you share your perspective of his or her story? Will you expand on it by including elements of the environment, or eliminate them focusing solely on the child's face or body language? How does the child interact with others, their environment, or themselves in their imaginary world and play? Is the child aware of the camera or have they bored of it and forgotten its presence? Generally, the younger the child, the shorter their attention span. This can be a great asset for a photographer who is after candid moments. However, this freedom is harder to come by as the child grows into adolescence.

What is the best way to be invisible to the child? Be around long enough that you are not noticed (sudden movement and arrivals make us conspicuous). Because children act very differently when they know the lens is on them, be less apparent and consider using a longer lens and blending into your environment, but just for the initial shots. Don't be afraid to get close and interact with children. Ask the parents for insights that will aid the interaction. The child will more likely be at ease if they've seen you interact with a parent. Although a long lens has its place (and certainly this works for the paparazzi), I would suggest that it be only one tool or approach to capturing candid images.

Each one of these is enhanced by the categories before it. Idealized images, like portraits, are aided by a splash of the candid. Fantastic images combine the strengths and requirements of both the authentic and the ideal and saturate them with concepts, production, and personal vision. ▴

Henri Cartier-Bresson (p. 62) rarely used a lens wider or longer than 50mm in focal length. As we'll discuss in Chapter 3, this is considered a "normal" lens and best approximates what we see with our eyes. What is more authentic than that?! Still, using an even wider lens, like a 28mm or 35mm, can allow you to get even closer to the action and still capture important environmental in-

formation. With a 28mm lens we are not just looking at the scene, we become a part of it and allow our viewers that same access. Many street photographers, like Garry Winogrand, Robert Frank, and Cartier-Bresson avoided long lenses. Using a long lens defiantly narrows the perspective of our shots. It's up to the photographer to determine whether that is a good thing or not. Remember, there is also nothing wrong with the child being aware of the camera, as long as they are not terribly influenced by it, therein losing the candid flare of their gestures. If we don't want our images to feel voyeuristic, we can't simply hide behind a long lens like a paparazzo.

Another common misconception is that one has to shoot a lot of images of childhood to get anything good. But as we observe and develop skills of reading the behavior of others, we can better discern the "decisive moment" and capture just the best photographs. This will actually benefit us (and our time editing) as we are selective and only shoot when we anticipate the shots that fall within the objective. Cartier-Bresson coined the term "Decisive Moment;" visually it is defined by gestures, expressions or significant action. Be patient and calm, wait for it, and when it presents itself, get the shot! Nervous energy and fear prompt us to engage the shutter beyond what is necessary, and the image we are after can fall between frames.

Don't be afraid and trust your instincts! Procrastinating and thinking you'll get the shot later is a mistake. Capture the image when you see it. If you can anticipate a similar image, use that foresight to make another photograph, but never neglect the first shot. Each photograph belongs to its own time and it may or may not happen for you again. As we learn more about the subject and scene through observation, experiment with angles and position relative to the light source. As a general rule, avoid flash, as it is conspicuous and can cause the spontaneity of light and circumstance to be rendered flat. As candid moments present themselves, try moving around until you've completely exhausted the possibilities of the shot you're after.

When it comes to the possibilities for candid photographs, no camera is better than the one you have with you. We don't always know when the perfect shot will present itself, so always be ready with a camera. Luckily, nowadays, cell phone cameras are always at our finger-

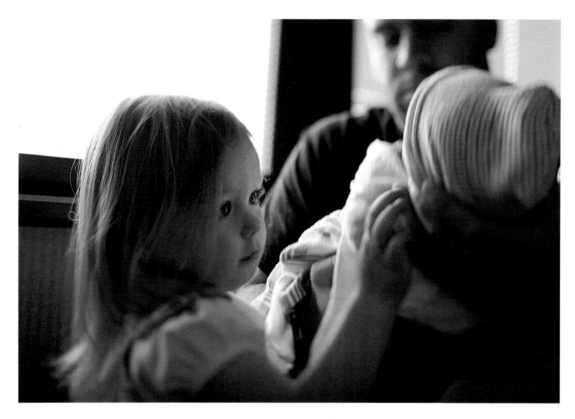

image 1.4
Look for natural fill light. Here the white blanket redirects the window light and provides a natural-looking fill to the little girl's face.

Shutter Speed: 60
F-Stop: f/2.8
ISO: 160
Camera: 35mm DSLR
Lens: 45mm tilt/shift
Light: window light, no added fill

tips. Yes, I am making a plug for knowing how to use a cell phone camera. Although these are not cameras that generally produce high-quality images (because of their tiny sensors), they wonderfully accomplish the first requirement of a candid image: having a camera when the moment presents itself. This minimal equipment allows for spontaneity, and if we know how to fully take advantage of all it's capable of doing (including but not limited to incorporating apps built for it), we can embrace the inevitable flaws that occur with this limited tool. It may sound quaint, but we have a lot to gain by knowing how to best use our cell phone cameras. They are not that complicated and there is not a lot to know, so as we become a scholar of this small bit of information, we'll best utilize that camera which is always with us.

The next step up is the ever-popular point and shoot variety. Although they generally have much smaller sensors than Digital Single Lens Reflex (DSLR) cameras, their sensors and lens quality often dwarf the size and

The gift of the authentic is the most valuable thing that we photographers offer our viewers. Whether our objective lies purely in a journalistic style or in idyllic or fantastic imagery, the mark of quality in an image is truth. Truth is the authentic element that reaches out of the photograph and catches our attention.

performance of our cell phone cameras. Carier-Bresson did not capture his timeless images with a hefty SLR, but with a smaller, compact Leica™ camera. Today many street shooters who target candid moments still turn to this workhorse of a point and shoot, proving that a good quality compact camera is still a contender, even for highly acclaimed professional photographers.

Jacques Henri Lartigue (p. 58) also had a knack for capturing candid moments. One of his biggest assets,

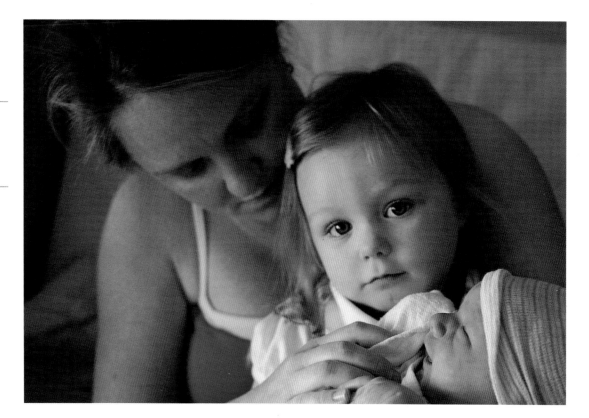

aside from his talent and passion, was his access. Not just anyone can maintain his or her subject's unaffected ease in the presence of a large formidable camera. For Lartigue this ability was a direct result of his familiarity with his subjects. There are two lessons to be learned here. The first, we must look closely at what is nearest to us: a world that may only be accessible to us alone. However, if your camera leads you to discover new horizons, outside the familiar, find a home in this new venue. If it is dear to us then a natural approachability will occur with our subjects, because we care. Second, although we are the one with the camera, making all the decisions of what to capture and how, there is something very powerful about maintaining a humility and small presence when photographing, especially with children. This allows us to slip into the background and be a "fly on the wall" through more observation and less talking. As Perry Farrell put it, "I want to be more like the ocean, no talking, all action."

One last point, although it might be obvious to many: if a child strongly objects to an image being taken, we should stop shooting. It may be you or just what the camera represents to them, or it could have nothing to do with you and they are just not feeling the love. Some photographers just need to know when to put the camera down: others need to worry less that every picture is an assault and relax into the photo shoot. It can be a fine line so it's difficult to make a hard-and-fast rule, but if the child is uncomfortable and upset, the line has been crossed. Take every occasion to help the child feel comfortable in your presence so that the request to stop will not be made; but when it is, it must be considered. There is nothing wrong with asking for a couple more shots or distracting them with a break or a reward, but the shoot should wind down. Willing and unaware subjects are always the most photogenic. Images of forced smiles and of children with cowering body language will ultimately just make the viewer sad and uncomfortable. Why risk the memory and the possibility of ease in fu-

ture shoots for this type of image? It's just not worth it on so many levels.

The gift of the authentic is the most valuable thing that we photographers offer our viewers. Whether our objective lies in a journalistic style or in idyllic or fantastic imagery, the mark of quality in an image is truth. Truth is the authentic element that reaches out of the photograph and catches our attention. When an image is sincere it will have an impact that can't be manufactured by the elements and principles of design alone. The latter supports the former, but authenticity must never be underestimated or snuffed. As we discuss the other objectives let's ask ourselves how we can infuse them with a foundation of authenticity.

THE IDYLLIC
The formal portrait

There is something really powerful about a formal portrait. Perhaps it's the preproduction preparation, or it could be that we all sit a little taller when we know we are being photographed to look our best. Formal and idyllic photographs are all about the sitter being shown in the best light.

To accomplish this goal, we need to assure the sitter feels comfortable. Adults can be a very intimidating presence to child. Once we pick up the camera, there is an additional power discrepancy in favor of the photographer; the sitter is giving and we are taking. Because we all look better when we feel better, it is nice to swing the power pendulum toward the sitter, the star, the child! Ultimately, we must relinquish some control. Though it might make us feel somewhat vulnerable, lets face it, how much control do we really have when photographing a child anyway? We'll be better able to direct our image when we share control. Helping the child feel comfortable in front of the lens can be daunting, but it's an essential task.

The studio of Southworth & Hawes (p. 38) could easily be seen as an uncomfortable place to make an image. Sitters used braces and had to lean on pillars to maintain the stillness for the multiple seconds required for daguerreotype exposures. The physical control of these gadgets could easily create an unpleasant situation for the sitter as they struggled to be both natural and still. Even though these contraptions clearly impeded spontaneity at the sitting, the studio of Southworth & Hawes sought to make the experience of sitting for their camera as pleasant as possible. The way sitters were greeted and cared for created an atmosphere that resulted in an ease of expression, even for their youngest sitters. Today we have a huge advantage over the complicated daguerreotype process that required so much from the sitter and photographer alike. If we but offer our sitters a fraction of the reassurance Southworth & Hawes showed to theirs, we'll have a sure formula for success!

If you are a person who makes friends easily and interacts with children well, take full advantage of this gift. Establish a rapport and take the opportunity to know the children who sit before your lens. Simply showing genuine interest in a child can open worlds they keep hidden from others. If the child is reluctant and a bit dispassionate, this too can make a great shot (but generally parents will not treasure this shot until many years later).

> We all sit a little taller when we know we are being photographed to look our best. Formal and idyllic photographs are all about our sitter being shown in the best light and looking their finest.

It is easy to control variables in our studio and on our own turf. However, another way to elicit comfort is to meet our sitter within *their* territory. Environmental portraiture provides an additional element to the story of the child. For instance, if the child is involved in karate and we shoot them in their training space, they will simultaneously have one foot in reality and the other in the world of the idyllic. Effective environmental portraiture is demonstrated in the young faces captured in the photographs of Lewis Hine (p. 50). These children had an immense amount of confidence in spite of their difficult child labor environments. No matter how horrific the labor conditions they experienced were (especially by today's standards), there was a pride of ownership in their young expressions. Even with their ragged clothes and dirty faces, these children felt the respect and care of Lewis Hine. For them, the portrait offered acknowl-

image 1.6
The speed of the strobe/flash was 1/150th of a second. This allowed me to shoot at a very low shutter speed and capture both the natural light in the space and still freeze the motion of the father and son.

Shutter Speed: 8
F-Stop: f/8
ISO: 100
Camera: 35mm DSLR
Lens: 30mm
Light: Mixed: natural/strobe

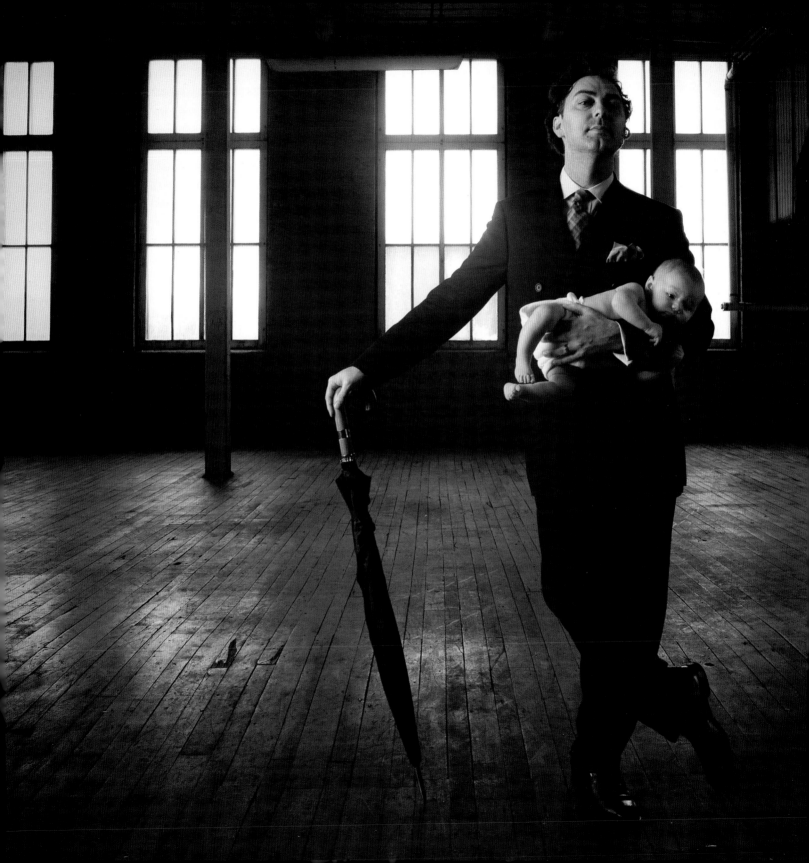

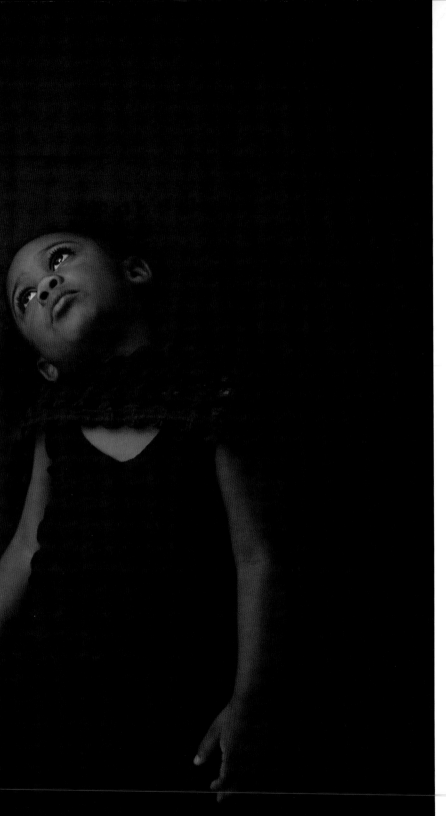

image 1.7
When a child is intent on putting on a performance for the camera, asking off-the-wall questions can provide a much-needed distraction, helping them break away from their self-made show. Here she is thinking about the answer to the question, "If you could fly, where would you fly to?"

Shutter Speed: 125
F-Stop: f/5.6
ISO: 100
Camera: 35mm DSLR
Lens: 48mm
Light: Diffused strobe/frontal

edgment and worth, which is one of the most powerful aspects of portrait photography.

For the photographer, foreign environments can make the technical aspect of image-making difficult. For instance, the location did not allow Mr. Hine to control the light as in a studio. Still, like Hine, we can utilize the natural attributes of the scene and move around our space to discover the best light. This is precisely how Hine preserved, in images, the emotional stories of these young laborers. Even today, over 100 years after the capture of these images, we share in the sincerity, impact and pride of these portraits.

If you are a person who makes friends easily and interacts with children well, take full advantage of this gift. Establish a rapport and take the opportunity to know the children who sit before your lens. Simply showing genuine interest in the child can open worlds that are keep hidden from others.

In speaking of Hine's work we briefly touched on his use of light. Let us now talk about this all-important element of portrait photography in more depth. Light is a main consideration before we press the shutter release on our cameras. The emotion that light adds to an image can change the direction and interpretation of the faces before us. We must never wait until the time that the perfect expression or gesture presents itself to begin our consideration of light. This must be the first consideration when we arrive on a location or prepare a space for the arrival of our sitters. Make the time to set up and assess the light situation before your child subject arrives. Test it with an assistant, a passerby or even by shooting your hand. How will the light wrap the child? Is a fill required to provide detail in the shadows? If so, what will provide that fill, a white wall, card, or flash? Who will hold the fill, if that is required? Do you need to soften the light with a sheer, or will the harsh shadows add to the story in the image? What physical directions will your light and environment allow you to shoot and how will you move around to capture the best of the child, location and light? These are infinitely important

questions to answer *before* the child or children arrive. More about light will be discussed in Chapter 3. When looking at images in this book and elsewhere, seek an understanding and sensitivity to what light may have been used. Slow down and take the time. Remember, these are not simply candid photographs. Foreseeable errors, of lighting or composition, should be eliminated to create an ideal image.

Access to a person or location can be a rare opportunity. Properly treat it as the precious commodity that it is. Our subjects will allow or deny access to their "best self" based on our interaction with them. Their expectation is for an idealized portrait. This is what they trust we will deliver. Always maintain that trust. When we neglect to prep the location or studio before a shoot, we may unseat that trust. Preparation helps us avoid mistakes that can make our subject nervous. Once nerves kick in, it is very difficult to bring them back to comfortable and relaxed. This is true for adults, as well, but is especially true with young children. Actually, don't think of this preparation as "time before the shoot," as this is an essential part of the shoot—it occurs just before the child is on set. With preparation, when the photographs are being captured, we can better focus on our interaction with the child, subtly directing them into the place of best light and personality-filled expressions.

A few technical tips for portraiture involve lens choice, depth of field and light. More information on these is contained in Chapter 3, but here is a little information to whet your appetite for technical insight.

Wide-angle lenses will always distort our subjects, especially at the edges of our lenses. The wider the lens, the more obvious the distortion will be. For tightly cropped portraits, it is not recommended to shoot with any wider than 50mm lens. 80mm is a good balance of depth and minimal distortion. Still longer lenses, which seem to flatten the image with the way they compress depth and eliminate distortion, will make the image more about the graphic outline of the shape of our subjects in frame. If the location requires the use of a wide lens, try to center the subject so that the increased distortion at the edges of the frame will not affect the sitter.

Depth of field is another great asset in portraiture. It can either eliminate distraction, when the lens is wide open

(f/2.8), or add valuable environmental information, when the lens is stopped down (f/16). When stopping down and including the background, always be aware of how background objects intersect or frame the child. A tree appearing to grow out of a head is very distracting while a tree that curves around the child's head frames and reinforces the child in the scene.

When possible, add a highlight in the child's eyes. This is easily accomplished by softly reflecting light into their face with a white card or disk. But remember, a little bit of bounced light can go a long way so don't make the fill too intense! A "catch light" in the eyes is best when subtle, yet this little addition to detail can add sparkle and life to the child's expression.

Lastly, a few tips for our interactions with children. When interacting, anticipate the image *before* it presents itself. This simply means observing one action and acknowledging its implication of the next. When the child has not blinked for a while, we can assume they are really trying hard to perform for the camera. Whether or not they know it, tension is building in their body language and an intervention from the photographer is required. Ask them (while showing them how) to clench their fists, squeeze shut their eyes, tighten their shoulders and hold their breath. Make this request with a tight voice that mimics the demonstration provided. If they squeeze themselves tightly enough they may even shake. This is our cue to quietly and calmly ask them to keep their eyes shut but to let out their breath, and relax their shoulders, face and hands. Then ask them to slowly open their eyes and look at you (smile at them when they do this). This little game will require their attention and distract them from thinking so much about the shot. Next time, have them jump in place and jiggle their body. It can be fun to experiment with expressions like angry, sad, happy, confused (that is my personal favorite), and any other game that will keep them on point but relaxed. Always start with the most calm games first and move then to the wacky and silly games. This will provide a natural

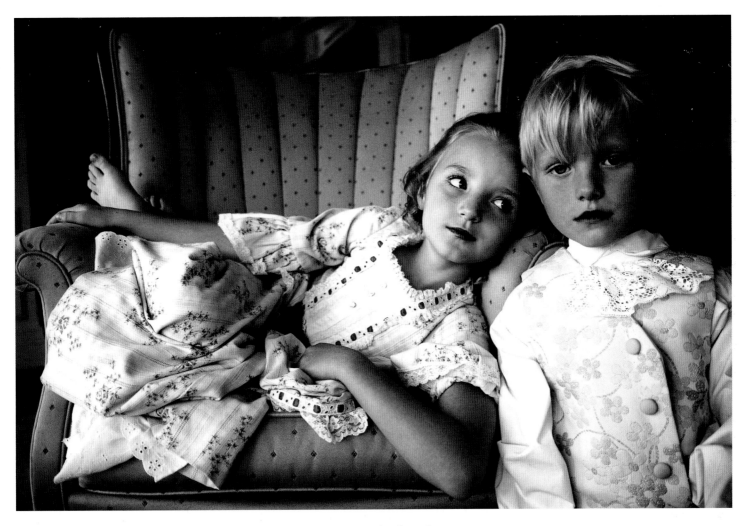

image 1.9
Pay attention to the interaction between two or more subjects in your frame. The interplay of children is something not to be missed!

Shutter Speed: 30
F-Stop: f/3.5
ISO: 100
Camera: 35mm DSLR
Lens: 28mm
Light: Natural side window light

evolution of emotion for the camera and will give better insights as we work with each individual child.

Portraits, especially child portraits, are exhausting and require a lot from the photographer. It is up to us to set the scene both physically and emotionally, a big responsibility! Yet, as we relish the experience and merge fun into our objectives, portraits can be rewarding and the basis for friendships and lifelong associations. Formal and idyllic photographs are all about the sitter, helping them present their best and most endearing self in tangible, photographic way.

THE FANTASTIC
Beyond reality: the conceptual image

In the late fall of 2000, I was awakened by a tug from my four-year-old niece. We'd had a slumber party the night before, a girl's night, and we'd wrapped her hair around strips of rags to create curls in the morning. I smiled at her head of rags, gave her a hug and wished her a good morning. It was a misty dawn that warmed into an overcast day, and the view of the trees in the mist reminded me of a children's poem I had heard, entiled "Somewhere," by Walter de la Mare.

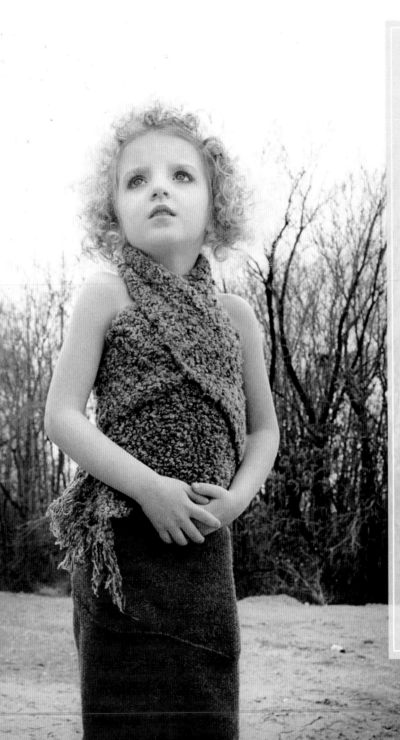

SOMEWHERE
by Walter de la Mare

Would you tell me the way to Somewhere—
Somewhere, Somewhere.
I've heard of a place called Somewhere—
But know not where it can be.
It makes no difference,
Whether or not
I go in dreams
Or trudge on foot:
Would you tell me the way to Somewhere.
The Somewhere meant for me.

I want to be off to Somewhere,
To far, lone, lovely Somewhere,
No matter where Somewhere be.
It makes no difference
Whether or not
I go in dreams
Or trudge on foot,
Or this time tomorrow
How far I've got,
Summer or Winter,
Cold, or hot,
Where, or When,
Or Why, or What—
Please, tell me the way to Somewhere—
Somewhere, Somewhere;
Somewhere, Somewhere, Somewhere, Somewhere—
The Somewhere meant for me!

Again my niece nudged me for attention.

"Can we do photos while you are here?" she asked.

This was our thing, talking about ideas for photographs, then going out and making them.

"Absolutely," I replied and with that we fixed breakfast and started our day. I unrolled her rags to reveal tight-spiraled curls. She looked very cute and she asked again as she looked up at me with her big eyes,

"Can we do photos?"

Although a portrait would have sufficed I couldn't help but be inspired by her gangly limbs and bushy hair. They so well mimicked the trees outside and the poem in my head. We didn't have much in the way of an outfit for her, so I wrapped her in my scarf and gave her a little overnight bag that looked like a suitcase just her size. I wanted the image to be special but we didn't have a lot of time or resources, so I filled the suitcase with popcorn (a surprise reward at the end of the shoot) and we headed outside. I shot one roll of 35mm film and 3–4 sheets of 4x5 film. We spent, at most, 20–30 minutes together on that shoot, but it is a memory indelibly preserved in the images, and fantastical ones at that!

Inspiration can come from literature, current events, music; things that move you and cause you to think. What do you have to say? What do you believe and treasure? Ideas can come from anywhere and when they come, embrace them.

image group 1.10
I shot very low for this whole shoot so the "lost" child would look empowered.

Shutter Speed: 125
F-Stop: f/4 (f-stop right: f/8)
ISO: Kodak 160NC (film)
Camera: 35mm SLR
Lens: 100mm (lens right: 70mm)
Light: Diffused, overcast

As artist-photographers, perhaps nothing expresses our convictions or opinions more than the conceptual image. Generally, there is a story or meaning in this type of imagery. Since it doesn't document a particular time and space as other objectives we've discussed do, its expression and story are the thesis and substance of the photograph. This genre generally requires a fantastic investment of time, money and effort. Most often, an immense amount of preparation and pure production (both before and after the shoot) is required. Some feel conceptual images are simply making babies into peapods or flowers in pots, but I feel that the most success-

ful images, in terms of substance, have an air of authenticity that is true to childhood no matter how fantastical the scene.

In making a conceptual image, we often find ourselves out on a metaphorical limb because the conceptual photograph can become cheesy or controversial exceptionally quick. A way to avoid these pitfalls is to be somewhat subtle in our presentation of the concept we wish to portray, and let the individual child or the essence of childhood shine through in the final image. Even theatrical images need to hold a place of truth. This is where the true artistry lies.

Julia Margaret Cameron (p. 42) was one of the first successful conceptual photographers. Her success was aided in her ability to typecast her friends and neighbors and those reliably available to her. She incorporated Victorian standards and Pre-Raphaelite notions of bringing

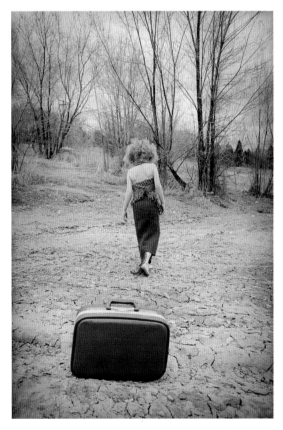

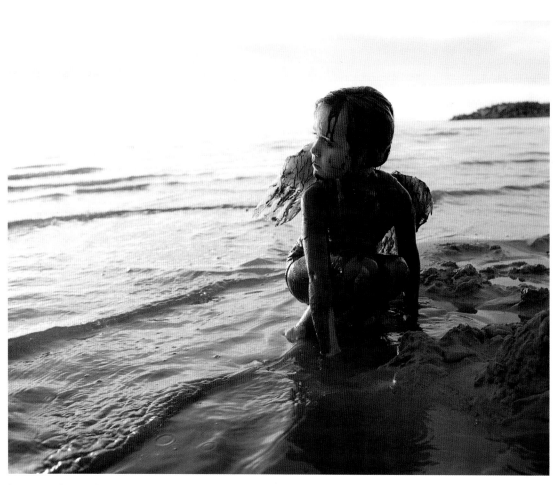

image 1.12
Moving around your subject will quickly change the direction of light from backlit, to sidelit, to front lit. This affects the feel of the photograph too.

Shutter Speed: 60
F-Stop: f/4.5
ISO: 100
Camera: 35mm DSLR
Lens: 32mm
Light: Natural with soft strobe fill

literature alive in her images. Her inspirations organically bloomed from these ideals because she was well-versed in them. Even her portraits, though simple, were assigned descriptive titles to suggest that her sitters were plucked straight from the Bible, time-honored texts, or emotional meanderings. In all ways, Cameron was true to her inspiration.

When conceiving conceptual photographs, draw from your own unique understanding and perspective of the world. Inspiration can come from literature, current events, music; things that move you and cause you to think. What do you have to say? What do you believe and treasure? What are the things you notice that others may not? Ideas can come from anywhere and when they come, embrace them. Sometimes inspiration comes from directions and events we could have never anticipated and when they present themselves, pay attention. Write down your thoughts and you'll discover an entry point for your conceptual work.

When the Deepwater Horizon oil disaster happened in the spring of 2010, we were all confronted by the truth of our consumption of this natural resource and what can happen when desire trumps good judgment. The media broadcasted images of oil flowing into the Gulf Coast and its impact on the land and sea. It covered all that is precious to Americans in a slick tar. I immediately thought of the children who had lost their fathers in the destruction of the rig as well as families who were in the process of losing their livelihood. Stirred by this event, I envisioned a series of images to address the legacy of

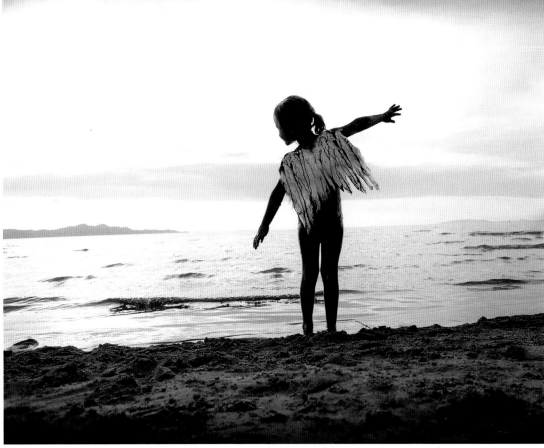

image 1.13
When shooting for a strong silhouette, look for interesting shapes and don't forget to have the child turn their head to a full or 3/4 profile.

Shutter Speed: 160
F-Stop: f/5.6
ISO: 100
Camera: 35mm DSLR
Lens: 25mm
Light: Natural with soft strobe fill

this incident. I shared my concept with the children who eventually posed for these shots. The shoot allowed them to experience, even if just for pretend, what was broadcast into their living rooms. It was a chance for the children to ask questions and learn about this event as a tangible story. It was empowering, and fun too—after all, what child wouldn't jump at the chance of being covered in gallons of chocolate syrup while learning an object lesson?

Unlike the "Somewhere" photographs, this shoot required a good deal of planning and coordination with parents, props, children, and travel. How do we make complicated shoots happen? If we are creative enough to come up with concepts, we can apply that same creativity to the execution of our concepts, one step at a time. It also helps to go beyond collaboration with just child and parents and wrangle a team to work with you. We all work at different levels of production but the end result of a fantastical image is generally distinguished by its "production value." Production value illustrates an effort beyond just showing up and taking a candid shot, it shows dedication and forethought.

An essential first step to any shoot is casting, and I find that when I shoot conceptually it is a little bit harder to explain my vision to a parent. They are like "Sure, I'd love you to take a free portrait of my child," and I am left to explain that this image is not about an idealized notion of their child but of a completely random concept. In fantastical images we are shooting for what we want, *not* what others want. Still, parents generally love pho-

WYNKEN, BLYNKEN, AND NOD
by Eugene Field

Wynken, Blynken, and Nod one night
* Sailed off in a wooden shoe-*
Sailed on a river of crystal light,
* Into a sea of dew.*
"Where are you going, and what do you wish?"
* The old moon asked the three.*
"We have come to fish for the herring fish
* That live in this beautiful sea;*
* Nets of silver and gold have we?"*
* Said Wynken, Blynken, and Nod.*

The old moon laughed and sang a song,
* As they rocked in the wooden shoe,*
And the wind that sped them all night long
* Ruffled the waves of dew.*
The little stars were the herring fish
* That lived in that beautiful sea-*
"Now cast your nets wherever you wish-
* Never afeard are we";*
* So cried the stars to the fishermen three:*
* Wynken, Blynken, and Nod.*

All night long their nets they threw
* To the stars in the twinkling foam-*
Then down from the skies came the wooden shoe,
* Bringing the fishermen home;*
'Twas all so pretty a sail it seemed
* As if it could not be,*
And some folks thought 'twas a dream they'd dreamed
* Of sailing that beautiful sea-*
* But I shall name you the fishermen three:*
* Wynken, Blynken, and Nod.*

Wynken and Blynken are two little eyes,
* And Nod is a little head,*
And the wooden shoe that sailed the skies
* Is the wee one's trundle-bed.*
So shut your eyes while mother sings
* Of wonderful sights that be,*
And you shall see the beautiful things
* As you rock in the misty sea,*
* Where the old shoe rocked the fishermen three:*
* Wynken, Blynken, and Nod.*

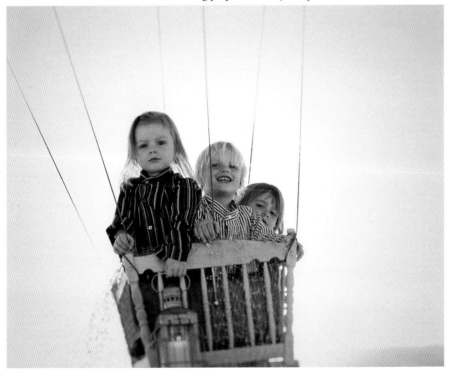

tographs of their children, and if you are trustworthy, have a portfolio of your work on hand and are open to concerns, often parents will give permission if the child is excited to participate. A child's willingness to participate is essential, but *never* ask the child before speaking to the parent. Few things will tear down the trust of the parent faster than making their relationship with their child difficult. Equally, if the parent is onboard but the child is uninterested or uncomfortable, don't cast that child. Even if we have a great child, it is not a bad idea to cast a second child, as well. This takes the pressure off the children and photographer alike.

Other production points to consider for this genre are the wardrobe, location, and any props needed. Who is going to do the child's hair and who is going to look after their needs when you are not with them? Do you have enough food (and sweets for a bribe at the end) to keep the children and crew nourished and happy? All this might sound complicated, but there is nothing more valuable then preproduction. Preproduction allows us to focus on capturing the image and the child when on set. Being prepared for myriad possible roadblocks will allow

for creativity and collaboration, and a happier set.

My last example for this section is an image made of and for another pair of my young nieces and a nephew, all on the cusp of turning three. They were all related, from three different families, and visiting the same town at the same time. Legacy is really important to me, and yet I hadn't ever photographed these children together. I had two weeks before we all went our separate ways and felt compelled by circumstance and a favorite childhood poem. My favorite bedtime poem when I was a child was "Wynken, Blynken, and Nod" by Eugene Field. The poem is about the sailing journey of three children and, to me, these three were the epitome of the "fisherman three" described in the poem. My next two weeks were a whirl as I sewed costumes, located an eight-foot weather balloon, and rigged it to my very own childhood crib. There were fittings and the coordination of schedules and finding a location, pulling together a skeleton crew, and the list went on. It was a true hassle but worth all the effort. This image will forever connect them to each other, to me, and to the legacy of literature and imagination of our family.

My niece from the Somewhere shoot is now 15 and my two nieces and nephew of the Wynken, Blynken, and Nod shoot just finished kindergarten. Time is not going to preserve their childhood adventures, but photographs can. For me, photographs, especially of children, are about both the image and the memory, as the title of the book suggests. When I ask my 15-year-old niece about our impromptu "Somewhere" photo shoot and what she remembers, the first thing she said was, "I remember the popcorn in the suitcase and how excited I was about that."

As we share what is true and dear to us through our images and process, we make connections beyond the surface of the printed picture. The image becomes about feeling and reminiscence and moves the viewer from within.

Like our children, our ideas are our legacy.

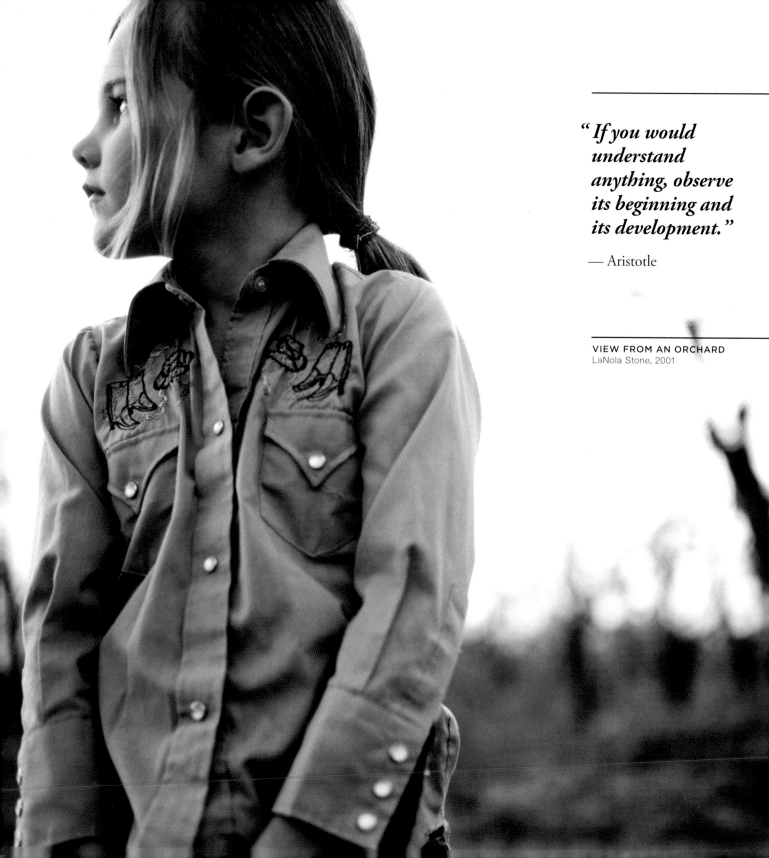

" If you would understand anything, observe its beginning and its development. "

— Aristotle

VIEW FROM AN ORCHARD
LaNola Stone, 2001

EARLY IMAGE-MAKERS

2

WHAT HISTORY OFFERS US

The essence of photography is history. We press the shutter in the present, and the image recorded instantly becomes the past. The significance of this was not lost on the early practitioners and connoisseurs of the medium. The first photographs were called a "mirror with a memory," and the impact of a photograph's exact likeness, from mere moments before, was miraculous. Photography today has become commonplace, and the medium continues to evolve and reinvent itself, as we, the artist-photographer, must too. However, in studying the past, we'll find that present struggles strangely mirror the photographic quandaries of yesterday.

HOMAGE TO THE PAST
Standing on the shoulders of the masters

In photography, as in life, we build on the foundation of what has come before and we owe a debt of gratitude to the pioneers of our field. There is something correct and respectful about honoring those who have blazed paths for us, if only by knowing who they are and a small morsel about their lives and contributions. Though it would be impossible to fully examine each of the following photographers in the pages of this book, this chapter seeks to lay a foundation for further inquiry into their lives and place in the history of photography.

Each of the photographers in this chapter had to overcome the limitations of their medium. Some tirelessly worked to iron out the kinks, like Southworth & Hawes with their modifications to the daguerreotype camera, while others embraced the flaws of their procedure, even in the face of strong criticism from the establishment, like Julia Margaret Cameron with the wet plate collodion process. All spent countless hours learning their craft and they each had a dedication that set them apart from their contemporaries. Käsebier doggedly pursued her career in a time when women couldn't even vote. Hine used his insight as an educator to elicit change through exposing, in photographs, the young lives be-

hind factory walls. Steichen's dedication to the medium stretched over 70 years, in and out of different capacities from artist to curator and even through service, as a photographer, in both world wars. Each photographer contributed to the foundation for generations to come.

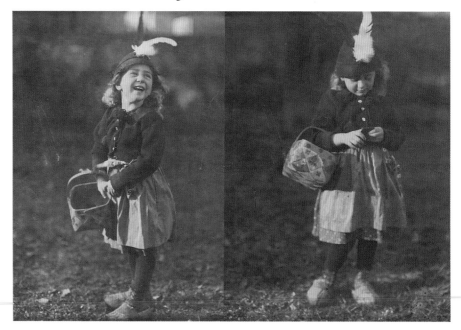

Edward Steichen
GIRL WITH FEATHERED CAP

Diptych, 4.5in x 3.5in
Vintage Gelatin Silver Print
Courtesy of Treadway Gallery, Chicago
Permission: Estate of Edward Steichen

At the turn of the century, Käsebier influenced Steichen and Hine, and Hine went on to teach another great, Paul Strand. Our field is an honorable web of dedication, tenacity, and results. As we embrace the history of the photographers that came before us, we have the opportunity to use their platform as a springboard for our own work.

A CONTEXT TO OUR WORK
The foundation for contemporary photographs

As quoted in the opening of this chapter, Aristotle asks us to approach understanding with an eye to its evolution. As we pick up our cameras to capture an image with the mind of an artist-photographer, the historical context of past lessons and anecdotes can present themselves as influences within our own work. Only the separation of time and content, embodied in photography, can allow us to elaborate and draw conclusions while looking at visual evidence long after the fact. When we study and contemplate the images of the past we'll instinctually add context to our own work.

I am not suggesting that one should postpone picture-taking while acquiring an historical foundation. Make photographs, but all the while hone your craft. Learn and appreciate the work and insights of photographers that have come before and listen to the lessons that can be derived from their work. When you feel inclined to capture an image, your instincts will be buoyed by the context of history and your perspective toward it.

The general public received photography in 1839. Before then, to have a rendering of oneself would entail sitting for hours for a painting (often made in miniature form) or having a silhouette trimmed to one's likeness. The exactness of the daguerreotype process, one of the first photographic methods, was unprecedented. (Its detail is still remarkable, even by today's standards.)

Photography was presented to an anxious population that was ready to receive it. As with all new technology, it had its idiosyncrasies and challenges. While a painter could render a sitter motionless on the canvas, the camera recorded precisely what it saw through its lens for the entire duration of the exposure, including movement, blemishes, and focus (or lack thereof). Yet, the recording

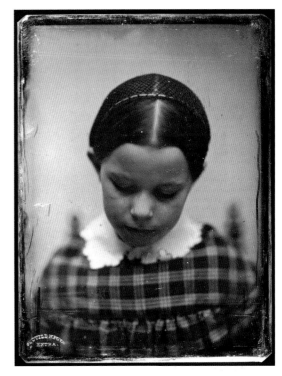

Southworth & Hawes
ALICE MARY HAWES

ca. 1852
Daguerreotype
Quarter Plate (3 1/4 x 4 1/4 in.)
George Eastman House, International Museum of Photography and Film

of moments was infectious. It was a revolution of possibility to have one's likeness made in a matter of minutes, and a literal likeness at that! Photography was born whole, the image lived on the plate at first exposure, even if blurred or imperfectly exposed. At first, photography was seen merely as a recording device, but the question quickly arose of how this new technology would assist the needs of artists, and how to emphasize its advantages and pacify its shortcomings. Although the tools of photography have changed, those who seek to master photography with an artist's eye must ask themselves the same questions. After all, simply pushing a button is the only requirement for taking a picture. Today's photography is not that complicated if your goal is just to record an image. Yet high-art photography is one of the most complicated of all forms of art. It's burdened with an expectation of ease, yet the elusive and subtle expressions of a subject, whether child or countryside, cannot be forced or manipulated. It requires gentle collaboration and an acute sensitivity to time, subject, and place. And, of course, it is enhanced by technical mastery as well.

These, and the placement of our work in the historical timeline of all work, are what will define our most successful photographs.

ADVANCING OUR STYLE
Development through, not imitation of, the past

One can develop an immense understanding through exposure to lives and styles beyond our own, whether similar or different. The narrative of history offers the power of reflection and full-bodied perspective of art as we develop our own unique style. Another goal of the artist-photographer is to enlighten one's own emerging style by providing context, a foundation for the precedent of our style.

This chapter is by no means a complete and comprehensive history of the photographers who've captured childhood through their lenses. Rather, it offers a brief insight into the work, style, limitations, and opportunities of photography's masters: Southworth & Hawes, Julia Margaret Cameron, Gertrude Käsebier, Lewis Hine, Edward Steichen, Jacques Henri Lartigue, and Henri Cartier-Bresson. Each of these photographers used different technology and the results varied based on the time, tools, subject, and approach. The influence of many of these photographers is deeply present in the work of contemporary artists, filmmakers, authors, and the like. They planted the seeds for countless literary and visual works of art. Although some of the information in the following photographs may be unfamiliar, as you explore an extended body of their work in other books, via the Internet, and by visiting museums and galleries, you will assuredly find images that are recognizable and embedded in the psyche of our contemporary culture.

In addition to being a review of the history of each photographer, this chapter is about taking the time with each image to ask deeper questions... What inspires? What is passé at first glance? What do you immediately like and dislike? Why? As anyone who deals with inquiring children can attest, "Why?" is the universal follow-up question to almost any statement in a conversation. Approach this gallery with the inquisitiveness of a child. Use it as a catalyst to your exploration, as an appetizer to a banquet of curiosity and discovery.

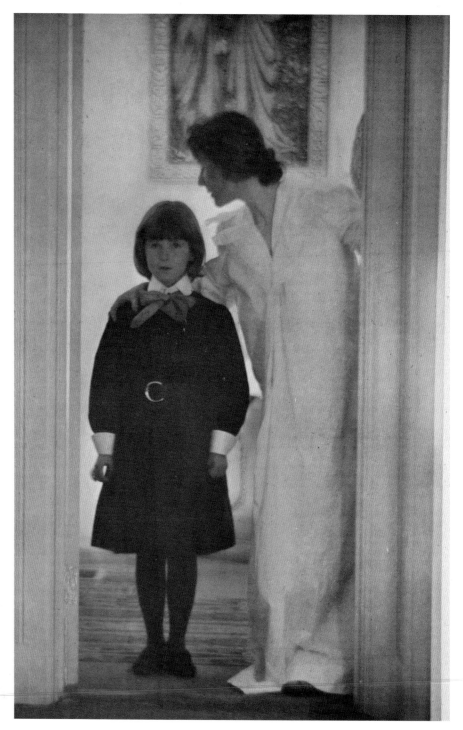

As an artist-photographer, seek understanding of the precedent by which many will consciously and unconsciously judge your work. Inform your images and open doors to the style that lies dormant inside of you; the images that only you can take because of both who you are and what you've been exposed to in technology, education, and circumstance.

Style may seem elusive and intangible, but as it has for many before us, style will find a perch in your own work over time and through consideration of your images and the influences that birthed their creation. Style is honed through the production, shooting, and editing of photographs. Like quicksilver in the hand, it will dart away if you grasp at it. Style will develop organically through the study of what has come before and your reactions to that work. More intently than in any other medium, photography intrinsically embodies history and is a document of time-past mere moments after it is created. Added to the innate magic of the medium, and through consideration and time, your own subject, approach, intent, and style will come to present itself in your work.

Gertrude Käsebier (left)
BLESSED ART THOU AMONG WOMEN

1899
9 1/16 x 5 3/16 in.
Photogravure (photomechanical print)
United States Library of Congress

Lewis Hine (right)
GAME OF CRAPS. CINCINNATI, OHIO. AUG., 1908

5 x 7 in.
Glass Negative
United States Library of Congress

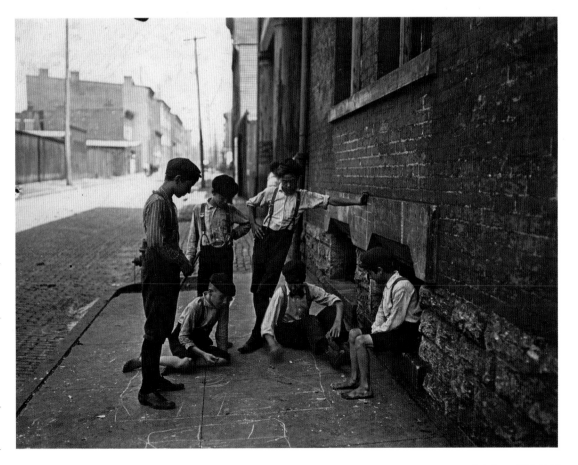

SOUTHWORTH & HAWES *1843–1863*

Josiah Johnson Hawes 1808–1901

Albert Sands Southworth 1811–1894

1800 1900 2000

HISTORY

In 1839, sitters had to remain motionless for enough time to allow light, reflected from the scene, to leave its impression on the film plate. This would create a stoic portrait, as well as a blurry one if the sitter was not properly clamped into place. Four years later, with the same process, Southworth & Hawes made claim that their images could capture a "representation of beauty, and expression, and character," that was the "finest expression of which that face and figure [were capable]." To achieve this, Albert Southworth and Josiah Hawes, vastly improved the length of exposure, and softened the harsh contrast associated with the original daguerreotype process. They had the advantage of "faster" Voigtlander lenses, improved sensitivity of the film plate, and made brightening modifications to their daguerreotype camera. Because these measures could dramatically reduce sitting times to just a few seconds, the partnership created some of the most advanced images of their day.

Although they were, independently, early adopters, it wasn't until 1843 that together they opened a studio on Tremont Row in Boston. Their skillful hands, advanced studio, and quicker exposures resulted in superior images, and their notoriety grew. Yet even the most skilled photographer, with the best tools, experienced a challenge when photographing a very young sitter.

STYLE

The Southworth & Hawes studio produced a quality in its photographs that set them apart from many of their contemporaries, especially when working with children. This recognition was not by chance or through talent alone, but through design, forethought, and improvement of commonplace practices of the daguerreotype.

For Southworth & Hawes to achieve their unique class, style, and aesthetic in images, the *entire* experience of image-making was considered, from plate polishing to the greeting and styling of the sitter, whether child or adult. They offered true precision and reverence for the process. Since the camera captures exactly what it sees, if their subject was nervous, uncomfortable, or even introspective, the camera could potentially capture these emotions. The human mind has a considerable ability to detect false information, and the longer the capture time, the more evident the façade of a painted-on expression. Southworth & Hawes recognized the importance of subtle information, and they masterfully released the shutter to capture the best possible expression. They succeeded and thrived in an overpopulated field primarily because clients were drawn to their holistic and authentic approach to photographing. Even though seconds were required for their exposures, their images often reflected the ease of contemporary snapshots, generated by the caring interaction between sitter and their artisan photographers.

"Their style, indeed, is peculiar to themselves; presenting beautiful effects of light and shade, and giving depth and roundness together with a wonderful softness or mellowness. These traits have achieved for them a high reputation with all true artists and connoisseurs."

— Marcus A. Root, August 1855
Photographic and Fine Art Journal

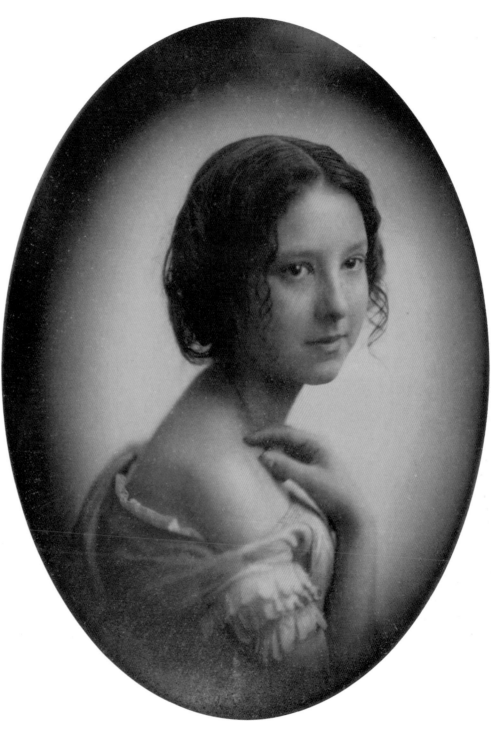

Southworth & Hawes
**YOUNG GIRL WITH HAND
RAISED TO SHOULDER**

ca. 1850
Daguerreotype with Applied Color
Whole Plate (6 1/2 x 8 1/2 in.)
Matthew Isenberg Collection

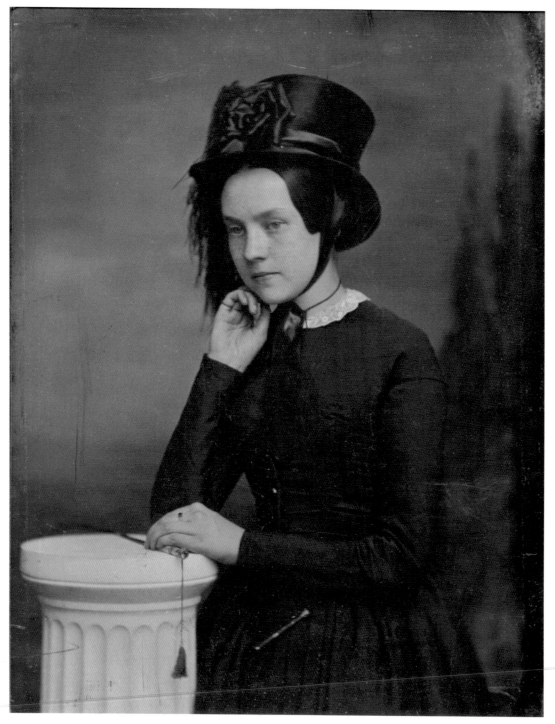

Southworth & Hawes
**YOUNG ARISTOCRATIC GIRL IN
HER RIDING HABIT**

ca. 1850
Daguerreotype
Quarter Plate (3 1/4 x 4 1/4 in.)
Matthew Isenberg Collection

Southworth & Hawes
UNIDENTIFIED CHILD

ca. 1850
Daguerreotype with Applied Color
Quarter Plate (3 1/4 x 4 1/4 in.)
George Eastman House, International
Museum of Photography and Film

JULIA MARGARET CAMERON *1815–1879*

Julia Margaret Cameron 1815–1879

1800 1900 2000

HISTORY

Julia Margaret Cameron was 48 years old when she fully embraced photography. Her genius is manifest in portraiture that conveyed a narrative. Nearly one in every six images she produced employed local children as her little actors. Her stories were often deeply intertwined with allegory and lore, and seem to reveal more about the photographer than her sitters. In fact, her credentials to create these photographs went far above her use of the troublesome and unforgiving process to make her images. Cameron's breadth of skill included resourcefulness, substantial cultural knowledge, and a devotion to literature, drama, and Victorian ideals.

Although Cameron's images seem effortless, she used the arduous wet plate collodion process to create them. In simplified terms, just prior to shooting she made her own film from a mixture of toxic chemicals, which she poured onto glass. She'd then have to capture her images while the chemistry was still wet on the glass plate, and likewise develop it before it dried. During that brief window she'd commit an intense allegory to the wet plate. And yet, her results appear effortless, soft, and complex with emotion.

Cameron understood the importance of creating art authentic to herself, rather than the over-intellectualizing, formulaic approach so prevalent in the late 1800s. Cameron's work is generally placed within the Pre-Raphaelite movement, the first real avant-garde movement in art. Yet she did not enjoy the embrace of the contemporary art connoisseurs of her time.

STYLE

Children were often the subject of Victorian art and from this convention Cameron did not stray. To the Victorian artist, childhood represented idealized beauty and virtue. It also helped that children were naturally available to Cameron's upper middle class, middle-aged position as wife and mother. She often recruited the neighborhood children, friends, and her staff as sitters. One of her young models, and later mother of the author Virginia Woolf, described the experience as being "pressed into the service of the camera." Cameron also unabashedly invited her friends, including Alfred Lord Tennyson, Charles Darwin, Henry Wadsworth Longfellow, and George Frederic Watts to be her subjects. She was committed to expressing the emotion behind the stories told in her portraits, and did not shy away from the casting and production required. She'd "[tousle] hair to get rid of its prim nursery look," and used props and costume as essential and integral elements in her photographs.

Cameron was able to work and produce art by being resourceful. She would enlist models from within her community, shape soft natural light to filter across her subjects in her modest garden or through a window in her home, and pull props from around her. She worked for only a short portion of her life, but produced a full lifetime's volume of work! She found her passion and embraced it, no matter the difficulty. Her resulting images relay the melancholy and substance of feminine humility, deeply entrenched by the confidence and determination that were distinctly hers.

"I longed to arrest all beauty that came before me, and at length the longing has been satisfied."

— Julia Margaret Cameron

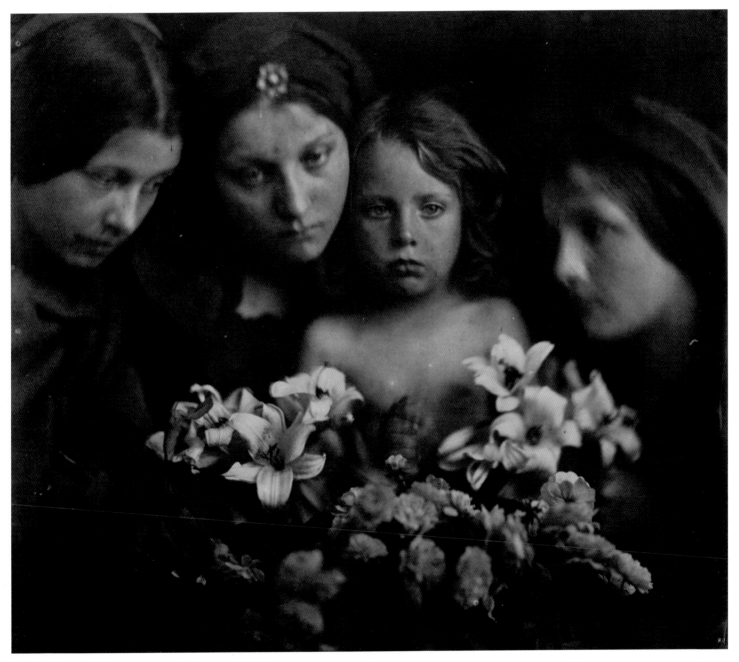

Julia Margaret Cameron
WIST YE NOT THAT YOUR FATHER AND I SOUGHT THEE SORROWING?

ca. 1865, 25.2 x 28.8 cm, Albumen Print
George Eastman House, International Museum of Photography and Film

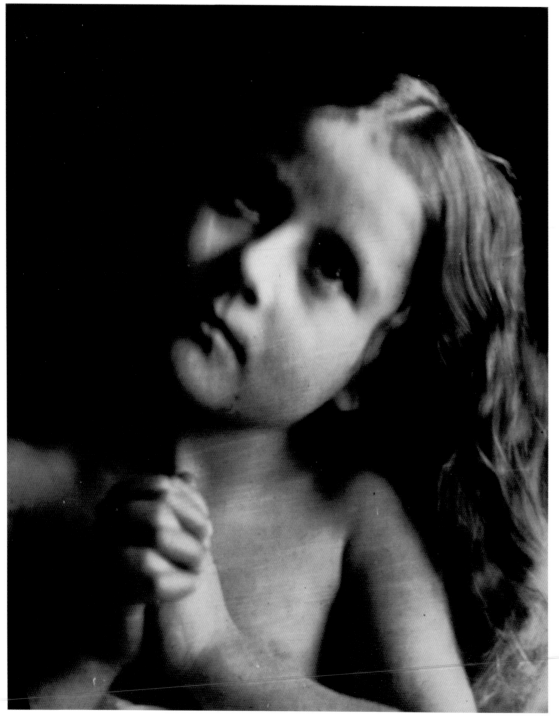

Julia Margaret Cameron
PRAYER

ca. 1866
34.7 x 27.8 cm
Albumen Print
George Eastman House, International
Museum of Photography and Film

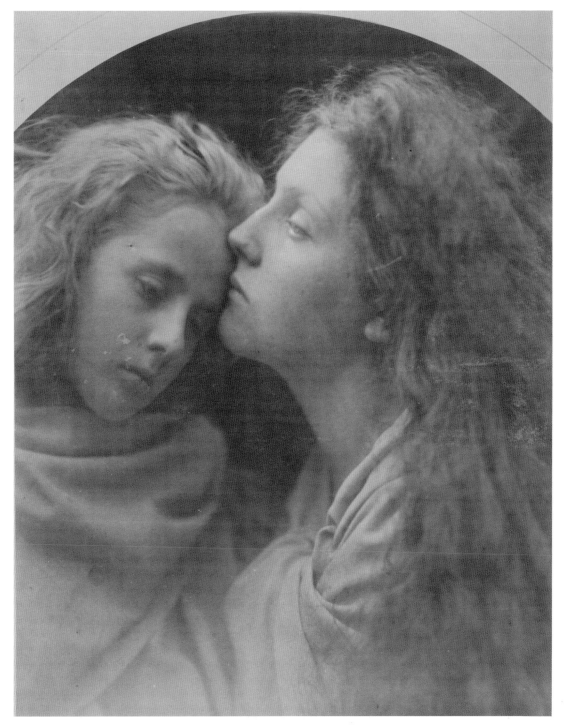

Julia Margaret Cameron
THE KISS OF PEACE

1869
36.0 x 27.8 cm
Albumen Print
George Eastman House, International
Museum of Photography and Film

GERTRUDE KÄSEBIER *1852–1934*

Gertrude Käsebier 1852–1934

1800 1900 2000

HISTORY

Gertrude Käsebier enjoyed much of her early childhood on the frontier of the Colorado Territory. During her teenage years, to provide refinement for their growing children, Gertrude's family left the West to live in the more established community of Brooklyn, New York. Still, young Gertrude always carried the boundless spirit of the West in her heart. As a young woman, she was spontaneous and artistic, yet at 22 she chose to marry a prominent and reserved businessman. In her marriage Käsebier felt caged; she did not enjoy her new role as a subservient wife. Her mother felt she had married up, but her free spirit felt tethered down. Regardless, although she only endured the role of wife, she wholly embraced her experience as a mother.

At 37, when Käsebier's children were nearly grown, she persuaded her husband to move from their New Jersey home back to Brooklyn. There, she and her daughters enrolled in the newly opened Pratt Institute and studied painting. Pratt introduced her to photography as a drawing aid, not encouraged in its own right. Yet, Käsebier felt passionately about photography, and fully embraced the medium. After receiving much recognition from contests and solo exhibitions of her work, she became one of the first two women to be elected to the exclusive British Linked Ring photographic society, in 1900. She was highly sought-after for many years until she closed her New York studio in 1929, at the age of 77.

STYLE

True to the "pictorialist movement" of the time and on the heels of Victorian ideals, Käsebier focused her camera on a subject that she knew well, motherhood. Although many could use today's standards to classify her work as sentimental, it was revolutionary for its time. It celebrated women and children as independent and strong beings. Because of this subtle adjustment of the Victorian portrayal, her work was heralded and widely recognized for the strength of femininity it presented. Her photographs went on to open the inaugural issue of Camera Work (Alfred Steglitz's groundbreaking publication for the pictorial arts), and in this she spearheaded the feminine tradition within the pictorialist movement of photography.

The titles of her work were open-ended, and seem ambiguous yet direct by design. Käsebier invited the viewer to find his or her own connection to the work, and the titles operated as a sheer nudge. In viewing her work and creating your own, remember, that which is not seen but merely suggested in images is as important as the blatant content of the images themselves. Käsebier's work was successful primarily because early on she connected to an aspect of herself that she truly valued, and then made authentic photographs to communicate her ideals. Her work is saturated with the heft of experience and insight, yet is as gentle and approachable as childhood itself.

"A woman never reaches her fullest development until she is a mother."

— Gertrude Käsebier

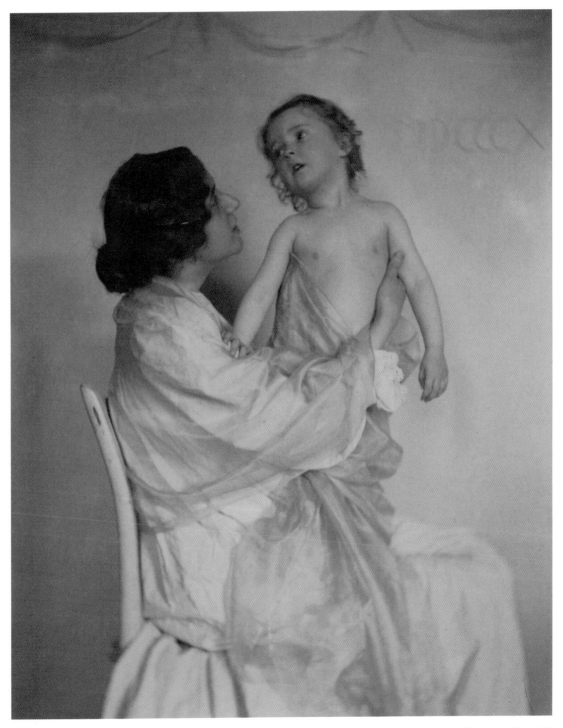

Gertrude Käsebier
ADORATION

ca. 1897
Platinum Print
19.4 x 15.3 cm
George Eastman House, International
Museum of Photography and Film

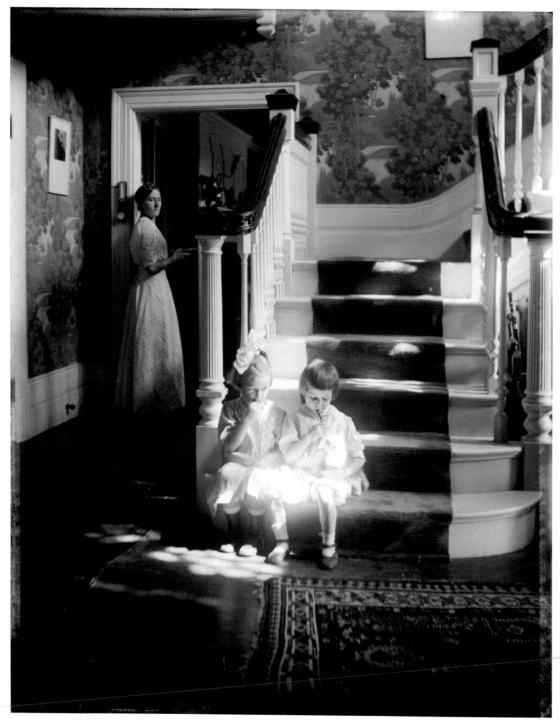

Gertrude Käsebier
LOLLIPOPS, A STUDY OF MINA TURNER AND HER COUSIN ELIZABETH POSED IN WABAN, MASS.

ca. 1910
8 x 10 in.
Glass Dry Plate Negative
United States Library of Congress

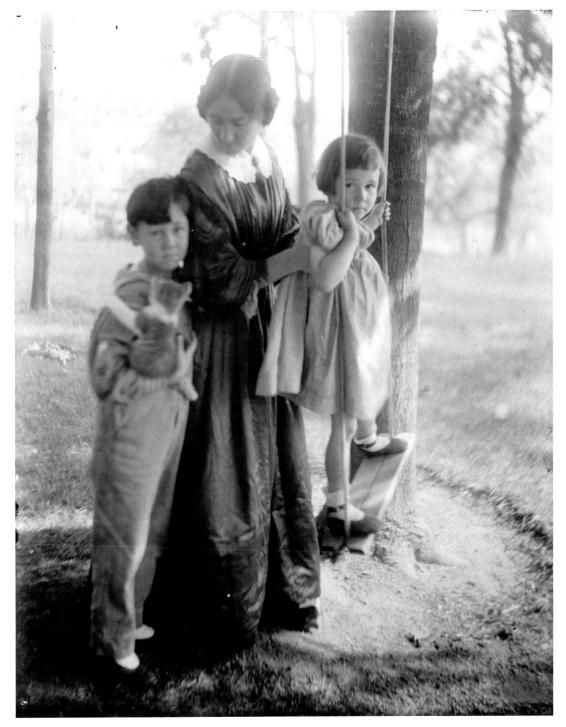

Gertrude Käsebier
THE SWING, A STUDY OF MRS. TURNER AND HER CHILDREN. MADE AT WABAN, MASS.

Ca. 1910
8 x 10 in.
Glass Dry Plate Negative
United States Library of Congress

LEWIS WICKES HINE *1874–1940*

Lewis Wickes Hine 1874–1940

1800 1900 2000

HISTORY

For a man whose work is notorious for the portrayal of childhood, not much is known about the childhood of Lewis Hine himself—what his experiences were and how his perceptions were shaped. We do know that at the age of 18, after the death of his father and while working to support his mother and sister, Hine was employed at a furniture factory in Oshkosh, Wisconsin. There, he earned a mere four dollars per week for 78 hours of hard labor. Was it his experience with manual labor for diminutive pay, or his natural aptitude as an educator (his first career), that compelled Hine to use his camera to help expose and correct the social ills associated with child labor? In either case, his conviction for change was robust.

In 1907, armed with a Graflex camera, Hine left his career as a professional educator and accepted a position with the National Child Labor Committee. There, he spent the next 12 years making images of the exploitive working conditions of children in the Industrial Age. His photographs documented the conditions witnessed by Hine, and the stories told by children themselves were also recorded during his travels. He was focused on informing the public. His images sought to make the public aware of the prevalence of exploitive child labor. It was Hine's hope that the viewers of the photographs would be horrified and therein moved to action. In many ways, he traded one job as an educator of students for another as educator of the citizenry of the United States during the Industrial Age.

STYLE

Lewis Hine was anything but a large, formidable presence when he walked into a room. It was his small build and genuine respect for his little subjects that allowed him to capture the intensity of their plight while still preserving their resilience and dignity. His work cannot be set aside as snapshots or merely found expressions. Often, his young subjects gazed directly at the camera lens with a hope and sadness that can only coexist in the eyes of a child. Hine understood the impact of these young eyes, penetrating through their situation of hard labor, a situation more powerfully communicated in accompanied reports once the viewer had been captured by the child's gaze. Hine knew that if his images were to help reform child labor, he would have to be honest and not manipulate the story before him. "The story" was intriguing enough, and his job was to accurately record it with as much detail and simplicity as possible. Hine was an authentic teller of tales who deliberately avoided a retouched or staged situation. He presented the facts of child labor abuses in images at exhibitions, in presentations, on posters, and the like. Hine's intention was to use every outlet, be it writing or photography, to communicate what he personally witnessed. His approach was clear, direct, and poignant. Because of his sincere approach, children opened their world to his camera, returning their stories for the respect that Hine consistently offered to them.

"Photography can light-up darkness and expose ignorance."

— Lewis Wickes Hine

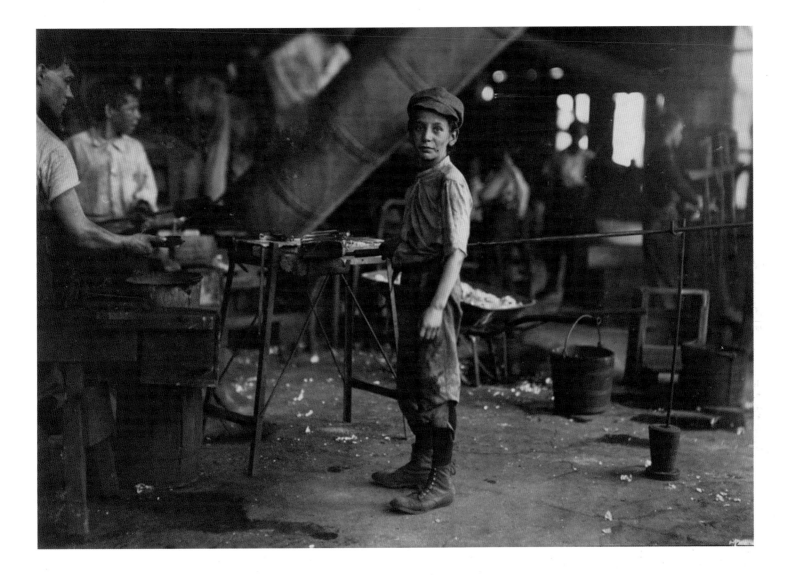

Lewis W. Hine
**"CARRYING-IN" BOY IN GLASS FACTORY,
ALEXANDRIA, VA. WORKS ON DAY SHIFT
ONE WEEK AND NIGHT SHIFT NEXT WEEK.**

June 1911
Gelatin Silver Print
United States Library of Congress

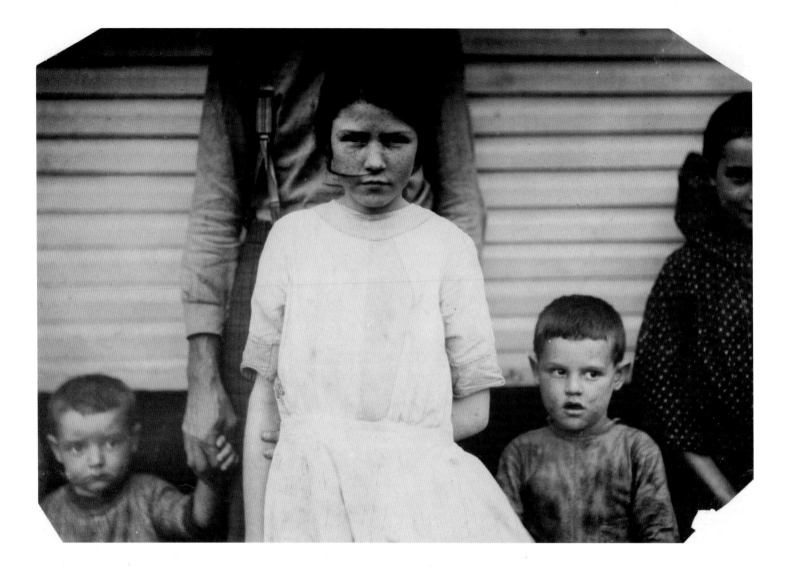

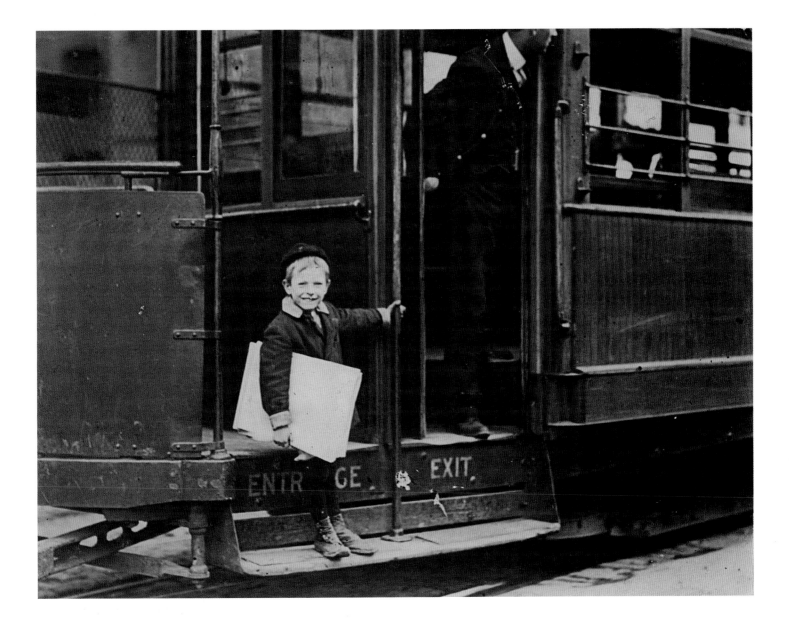

Lewis W. Hine
**FRANCIS LANCE, 5 YEARS OLD, 41 INCHES
HIGH. HE JUMPS ON AND OFF MOVING
CARS AT RISK OF LIFE. ST. LOUIS, MISSOURI**

May 1910
Gelatin Silver Print
United States Library of Congress

EDWARD STEICHEN *1879–1973*

Edward Steichen 1879–1973

1800 1900 2000

HISTORY

Edward Steichen might not generally come to mind when discussing the topic of childhood photography; yet for all his public accolades in the medium of photography, Steichen did not neglect to utilize his talent to capture that which was most precious to him, his daughters and later his grandchildren (shown right).

Though he was ever the dedicated artist and art promoter, Steichen was also a father. In 1915, he became a single father when his wife left and took their youngest child to war-torn France. He was able to convince his wife to leave their eldest daughter with him in New York. The separation from his younger daughter, Kate, and the limited time he had with the elder, Mary, while involved in her studies was completely devastating to him. Steichen used his camera to connect with his girls even though his work often took him far away. The Steichen family albums are a treasure trove of images by a skilled master infused with his affection for his little girls. As a grandfather, he continued the masterful documentation of childhood through photographs of his grandchildren.

As you explore Steichen's work beyond the pages of this book, you will find the work of a fashion photographer, aerial reconnaissance and naval photographer during both world wars, a portrait photographer, and curator of one of the most renowned exhibits ever held at the Museum of Modern Art in New York City! Whatever the photographic and artistic call, he was always ready to serve with his expertise.

STYLE

As Steichen, himself, expressed, "The artist, in any medium, does not live in a vacuum. There is a relationship between everything that is being done and everything that has been done before."

The work of Edward Steichen exemplifies this statement. Steichen never bound himself to one look or style. He continually informed his work with art of various mediums and interactions with other artists, photographers, and intellectuals. When he looked through the camera lens it was with the instinct and insights from a lifetime of artistic growth and relationships. He explored many types of art including painting, before he excelled in photography; within photography he continually experimented with thought, subject matter, and process. A predominant facet of his work was his instinct for good content, captured with skill and craftsmanship. From this, Steichen never wavered. He was not only a producer, but also a lifetime connoisseur and promoter of art thought and beautiful things.

"A portrait is not made in the camera but on either side of it."

— Edward Steichen

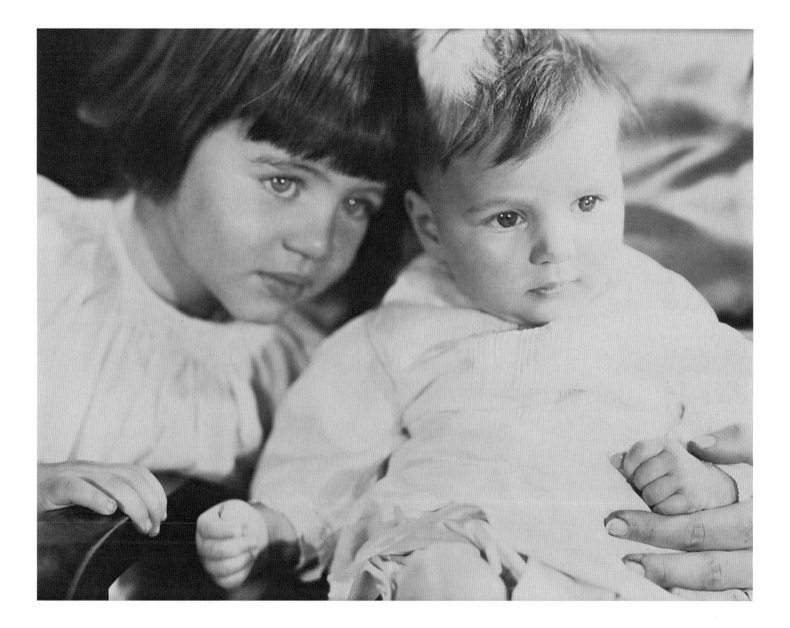

Edward Steichen
NELL AND JOAN

ca. 1928
7.9 x 9.8 in.
Vintage Gelatin Silver Print
Courtesy of Treadway Gallery, Chicago
Permission: Estate of Edward Steichen

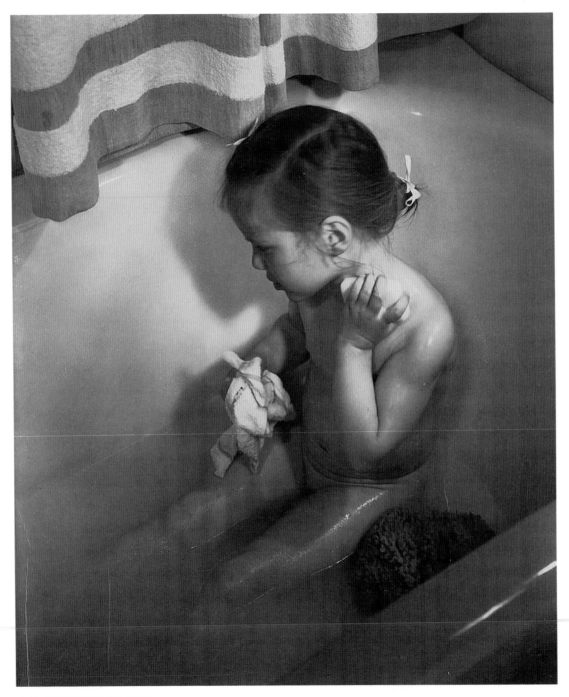

Edward Steichen
CHILD IN BATH

ca. 1930
9.9 x 7.9 in.
Vintage Gelatin Silver Print
Courtesy of Treadway Gallery, Chicago
Permission: Estate of Edward Steichen

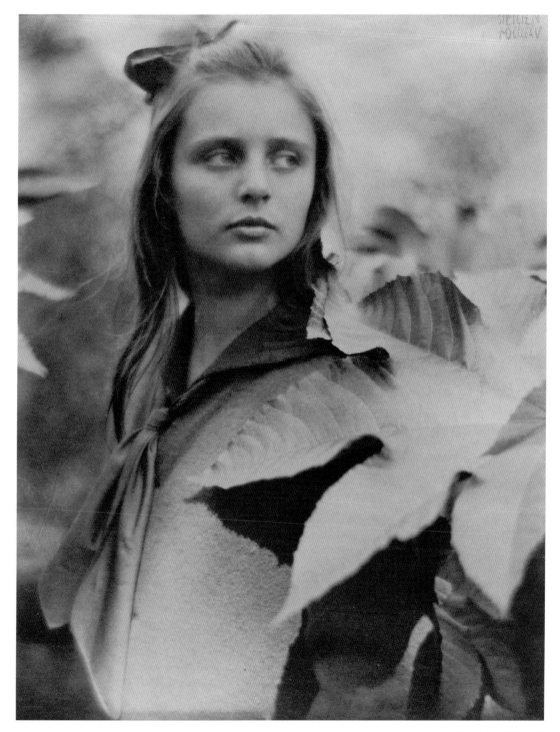

Edward Steichen
PORTRAIT OF MARY STEICHEN

1915
9 1/2 x 7 1/2 in.
Vintage Palladium Print
Courtesy of Michael Shapiro Photo-
graphs, Westport, Connecticut
Permission: Estate of Edward Steichen

JACQUES HENRI LARTIGUE *1894–1986*

Jacques Henri Lartigue 1894–1986

1800 1900 2000

HISTORY

When Jacques Henri was six years old, his father placed a camera in his hands. The connection was instant. On his very next birthday, he was gifted, as young Lartigue describes in his diary, a camera "…made of polished wood with bellows made of red-bordered green fabric, in accordion pleats." He continued to describe his kit, "A tripod taller than I, also in wood. Frames to hold large greenish-yellow plates wrapped in beautiful black paper, which I was quite wrong to unwrap in the light. And all sorts of things too complicated and heavy for a little boy only 1.20 meters."

Beyond his extensive journals and sketchbooks, Lartigue was now a photographer. Born into a bourgeois world of opulence and excess, yet being comparatively small and weak as a child, he was often relegated to observing the exciting world of his family. As his health improved, he spent more time outside, which allowed him, and his camera, to witness the full scope of his family's playful pastimes. The Lartigue family possessed a flirtatious enthusiasm for life. They embraced the new inventions that contributed to the feverous energy of the early twentieth century, like automobiles and airplane-like contraptions. Young Jacques Henri captured this unique time and circumstance with both abandon and exactness.

For most of his life, Lartigue's work went unnoticed, until, quite by chance, it was discovered and introduced to John Szarkowski in 1962, leading to a solo exhibition at the Museum of Modern Art the following year.

STYLE

Jacques Henri Lartigue was a master of the art of observation and documentation. Even at six years of age, and through the then cumbersome photographic process, he possessed an intrinsic talent that he playfully explored. He never ignored the technological precision required by his cameras, yet he was drawn to capture the spontaneity each moment had to offer. "His genius was to see the light side of life, to see the positive aspects of people," noted David Puttnam, a friend of Lartigue.

Without an art education or much guidance, Lartigue had an uncanny knack for capturing precise "moments of gesture" before his lens. It was as if he anticipated the opportunity for each shot before it presented itself. When viewing his photographs, ask yourself, "where exactly was Lartigue when he captured his images?" It seems he was nearly as involved in the moment as his subjects, and therein his perspective blurs the line between photographer and subject. Always seeing the world through the lenses of his eyes, Lartigue was the camera, and the box with film in his hands was merely a contraption to make a tangible record of the image he'd already taken in his mind. Lartigue had the advantage of a youthful and wide-eyed perspective and an exploring confidence as he effortlessly assigned a frame to an event. It was his ability to maintain this playful and childlike point of view that enabled him to successfully commence a photography career (with clients such as Vogue), 62 years after he shot his first photograph.

"Robert, Zissou, and Louis are too big and I am too small. Most of the time they won't let me play with them: I have to be a spectator."

— Jacques Henri Lartigue
(entry in his childhood diary)

Jacques Henri Lartigue
IN MY ROOM, MY COLLECTION OF RACING CARS

1905
Gelatin Silver Print
11 5/8 x 15 5/8 in.
© Ministère de la Culture - France / AAJHL

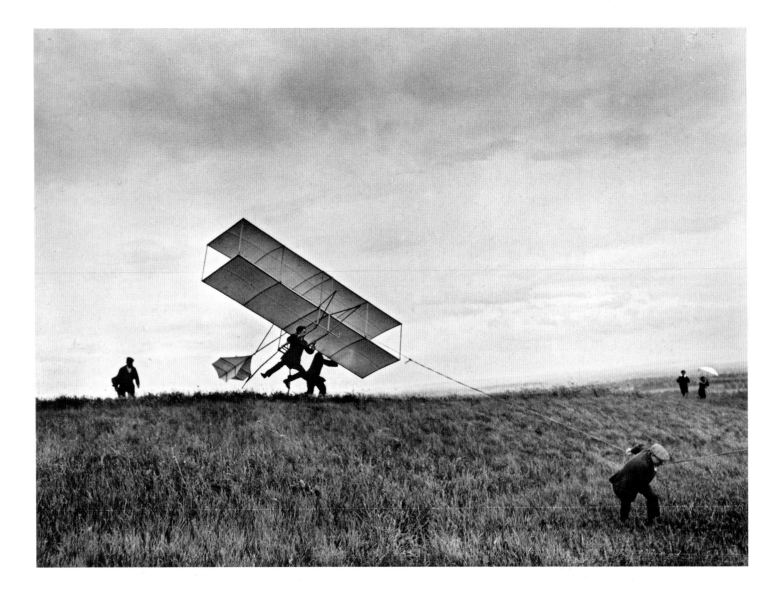

Jacques Henri Lartigue
**THE XYZ TAKES OFF... PIROUX, ZIS-
SOU, GEORGES, LOUIS, DEDE, AND
ROBERT TRY TO TAKE OFF WITH IT**

1910
Gelatin Silver Print
7 1/4 x 9 1/2 in.
© Ministère de la Culture - France / AAJHL

Jacques Henri Lartigue
**MY HYDROPLANE WITH AERIAL
PROPELLOR (MON HYDROGLISSEUR
À HÉLICE AÉRIENNE)**

1904
Gelatin Silver Print
6 1/4 x 8 9/16 in.
© Ministère de la Culture - France / AAJHL

HENRI CARTIER-BRESSON *1908–2004*

Henri Cartier-Bresson 1908–2004

1800 1900 2000

HISTORY

Henri Cartier-Bresson's family, although financially comfortable, did not live an opulent life. Young Henri learned respect for hard work and always seemed to have an aversion to excess. His demeanor, his tastes, and his art were unadorned. In 1932, Cartier-Bresson was introduced to the relatively light and portable Leica camera. Although he already had a propensity for imagery (he was also a skilled painter), this new tool opened up a whole world of creating decisive images in an instant. This simple but effective device, with its sharp and exacting lens, produced quality images. With it, Cartier-Bresson was instantaneous and discreet in his captures. His candid approach has been said to have inspired both street photography and reportage alike. In 1947, Cartier-Bresson helped found the Magnum Agency with other photojournalists such as Robert Capa and David "Chim" Seymour. Photographers, in general, are fortunate to create a handful of distinctly decisive images during their careers. Cartier-Bresson had hundreds of effortless masterpieces.

STYLE

The term "decisive moment" is irrevocably linked to the work and style of Cartier-Bresson. He saw the world as if through the viewfinder and never squandered time shooting repetitively after a moment that had already passed. Each moment has its own opportunity to be photographed and he felt that it was a shame to keep looking for what had already become extinct in the instant prior. This would risk acknowledgment of the image in the instant to come. Cartier-Bresson loved and was sensitive to the life around him.

Technically, he kept his tools simple, which allowed him to photograph quickly, but not rushed, as he traveled and observed the world. He typically used a 50mm lens, approximating his eye's perspective, with the goal to make tangible photographs of his scene before him. Since everything happens in a fraction of a second, if one fusses too much with one's equipment they are likely to miss the images unfolding before them. Cartier-Bresson never seemed to miss a shot.

His work with children was especially respectful of their unique brand of spontaneity. Cartier-Bresson didn't speak of the way he may have distinguished his children's work from his images of adult life, but it is evident that his philosophy of respect and consideration for all his subjects served him well when children were before his lens. His images effortlessly relay their narrative, just as if we were in that place and time while on a stroll with Henri Cartier-Bresson.

"You mustn't want, you must be receptive; don't think even, the brain's a bit dangerous. Sensitivity is the flavor of moments."

— Henri Cartier-Bresson

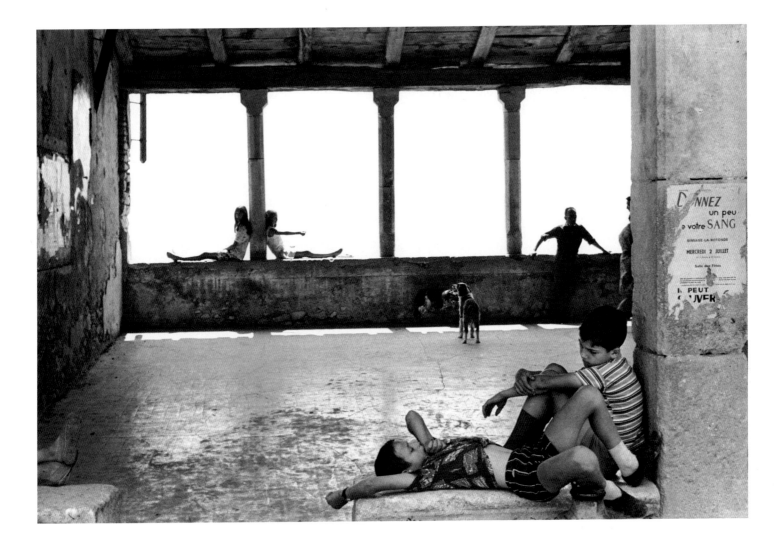

Henri Cartier-Bresson
FRANCE. THE ALPES DE HAUTE-PROVENCE 'DEPARTMENT'. TOWN OF SIMIANE-LA-ROTONDE

1969
Gelatin Silver Print
Henri Cartier-Bresson/Magnum Photos

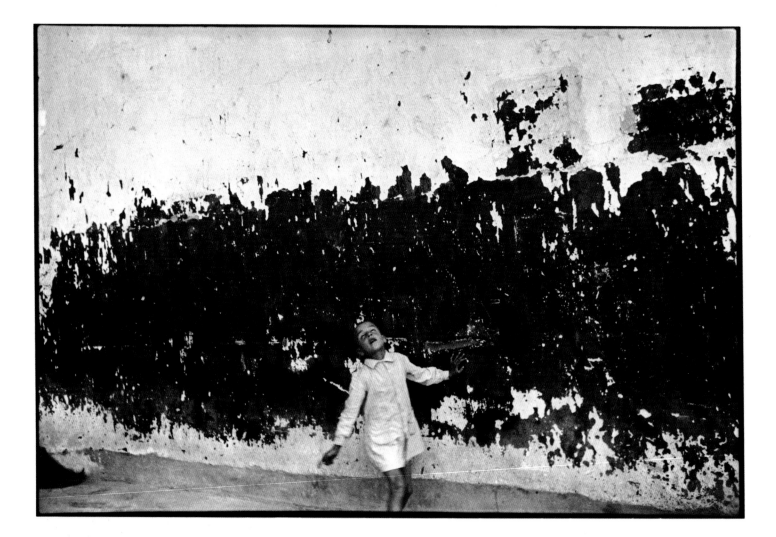

Henri Cartier-Bresson
SPAIN. VALENCIA

1933
Gelatin Silver Print
Henri Cartier-Bresson/Magnum Photos

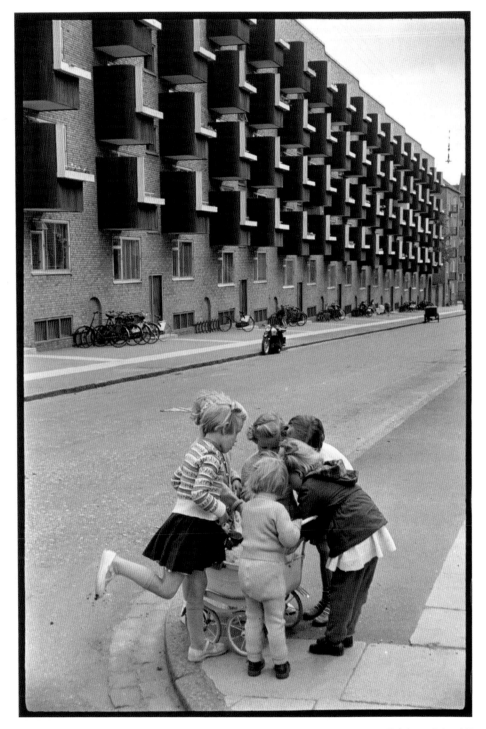

Henri Cartier-Bresson
DENMARK. COPENHAGEN

1969
Gelatin Silver Print
Henri Cartier-Bresson/Magnum Photos

HISTORICAL TIMELINE

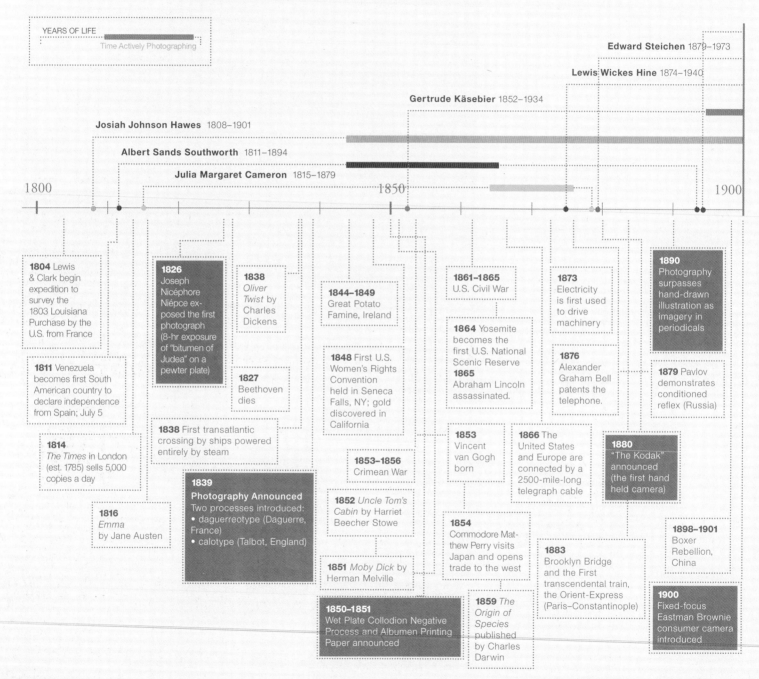

YEARS OF LIFE
Time Actively Photographing

Edward Steichen 1879–1973

Lewis Wickes Hine 1874–1940

Gertrude Käsebier 1852–1934

Josiah Johnson Hawes 1808–1901

Albert Sands Southworth 1811–1894

Julia Margaret Cameron 1815–1879

1800 1850 1900

1804 Lewis & Clark begin expedition to survey the 1803 Louisiana Purchase by the U.S. from France

1811 Venezuela becomes first South American country to declare independence from Spain; July 5

1814 *The Times* in London (est. 1785) sells 5,000 copies a day

1816 *Emma* by Jane Austen

1826 Joseph Nicéphore Niépce exposed the first photograph (8-hr exposure of "bitumen of Judea" on a pewter plate)

1827 Beethoven dies

1838 *Oliver Twist* by Charles Dickens

1838 First transatlantic crossing by ships powered entirely by steam

1839 **Photography Announced** Two processes introduced:
• daguerreotype (Daguerre, France)
• calotype (Talbot, England)

1844–1849 Great Potato Famine, Ireland

1848 First U.S. Women's Rights Convention held in Seneca Falls, NY; gold discovered in California

1851 *Moby Dick* by Herman Melville

1852 *Uncle Tom's Cabin* by Harriet Beecher Stowe

1850–1851 Wet Plate Collodion Negative Process and Albumen Printing Paper announced

1853 Vincent van Gogh born

1853–1856 Crimean War

1854 Commodore Matthew Perry visits Japan and opens trade to the west

1859 *The Origin of Species* published by Charles Darwin

1861–1865 U.S. Civil War

1864 Yosemite becomes the first U.S. National Scenic Reserve
1865 Abraham Lincoln assassinated.

1866 The United States and Europe are connected by a 2500-mile-long telegraph cable

1873 Electricity is first used to drive machinery

1876 Alexander Graham Bell patents the telephone.

1883 Brooklyn Bridge and the First transcendental train, the Orient-Express (Paris–Constantinople)

1879 Pavlov demonstrates conditioned reflex (Russia)

1880 "The Kodak" announced (the first hand held camera)

1890 Photography surpasses hand-drawn illustration as imagery in periodicals

1898–1901 Boxer Rebellion, China

1900 Fixed-focus Eastman Brownie consumer camera introduced

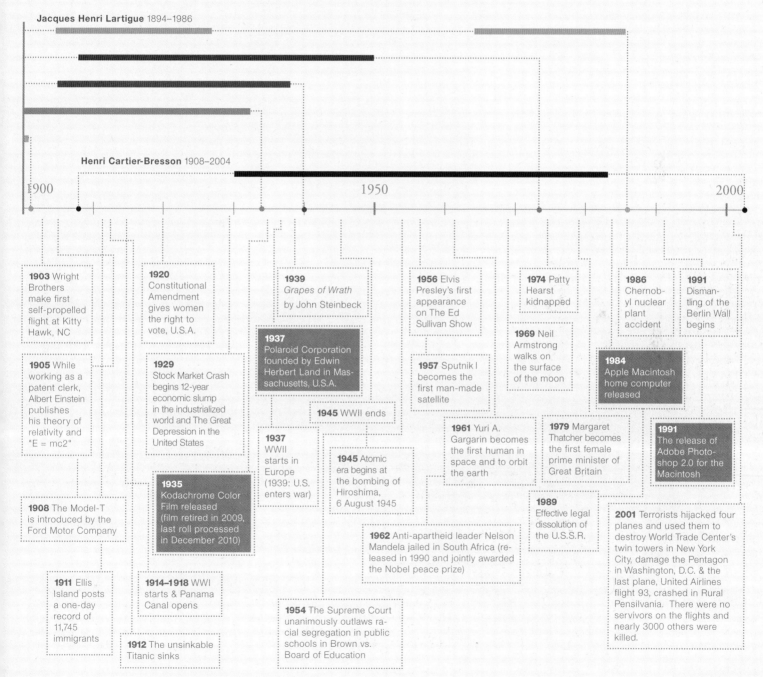

Jacques Henri Lartigue 1894–1986

Henri Cartier-Bresson 1908–2004

1900 1950 2000

1903 Wright Brothers make first self-propelled flight at Kitty Hawk, NC

1905 While working as a patent clerk, Albert Einstein publishes his theory of relativity and "$E = mc2$"

1908 The Model-T is introduced by the Ford Motor Company

1911 Ellis Island posts a one-day record of 11,745 immigrants

1920 Constitutional Amendment gives women the right to vote, U.S.A.

1929 Stock Market Crash begins 12-year economic slump in the industrialized world and The Great Depression in the United States

1935 Kodachrome Color Film released (film retired in 2009, last roll processed in December 2010)

1914–1918 WWI starts & Panama Canal opens

1912 The unsinkable Titanic sinks

1939 *Grapes of Wrath* by John Steinbeck

1937 Polaroid Corporation founded by Edwin Herbert Land in Massachusetts, U.S.A.

1945 WWII ends

1937 WWII starts in Europe (1939: U.S. enters war)

1945 Atomic era begins at the bombing of Hiroshima, 6 August 1945

1962 Anti-apartheid leader Nelson Mandela jailed in South Africa (released in 1990 and jointly awarded the Nobel peace prize)

1954 The Supreme Court unanimously outlaws racial segregation in public schools in Brown vs. Board of Education

1956 Elvis Presley's first appearance on The Ed Sullivan Show

1957 Sputnik I becomes the first man-made satellite

1961 Yuri A. Gargarin becomes the first human in space and to orbit the earth

1974 Patty Hearst kidnapped

1969 Neil Armstrong walks on the surface of the moon

1979 Margaret Thatcher becomes the first female prime minister of Great Britain

1989 Effective legal dissolution of the U.S.S.R.

1986 Chernobyl nuclear plant accident

1984 Apple Macintosh home computer released

1991 Dismantling of the Berlin Wall begins

1991 The release of Adobe Photoshop 2.0 for the Macintosh

2001 Terrorists hijacked four planes and used them to destroy World Trade Center's twin towers in New York City, damage the Pentagon in Washington, D.C. & the last plane, United Airlines flight 93, crashed in Rural Pensilvania. There were no servivors on the flights and nearly 3000 others were killed.

*" If the only tool you
have is a hammer,
you tend to see
every problem
as a nail. "*

— Abraham H. Maslow

M STI E
LaNola Stone, 2004

TOOLS OF
THE TRADE

3

THE NUTS AND BOLTS OF IMAGE-MAKING

Because children don't prescribe to a cookie-cutter way of doing things I don't want this book to suggest that there is a cookie-cutter way to photograph them. However, it would be a disservice to neglect the basic and most important elements of making our photographs: camera (our technology), light and action (our subject of childhood). This chapter will briefly touch on important facts about our tools, basic exposure, and how to determine our exposure based on creative needs and technological requirements. We'll finish the chapter with insights on light, one of the most important elements when making a photograph.

KNOWING OUR TOOLS
We are our best tool

In 1839, when photography was first introduced to the public, all that was required to be a photographer was the ability to follow directions and ownership of a camera. The perfect likeness captured was new and magical, nothing like it had come before, and—it can be argued—that nothing since has had the same overnight popularity and integration. Today, the prevalence of photography is so omnipresent that it is almost impossible to imagine a life without it. Child to grandparent, nearly everybody has a camera, and if you can talk on the phone, you can take a picture. So then, what does it take to qualify as a photographer nowadays? Technically speaking, the definition hasn't changed: A photographer is a person who takes photographs. Under this definition there are an immense number of photographers in the world; in fact one doesn't even need to know how to read or be capable of advanced thought to be able to take a photograph. Yet in this large group, there are serious photographers who desire more than a thoughtless capture from their cell phones or fully automatic cameras. This much smaller group of photographers can be further divided by three approaches.

As we look at serious photographers, professional and amateur alike, there are overriding schools of thought with which to categorize them. There are those who seek to make well-exposed photographs and they are willing to master the *technical* knowledge to do so. The next group is derived from the first. Within that group there are some who have seen good photography, make well-exposed photographs that are pretty, and repeat, following a *formula or recipe*, their successful compositions again and again.

In another group there are those that go still further; they press beyond formulas and mere good exposure (although that may be their foundation) and seek to be the creators of meaningful photographs. They know the rules and they understand that there are times to break them. This last group will invest the time, understanding and effort to know a bit of history in order to understand the shoulders on which they stand. They will seek to integrate the technology of the photograph into their creative expression and they will enter into the process of realizing an image by having an objective for their work. Still not satisfied, they will then continue to inform their work through viewing the work of others. And they share. In striving, sharing, and growth, they are becoming part of the culture of the artist-photographer.

Before this chapter delves into the mechanics of photography–and how knowing the mechanics gives us a creative edge–let's talk about what gives an artist-photog-

rapher his or her greatest advantage. What is it that will show unique perspectives in our work? What will help us develop that ever-elusive "style" that people are always talking about? And what does this have to do with photographing childhood?!

We are all born with the desire to create. From the moment children are able to sit and master their fingers, they will build blocks into towers, move toys within imaginary scenarios, and continually look to parents for elements with which they will create their own individual personas. Childhood exudes authenticity and creativity; even when children mimic, they are walking the path of individualism and development. Our own childhood created our foundational experiences, and is the basis of our current understanding. In photographing children, we recognize with familiarity the experience they are having and then add to it our own understanding.

This book is meant to both inform and inspire. We will spend most of this chapter reviewing the facts and technology of digital photography. To some, this might seem to be redundant. However, knowing our equipment is paramount to having creative control; it would be a disservice not to review it, albeit briefly. Feel free to either peruse or to read this chapter in depth; for some it will be a reminder of basic truisms, and for others valuable foundational information will be learned. There is an aspect of "the technical" in all creative work, but we must never forget that technology is there to serve our creative vision, not to dictate the image or the meaning therein. Technology notwithstanding, the goal must always be to capture images as we envisioned them, while permitting a healthy dose of the serendipity that childhood supplies.

There is an aspect of "the technical" in all creative work, but we must never forget that technology is there to serve our creative vision, not to dictate the image or the meaning therein. Technology notwithstanding, the goal must always be to capture images as we envisioned them, while permitting a healthy dose of the serendipity that childhood supplies.

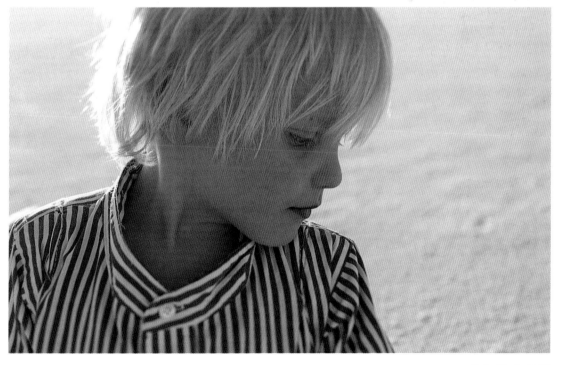

image 3.2
I placed the face of this boy in the "shade" of a 1-stop scrim. When using a scrim or shade consider letting the light spill on the hair for this effect.

Shutter Speed: 1000
F-Stop: f/5.6
ISO: 320
Camera: 35mm DSLR
Lens: 45mm tilt/shift
Light: 3/4 backlit with scrim

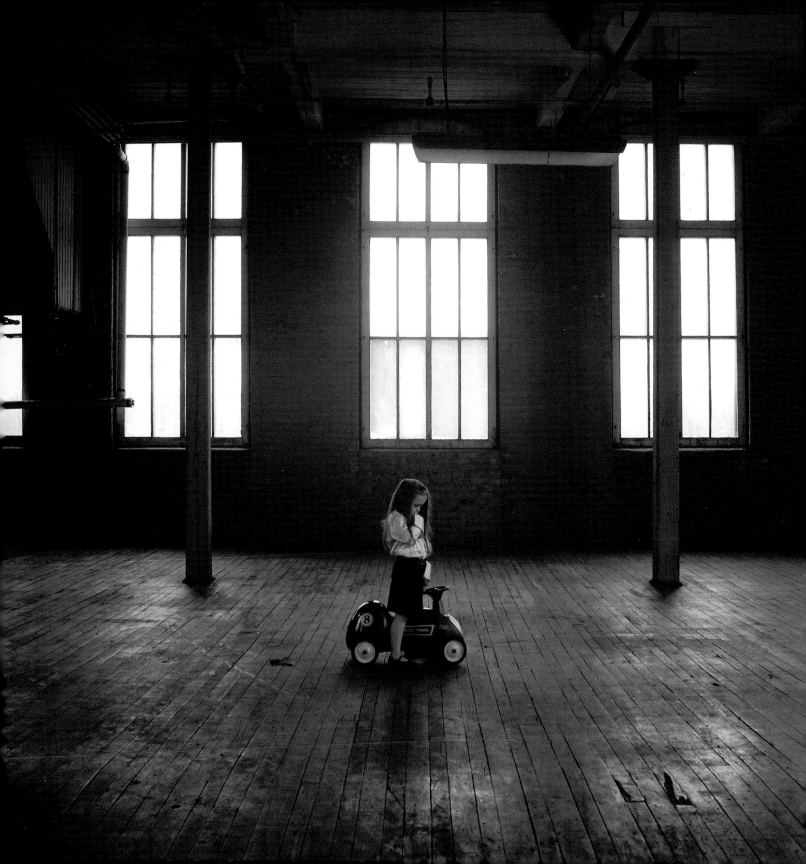

PREVISUALIZE
Input for the desired output

There are often "happy accidents" when photographing childhood. That is, opportunities we don't plan for, but which become available while we are shooting emotions, actions, or expressions. In many ways, photographing childhood provides far more of these opportunities than we could ever get within a perfectly choreographed scene. Planning is still important. But if we are patient and flexible, we will be able to turn accidents and/or mishaps into opportunities. The artist-photographer is always prepared for the unexpected.

Always remember, *luck is when the right preparation meets the right opportunity*. It simultaneously requires that we prepare, have a plan, and be open to the unforeseen opportunities as they present themselves. For instance, it can be a mistake to put our camera down when things do not go according to a well-laid plan. Give it a few minutes, see what comes of it and give yourself the option to go on to plan B only after plan A has run its full course. Still, the important part is having a plan!

Having a plan is especially important in choosing our light source, resolution, exposure, and lens choice. Consider the goals for the photograph when it is printed. What is the overall objective of that particular photograph, and our photography in general? How much will it be enlarged, and how will it be shared? These are important determinations as we plan our shoots.

To become an artist-photographer is to truly become acquainted with oneself and one's objectives. What is essential to our personal vision within the capture of the subjects before our lens? What is our personal character, our understanding of the world? And what do we see when we truly look? By letting the answers knead themselves into our images, we are inherently sharing the story of our perspective. This will help direct our narrative as we share our vision in pictures.

After getting acquainted with ourselves, we need to know our equipment. When we capture an image, we want to concentrate on creating photographs, not get stuck fumbling in the technical aspects of it. As photographers, we can't get around the fact that the technical is important. Have you ever taken a picture of a bright,

beautiful scene, like white sand castles or pure fluffy snow angels, only to discover, to your horror, that the image recorded was not bright and beautiful but a grey, underexposed mess? Conversely, have you shot a very dark scene in which you hoped to capture the subtlety of a form penetrating the darkness, only to discover an overexposed grey image? These are problems that arise if we base our exposure on the in-camera meter's idea of what a perfect exposure is, or worse yet, have the camera set to automatic, relinquishing all the creative power of exposure to a box mechanism for recording light. If we do this, the above-described situations will occur.

Since our goal is to not have to think too much about the technology, we need to know enough about it instinctually to avoid the pitfalls of in-camera exposure readings. As we read about the technical aspects of photography and test what we read, exposure will become second nature. As we know our tools, and are comfortable with them, many creative possibilities will be available with every release of the shutter. We will be able to print our images to the size we envision them and share visually with others the image that compelled us to released the shutter at that moment, in that situation and enveloped by that same light we saw at capture.

To become an artist-photographer is to truly become acquainted with oneself and one's objectives.

YOUR DIGITAL CAMERA
Not all megapixels are created equal

In today's digital world, the sensors of our cameras replace film. The size differentials of both film and sensor operate similarly; larger sensors, like larger film types, generally produce a finer detailed image. Sensors, like film, are sensitive to light and record light, but sensors record the light electronically (which is then converted to digital information). The amount and quality of the data captured is, therefore, significant. Besides the physical difference between a compact camera and a full-frame DSLR, the size and quality of the sensors contained in these higher-end cameras is paramount to the increased image quality we are able to extract from them. In short, full-frame digital SLR will give us a better quality, higher resolution image, and, in many cases, decrease the opportunity for ugly "noise" on the final photograph. Still, each format's attributes are not suitable for all photographers. How do we know the best camera for us? We must weigh benefits against the liabilities of each feature. If we were only concerned with the highest resolution and large images then we'd all have large cameras slung over our shoulders, yet most of us often rely on the cell phone camera that is typically in our pocket. This suggests value in convenience and availability. Basically there is no easy answer and in order to find the best camera, we need to focus on the features that best serve our needs and objectives. So, let's explore the features and benefits generally associated with common categories of cameras, and then independently we can utilize this information to find the most advantageous camera for us individually.

To create prints of our photographs at the size we desire, we must understand a bit about resolution. For the purposes of this chapter, we will just talk about the resolution ability of the actual camera that we use to capture our images. Marketers of cameras would have us believe that there is only one thing to look at when we compare cameras. They would have us believe that this "one thing" also dictates a need to upgrade our cameras to the latest model. This one thing is megapixels. But what most marketers will not bother to explain is what is actually creating megapixels. Most store clerks are not able to tell us accurately what a megapixel number means and why two cameras with the same megapixel count are not necessarily capable of giving us the same image quality.

Figure 3.1

Pixels
The black of the iris in the image left is made up of approximately 20 pixels. As we add more pixels to the space allotted on the page the image looks increasingly more clear. This is the effect of more pixels in a given area aka a higher resolution image. Note that the resolution of the eye has not actually changed, the viewer has simply moved back. This is why fuzzy images of a billboard seem clear when we view them from 50 plus feet away!

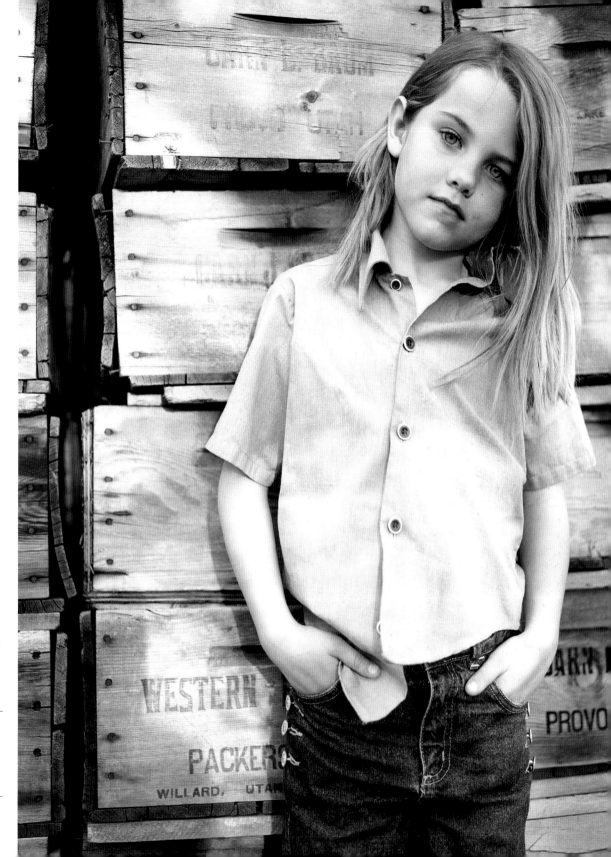

image 3.5
The clouds were changing
the light frequently. When the
clouds covered the sun the
dappled effect didn't show,
otherwise it was as shown on
page 92 (Image 3.19).

Shutter Speed: 250
F-Stop: f/8
ISO: Kodak T-max 400
Camera: 35mm SLR
Lens: 85mm
Light: Natural, dappled, overcast

So, to compare cameras solely based on the number of megapixels can be a mistake. For marketers, it is an easy feature to focus on, but the number of megapixels is only as good as the array hosting them. Let me explain.

As with most things in life, it is the *quality* of the megapixel, not simply the quantity that matters. We can avoid paying more for less quality–or needlessly upgrading our cameras–by understanding this: the size of the sensor is just as important as the amount of megapixels it records! Mind you, most salespeople don't know this and many photographers don't realize this fact either. So, I will explain the pure science of "the megapixel," so that when we spend our money, we will do so wisely and get the camera that best fits our needs and our budgets.

It is always best to start out with an objective–this will be a reoccurring theme in this book. In fact, the whole first chapter of this book was dedicated to pinpointing our objectives, and when it comes to buying a camera the best camera for our money is the one that best meets our needs. If the best camera for our needs is our cell

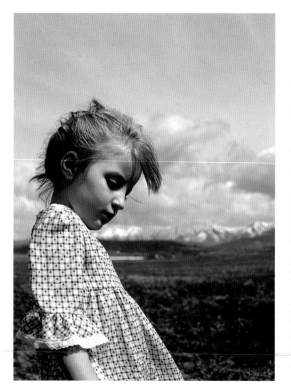

phone camera, then embrace that! There are a lot of great things one can do with cell phone imagery, the first, and most important is the ability to capture an image when no other camera is around. That alone is a great asset! Yet even with cell phone cameras, the most available marketing information about the camera feature is about megapixels. By the way, here is a tip concerning the use of your cell phone camera: The Hipstamatic Camera app for iPhone and a number of cell camera apps (including one from Adobe Photoshop) allow us to crop and edit right on our phones. There are even great apps that celebrate the low quality of our cell phone cameras by transforming the images with a "vintage" look or a nice contrast adjustment. Sure some can be cliché, but they are fun. Check them out!

So what exactly is a "megapixel?" A megapixel is simply one million pixels. It is often used as an indication of the resolution capability of a particular camera. Lets break it down further. A pixel is a digital dot. In the digital world of 1 and 0 a dot is a square (one up, one over). A greater number of pixels in an allotted space results in a more refined image, which results in higher, truer image replication. So, more pixels are good, right? Well, a higher resolution camera with a faulty lens, bad sensor, or one that has just plain taken bad photographs (due to user error) does not change the quality of the image, it just shows the flaws in higher fidelity! As much as marketers might want you to believe it, and no matter how nice it would be if it were true, having more megapixels does not always make for a better picture.

The sensor on a digital camera replaces film. Sensors, like film, are sensitive to light and record light, but sensors record the light electronically (which is then saved as digital information). When we compare cameras, the size and quality of the sensor is significant. Besides the physical difference between a compact camera and a DSLR, the size of the sensor contained in the DSLR camera is generally larger as well. This will give us a better quality high-resolution image and, in many cases, decreases the opportunity for ugly "noise" on the final image. A problem exists with smaller sensors, especially ones under the equivalent size of 35mm film (also known as "full frame" sensors). Although densely packing pixels on a small sensor will, in fact, increase the marketing power of the camera by allowing it a higher megapixel count,

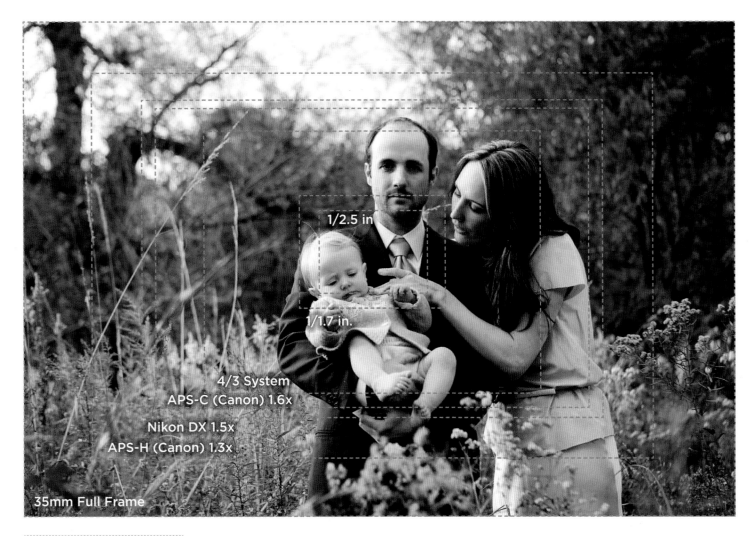

1/2.5 in

1/1.7 in.

4/3 System
APS-C (Canon) 1.6x

Nikon DX 1.5x
APS-H (Canon) 1.3x

35mm Full Frame

Actual size of above sensors

Large "medium format" sized sensors and small iPhone 3GS sized sensors are represented as black.

each of the "photo-sites," which captures pixel information (like buckets that hold light), now captures light information in a significantly narrower "bucket." As the sensor size stays the same, each photo-site diameter must decrease to make room for additional photo-sites. More photo-sites means more megapixels, but not a better image from these small sensors. The problem with these narrow buckets is that with some sensors this will also increase the heat generated by the chip, which will result in more "noise" in our images leaving color speckles all over our frame (especially in the shadows). There is definitely a point at which cramming more photo-sites onto a small sensor in order to collect more pixel information just yields diminishing returns. We will have a larger file size with a lesser quality image. Most current digital single lens reflex cameras (DSLR) will not only allow you the option of interchangeable high quality lenses; they typically come standard with a bigger sensor. Still, medium format cameras have a bigger sensor yet! But remember that bigger is not always better.

Always consider your needs. There is no need to spend the extra money for a 24MP DSLR if you only see yourself printing images that are 11 x 14 in. max. Everything

more than 8–10 MP inherently means more information, which means larger file sizes, which means more hard drives, which means more money and time processing and storing the images, all for a benefit that may go unused. There is a *big* exception to this for those that feel they need the ability to crop their images after the fact, therein utilizing only some of the pixel array allotted by a smaller portion of the sensor. This is a legitimate concern for a lot of photographers. Although this style of shooting can lead to additional editing time, many prefer this workflow and its flexibility. It's important to understand that by simply standing back or zooming out and doing most of your cropping in "post" (or after the fact), rather than in lens, makes one a candidate for owning a camera with more megapixels. Remember, when you crop in, you are essentially using a smaller sensor, and starting out with anything smaller than a 35mm sensor can be detrimental to your image quality. Always follow the rule to input for your output. Even magazine art directors will sometimes ask for space around the image so that they can determine the crop after the fact or that the image will fit the aspect ratio of the printed piece.

The aspect ratio is the size of the width verses the height. If we don't see our images in the aspect ratio that a 35mm camera produces (3:2), but in the more traditional 4 x 5 or 8 x 10 aspect ratio (4:5), this means trimming the sides of horizontal shots, or top and bottom of vertical ones, or both if our desired aspect ratio is square (1:1). Experiment with aspect ratios, it can completely change the feel of your image. Also, a certain aspect ratio could be required depending on our printing needs.

For those who like to retouch their pictures, the sensor does have an direct effect on the image quality, because the greater number of pixels allows better fine-tuning of the image.

One last thing with regard to image quality is the file format that our cameras provide. While cropping trims down the pixels edge to edge, the file type will determine a "trim" of the bit-depth of the file, meaning that, in order to save space on our memory cards, the camera indiscriminately decides for us what pixels we need and throws out the rest. This discarding of pixels occurs when we shoot in a JPEG setting. Although all sensors receive the full array of information from our lenses, between that reception and what is recorded onto our memory

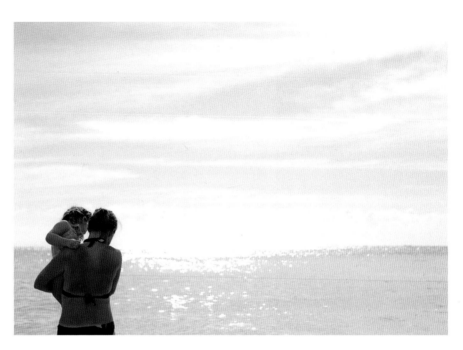

For those who like to retouch their pictures, the sensor quality has a direct effect on the final image quality. A sensor that provides a larger pixel depth allows a greater margin of error when fine-tuning the image.

cards as a JPEG, the image is processed to a smaller size (compressed) and we can loose valuable pixel information in the process. The reason professionals shoot almost exclusively in RAW is that RAW delivers *all* the information that the sensor collected, with full bit-depth. At first glance the drawbacks to this much larger file is evident; less pictures per memory card, more file space needed on our hard drives and, the big one, the amount of time in post (after shooting) to process the image to a useable file format (like tiff, psd, or jpg). So why shoot RAW? The answer is flexibility of the image and to use one's own creative prowess to determine the final output of the image rather than leaving that to an automatic and indiscriminate action in the camera. Do not be solely deterred by the extra time a RAW file may require in post, rather utilize programs that simplify this process thereby having the cake and eating it too.

image 3.8
The use of a 70mm lens provides more context and makes the photograph about the location.

Shutter Speed: 1600
F-Stop: f/5.6
ISO: 100
Camera: 35mm DSLR
Lens: 70mm
Light: Natural light

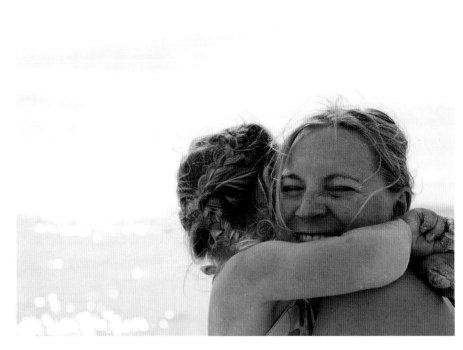

image 3.9
The use of a 200mm lens makes the photograph about the relationship. A natural fill is provided by the water.

Shutter Speed: 3200
F-Stop: f/5.6
ISO: 100
Camera: 35mm DSLR
Lens: 200mm
Light: Natural light

When choosing a camera we can simplify the massive amount of technical information by focusing on our needs and their relationship to the purchase. As the price for DSLR with "full-frame" sensors keeps falling and they become competitive with high-end compact point and shoot cameras, consider what that extra investment truly buys us. Not only do full-frame DSLR allow us to see the scene exactly as the lens does (and most importantly, as the sensor will record it), they also offer us the ability to change out lenses, which does mean having to purchase lenses separately. However, those lenses will stay with you as you upgrade the camera body. The modern DSLR generally have zero lag-time from when you shoot to when the camera records that data (a godsend when shooting children or anything that moves). Most important they have a larger "full-frame" sensor and an enhanced bit depth.

If you still feel that your style of shooting requires a compact camera, consider those that offer a larger sensor, a great lens, and the ability to shoot RAW. Some of these cameras on the more affordable end of the scale are the higher-end Panasonic Lumex cameras, and the always impressive Leica on the other end. Do your homework before you shop and remember that, while others might have good suggestions, as an educated artist-photographer, you know your needs better than anyone. A great objective website to visit for camera reviews as you first start to compare is dpreview.com; but avoid "the boards" and don't make it a substitute for going into the store, actually holding the cameras, testing them out, and asking trusted and knowledgeable professionals for their insight.

LENSES
The essentials of choosing a lens

After deciding on a DSLR camera, our next investment is the lens. If we are buying a point-and-shoot, and the lens is incorporated into the body of the camera, our lens consideration is made simultaneously with our camera purchase. Faster lenses, ones where the aperture of the lens can open quite wide (f/1.4 or f/2.8), are made to tighter specifications. They must have fewer aberrations or defects throughout the glass, even toward the outer edges of the lens. Slower lenses (lenses that have a maximum aperture opening of f/5.6–f/8 for example), utilize a smaller portion of the lens, since the aperture shields much of the glass from use. Fast lenses offer the ability to shoot in lower light conditions, since the aperture can open much wider and let in more light, but the compromise is significantly decreased depth of field (DOF), or the amount of perceived focus in an image. As we'll discuss in the next section, when we choose an aperture setting and gain one attribute (like light), we lose another (like DOF). The secret is to match our most desired attributes with our most pressing creative needs.

Another important part of the lens choice is the focal length. Focal length can be categorized in three groups: telephoto, normal and wide-angle. The names describe their attributes: "telephoto" makes things that are far seem near, "normal" approximates how we normally see, and "wide-angle" captures an image perspective wider than we typically see and exaggerates near-far relationships. When working with children, consider where the lens puts you in relation to the child and how much interaction the lens will allow you to have with your subject.

Long lenses, or telephoto lenses, record a tighter portion of the scene. Unlike what we see with our naked eye, a telephoto lens zeros in on one point and captures

just that. Cropping out the rest of the scene appears to bring the focal point closer to us, but we must also consider how far the lens requires us to be from our subject. Conversely, a wide-angle lens allows us to get within reaching distance of the child and we are able to interact with ease. This is especially the case with lenses that have "macro settings" which allow us to focus on subjects closer to the lens. The problem is that if you want to focus the image tightly on the child, you'll have to be uncomfortably close and because near and far relations are exaggerated, nose, to cheek, to ear, relations are distorted. So, what are your creative needs, and which lens will best help you accomplish them for the money you have for the investment?

In your search for the perfect lens(es) you will no doubt come across the terms "zoom" and "prime" lenses, so lets briefly touch on them. Prime lenses have fixed focal lengths (e.g., 50mm), as opposed zoom lenses, which have the ability to vary their focal length (e.g., 70–200mm). Prime lenses generally have better optics than zoom lenses, and therein are typically "faster," having a wider maximum aperture (e.g., f/1.4), for the equivalent price point of a zoom lens of the same speed. Because their optics are very sharp, they tend to be bright and easy to focus. Remember that unless we switch systems, our lenses stay with us when we upgrade our camera body. The investment in high-quality lenses will outlast the technology of our cameras and will deliver a better image for your sensor to record. All in all great lenses that serve our creative needs are a wise investment.

CONTROLLING EXPOSURE
Our camera and light working together

Three functions of our cameras control exposure: aperture, shutter speed, and ISO. Knowledge of these settings empowers creative photographers because each function has attributes that may or may not be desirable to you. Determining what is important *to you* will ultimately place priority on one function over another.

The one thing that all these camera functions have in common is that they deal with light, the ultimate variable in photography. Because light is so important, the bulk of this chapter is dedicated solely to light; its qualities and the power of the directionality. Before we talk about the quality and direction of light it's important to understand the tools (camera functions) that allow us record light.

F-stops

The first function that our cameras use when capturing light is the aperture (f-stops), which is the size of the lens opening through which light will travel. Using water as an analogy, the opening of a fire hydrant (think f/2.8 in camera terms) lets out more water than the opening of the standard faucet in your kitchen (think f/22 in camera terms).

Shutter speed

The next function is shutter speed. A shutter opens to the size of the aperture setting (f-stop) and then closes

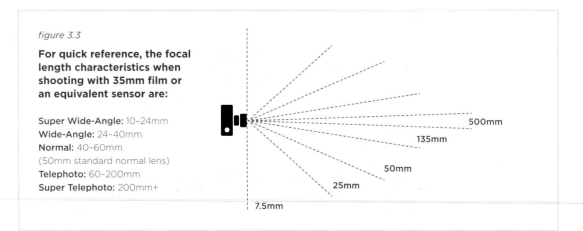

figure 3.3

For quick reference, the focal length characteristics when shooting with 35mm film or an equivalent sensor are:

Super Wide-Angle: 10-24mm
Wide-Angle: 24-40mm
Normal: 40-60mm
(50mm standard normal lens)
Telephoto: 60-200mm
Super Telephoto: 200mm+

500mm
135mm
50mm
25mm
7.5mm

in the amount of time we select. This is how long the hydrant or faucet might be left on before it is shut off again. Shutter speed, just as its name implies, is all about duration, how long the aperture is open. The aperture setting is the *size* of the opening.

ISO

The final control for exposure is the ISO or the sensitivity of our film or sensor. Think of this as a bucket to catch the water from the hydrant or faucet. Different buckets have different capacities to hold water just as different ISO ratings have varying capacities to collect light. The ISO setting determines the sensor's ability to absorb and/or record light (replacing one bucket with one larger or smaller)–just as shutter speed sets the amount of time that the light will have to be absorbed, and the aperture sets the size of the opening to let the light in. They all work together. Any change in one will directly affect the others.

Back to the water analogy: If a certain amount of water is needed to fill our bucket then we have various ways we can get the bucket filled, via a hydrant or faucet. If we open a hydrant for 1/60th of a second we will likely fill our bucket entirely in this very short time. But to extract the same amount of water from our kitchen faucet it might take 1 full second—yet, the end result is the same: a full bucket. Applying the analogy back to our cameras: if we make the aperture smaller (f/22, like a faucet) then we must compensate with a longer shutter speed to get the right amount of light to our sensor (the bucket). All this could be really confusing but since all the bucket sizes and faucet sizes are standard 1:2 it is very easy to go the next size bigger or smaller. When you choose the next larger bucket we know that it is twice as big as the previous one and the next smaller one is exactly half the size. That is, in camera terms …

f/22 has half as much light as f/16 which has half as much light as f/11, which has half as much light as f/8, and so on. These increments are called "stops" of light. So, f/22 lets in 2 stops less light than f/11.

TECHNOLOGY WORKING FOR YOU
Creative attributes of camera functions

The next question that will most likely come to mind is how these functions help us creatively. So far we haven't discussed anything our cameras can't do on their own. The relationship between the three functions is pretty basic but why we choose one over the other is what makes a photographer an artist. Without getting too deep into the physics of how things work (which is a fascinating back-story for another time), let's talk about why we would choose to prioritize one function over another when shooting with creative objectives.

F-stops

The creative function of your aperture or f-stop settings is depth of field (DOF). Visually, depth of field is the depth of "perceived focus" in our images (what appears to be in focus). For simplicity, the higher the number

figure 3.4
Three camera functions control exposure: aperture opening, shutter speed, and ISO. Generally we want to leave our digital camera set to the manufacturer's "optimal ISO" which will insure the most fidelity to our digital image files. The interplay of the other two can then provide a perfect exposure and fulfillment of our creative objectives!

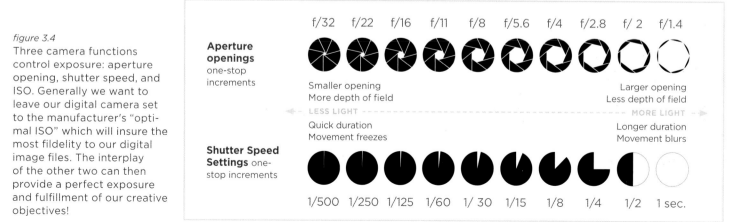

(f/8, example p. 83) the larger the depth of field (more appears to be in focus) and the lower the number (f/2.8, example p. 95) the narrower the depth of field (less appears to be in focus). Many cameras label the aperture priority mode as the "landscape mode," meaning a priority for a smaller aperture is considered thereby rendering most of our image in focus.

Shutter speed

The creative function of your shutter speed setting is the ability to freeze a moving subject or to allow movement to be recorded as blur. A question we may ask ourselves before making this choice is, "do we want to catch droplets of water mid-air or do we want their movement to blur and look soft like cotton candy?" We have the creative control for either. By choosing a fast shutter speed we can freeze a drop as it falls, whereas a slow shutter speed creates blur as our cameras record the movement. Many cameras label the shutter speed priority mode as the "action mode."

ISO

The creative function of ISO is the fidelity of the image. Generally speaking, our digital cameras have an optimal ISO, and the other ISO settings simply offer us flexibility when shooting in low or bright light situations. For the best image quality, always try to adjust the aperture and shutter settings (or even the amount of available light) before adjusting the ISO away from its optimal setting (refer to the owner's manual to find out what this is for your camera). With film, the higher ISO meant an increase in grain (image 3.11). With digital sensors a higher ISO will mean an increase in camera "noise." Having noisy images can be hard to fix without softening our image, though there are software programs and RAW processors that can help. Personally, I would argue that grain resulting from high ISO film is more desirable than digital noise. Operating on this premise, a tip for masking noise that appears as grain is to fully desaturate the image, thereby visually converting it to black and white (maintaining the ability to adjust the "color" channels separately). Black and white masks the color artifacts of digital noise. If we have a very successful image but the noise is too distracting, this can help. Applying a grain filter in Lightroom or Photoshop also helps the noise masking after image desaturation.

A tip for masking noise that appears as grain is to fully desaturate the image, thereby visually converting it to black and white, masking color artifacts from noise.

As we combine our understanding of exposure mechanics with the creative foresight we have options:

f/5.6 @ 1/250th = f/8 @ 1/125th = f/11 @ 1/60th = f/16 @ 1/30th

All the above exposures are the same as far as getting a properly exposed image (fill the same sized bucket), but the last one will show movement as a blur and a greater DOF (perceived focus) while the first will convey a shallower DOF yet it will better arrest movement. Which one to choose depends solely on our creative objectives for the shot. The adjustments are simple. One notch of our camera's aperture dial will open the aperture and decrease our depth of field. This means, however, that we must use one notch in the other direction on our shutter speed dial to let in less light by way of a faster shutter speed. Also note: many cameras today work in 1/3rd increments allowing us even more subtle control.

Histogram and the LCD display

All digital cameras include a digital display so that we can immediately see the results of our camera adjustments. If we accidently move a dial in the wrong direction we can detect this mistake quickly by viewing the display. It is a great gift, but it can also be a great hindrance. There is a colloquial term for looking at our displays constantly; it's called chimping (as in, a primate-type activity). We can get so absorbed in looking at our recent images that we miss the opportunity for new images. My suggestion is to "chimp" when dialing-in our exposure, but then to ignore your display until you need creative feedback from the images you have already captured. Some displays also can show us a histogram of the image. This is a graphical representation of the exposure and can quickly tell us where the density of information is in the image. As we'll discuss in the next section, knowing what the graph represents will help us interpret this important information. Contrary to popular belief, there is no *one* right histogram for all images. Take a look; the entirety of Image 3.10 is represented by Figure 3.5 and the faces by Figure 3.6.

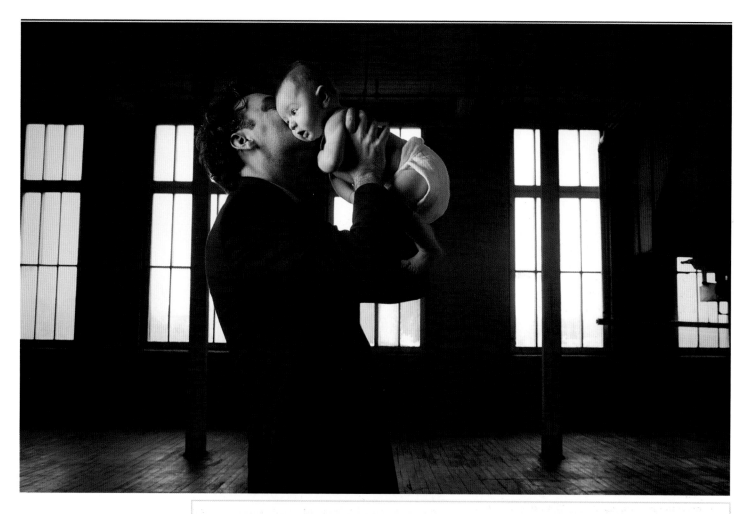

image 3.10
This is a great example of a side "key light" (provided by a strobe/flash) on the father and child while allowing the background to be lit naturally by the windows.

Shutter Speed: 1/8th of a second
F-Stop: f/8
ISO: 100
Camera: 35mm DSLR
Lens: 38mm
Light: Mixed; strobe/window light

figure 3.5
Histogram of the whole scene, which would, at first glance seem like a poor histogram.

figure 3.6
Histogram that represents the faces, where I chose to place my emphasis; this is where I want to assure that my histogram is perfect, and it is!

DETERMINING EXPOSURE
F-stop, shutter speed, and ISO

Most cameras have a built-in metering system to help us determine exposure. When we set our cameras on "auto," the camera decides what shutter speed, f-stop, and ISO are best for the shot. The camera's objective is to simply capture a fair exposure (one that is not too blurry or too dark). To do this many point and shoot cameras will often resort to manipulating the ISO, which we know is not the best way to maintain fidelity in our images. Automatic functions can work well for us in a pinch, but only as we have an understanding of what the camera is choosing to do automatically.

The camera does not have any creative objectives with regard to depth of field or desired movement in your images, but you may. As we assign creative control to our cameras, we loose a valuable tool of our own personal expression. We are left gambling that the camera will make good decisions even if our intent and the lack of intent of our cameras may not align. A camera's only goal is an adequate and even exposure based on presumptions of tonality that may not be true (more on that as we discuss metering). Even if we do nothing but assign a priority to the aperture or shutter speed (through a camera's priority modes), and leave the rest on auto, we are still addressing our objective within the shot because *we* are determining, at very least, what our priority is. An essential part of achieving our photographic objectives is to know what options are available and utilize them to enable our creative intent within our work.

Taking a light-meter reading

Before we can take creative control into our hands, it is important to know how our camera assigns an exposure. Cameras provide a meter reading by measuring the light reflected from a scene. Our cameras average the general luminance reflected into the camera and use this information to determine the f-stop, shutter speed, and ISO needed to record the scene. Because our cameras don't know what the scene actually looks like it will always assign a middle value in order to average the light it receives. In a lot of cases this captures the likeness of an image, but may not always give you a true likeness, or what our eye sees. We are then left to determine if the camera indeed rendered the scene as we saw it or not.

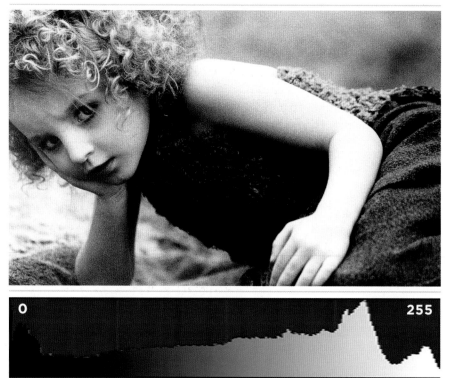

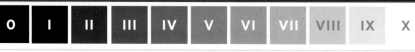

figure 3.7 **Zone Descriptions and Histogram Range**

ZONE 0 (0–24)
Total black, little to no file information

ZONE I (25–46)
Slight tonality emerging from within dark shadows, but no texture

ZONE II (47–70)
First suggestion of texture out of the shadows

ZONE III (71–93)
Low values show adequate texture

ZONE IV (94–116)
Very dark skin, average dark foliage, dark stone, or landscape shadows

ZONE V (117–139)
Middle gray (a.k.a. 18% gray)—what in-camera meters interpret to be the scene average: maintained grass; dark skin.

ZONE VI (140–163)
Average Caucasian skin; shadows on snow

ZONE VII (164–186)
Very light skin tones.

ZONE VIII (187–210)
Lightest tone with texture, textured snow

ZONE IX (211–233)
Slight tone without texture; glaring snow. 50% of file data is contained within 0–233 of the histogram.

ZONE X (234–255)
Pure white: light sources and specular reflections; lots of data resulting in a large file, no detail information without recovery (RAW files only)

If it did not, we must adjust the settings accordingly to attain a proper exposure. Many of us instinctually make these adjustments considering the LCD display after we shoot an image because we visually seek a proper exposure on that screen. Still, *how* we make that adjustment can be a vital part of our creative process. That is to say, will we speed up or slow down the shutter speed to capture movement or will we "open up" or "stop down" our aperture to record a desired depth of field?

Cameras record color, but don't see it. To a camera's metering system the scene is exclusively luminance. White, for example, has a high luminance and black a low luminance. Our cameras will always assume a middle luminance as the total luminance of a typical scene. This is because it assumes that every scenario will have both light and dark colors in equal proportions and therefore adjustments for "middle gray" will render an accurate image. This is not always the case. This is the reason an exposure of pure white can render as middle gray and conversely an exposure reading of pure black can also produce an image of middle gray. This explains why snow scenes often render too dark and night scenes often render too light. Try it. Take a picture on automatic of a white wall and a black wall and notice that both images are frightening similar.

This discrepancy from truth is not anything that should worry us because we now know what the camera wants to do and therefore can override it for our objectives. However, when making the decision of how to override our in-camera meters, we need to know one more thing: the "levels of luminance" or, as it's better known: the Zone System.

Simplified, the Zone System plainly divides our images into 11 levels of luminosity, each marked with a corresponding roman numeral. Level zero (0, total black) has absolutely no luminosity, level five (V, middle gray) has a middle value of luminosity, and level ten (X, pure light) is exclusively light like a secular highlight or a light source (see image 3.11). People often think that the Zone System is something too technical or difficult and therefore many try to do without it, but just understanding the above information and how it relates to exposure can provide essential creative control.

The levels of luminance reflected from the scene imitate the same ratio structure of f-stops, shutter speeds, and ISO; 1:2 (or 1-stop increments). As we go up the scale we double the amount of luminance and going down the scale we half the amount of luminance with every step. Ansel Adams (the formulator of this system with Fred Archer in 1939–40) provided descriptions for each of the 11 zones, and conveniently these descriptions translate well to today's digital information represented by our image histograms (reference Image 3.11 and Figure 3.7).

Light ratio

Light ratio refers to the amount of light on one side of the object compared to light on the other side of the same object. Visually understanding "stops of light" provides a vocabulary for describing and attending to these ratios. For example, if we know our ratios represent a 3-stop difference from a proper exposure to shadow than we know we have an option of using a fill light to decrease the contrast inherent in such a stark difference in the ratios.

Histogram

Histograms graph the exposure of an image. Strong contrast (ratio discrepancies) will be represented as a gap between peaks on our histogram. The most important thing to understand about reading histograms is the concept of *clipping*. Clipping is when the image data falls outside the parameters of an image capture. Since the left side of the histogram represents dark tones, clipping-left means the image is too dark, while clipping-right means the image recorded is too light. Everywhere in-between is simply a distribution graph of the luminosity of the photograph. The histogram has strong parallels to the Zone System as demonstrated in Figure 3.7. The horizontal axis represents the tonal variations the camera is capable of recording. The left side of the axis represents the black and dark areas, the middle represents middle gray and the right-hand side represents light and pure white areas.

RAW

Because images captured in RAW simply record the data needed to render the image, versus a processed JPEG, which provides an image, the file contains information that lies slightly outside the histogram. Because it con-

tains this information, recovery is more easily attained when images are not properly exposed. In addition, the photographer makes the determination on how to process an image and can process it again and again, in multiple ways, all from the same RAW file.

The drawback of shooting RAW is that a RAW file is much larger than a JPEG (because it retains all the information) and every RAW file must be considered and processed. Yet, with the robust RAW processers and catalogues available these days, these are not huge inconveniences if you have the right tools (i.e., Adobe Photoshop Lightroom).

LIGHT SOURCE
The defining element of a photograph

In photography, light is our medium in much the same way that clay is the medium of a potter. It's interesting to note that you don't need to be a potter to make a bowl; one can punch a fist into clay and make a bowl without even having to know much about clay. The bowl will generally function to hold liquid, except for the occasional complete disaster, but it will be merely functional, *not* a work of art. Again, photography is very similar. Press the button and our camera can do much of the work for us these days. This is great if we just need a document that X or Y happened, not so great if we want the image to speak beyond the document that it is. Just as a potter needs to understand their clay and craft to create exquisite bowls, a photographer must seek the understanding of light as a step to perfecting their images.

The emotion of a photograph is driven almost exclusively by the way it is lit. Of course, content and expression also contribute, but I am always amazed at how a simple change in lighting alters the mood of an image. When we sit and tell ghost stories, a flashlight held low, under our faces, will create an atmosphere of horror, like we are being lit from the depths of Hell. It seems this way because lighting from below is so contrary to the lit-from-above world we live in. This is just one simple example of the dramatic effects of lighting. When contemplating light, consider the situation where we'd naturally (or unnaturally) find that same type of light. Successful images are not blatant with their use of lighting; they simply convey emotion with light.

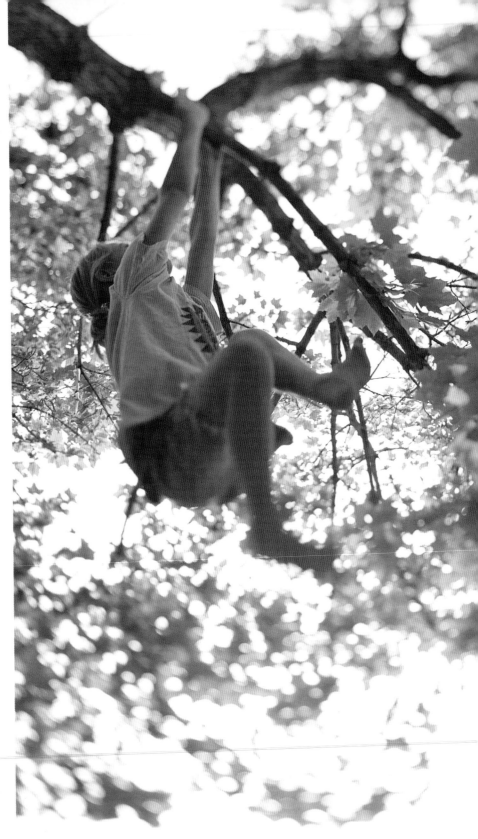

When working with children, remember that simplicity is our friend as well as a lot of previsualization and testing of light before the child arrives "on set." We can loose the spontaneity of childhood and its gestures if we force a child to endure multiple test exposures of our scene. Unless we are after tears, temper-tantrums, or tired tots, we'd be well-served to have what light we'd like in mind *before* the child arrives. The more that is figured out ahead of time, including contingency plans, the more likely we will have a shoot that both the child and photographer can enjoy!

As we consider and plan lighting scenarios, I cannot emphasize enough how important the understanding of light is to successful photography. Even those that naturally "feel" light and see it instinctually in a scene can benefit from understanding what they are naturally drawn to. This allows for a firmer foundation on which to build our photographic knowledge. When I began my

immersion into photography at age 14, I met with a good deal of success in competitions. Still, I didn't understand why my photographs were receiving these acknowledgments. I mean, I liked them, or I wouldn't have taken the time to set up studio lights, pick up my camera, capture the image, develop it, edit the proof sheet, make an enlargement… you get the point. But I can't tell you how frustrated I was not knowing *why* my images were achieving success and what I could do to prevent them from falling short. I would query my instructor and pled for guidelines and rules so I could knowingly recreate my formula. He would only reply that I was doing it, don't think too much; just keep doing it. Urg! My young mind couldn't wrap itself around this advice.

I've searched for years, through undergraduate and graduate degrees, and through my professional work, for the answer to these internal questions, only to realize that while there are, indeed, tangible laws of physics and composition that can help us, my instructor was right to suggest I not get too caught up in the minutiae. Perhaps, after you finish this chapter, put down the book, try out various lighting scenarios and learn about your instincts and how to trust them. Ask: "What just feels right and true to the way the world is naturally lit? What emotions do certain lighting scenarios evoke?" Objects work very well as we test lighting setups. They stay in one place, unlike children, and allow you to really see the light reacting to our subject. What do different directions convey and how can we influence the light quality and shape? Try to understand light in two ways; what it *looks* like and what it *feels* like. This will give us a well-rounded understanding of how our use of light will affect others and impact what we'll ultimately be able to communicate photographically.

White balance

There are two types of light, luminous and reflected, and they work together wonderfully! Luminous light creates a glow or emits light (like the sun), while reflected sources redirect that glow (like the moon). The sun is a luminous light source, as are light bulbs, fire, and a camera flash or strobe. Each of these sources emit light in a different way, specifically different electromagnetic frequencies, that we see as color. Generally, our eyes neutralize these color shifts, but our camera's sensor records the color just as it is transmitted. Because our sensors are

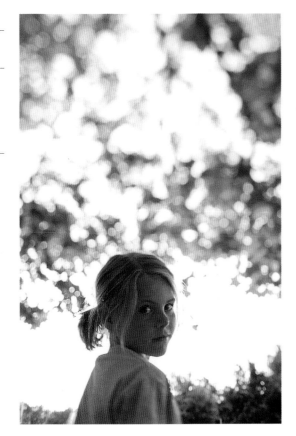

image 3.12 (left)
When the sun gets low in the summer sky it's a perfect time to backlight your child subject with a warm glow. A little fill from a white card makes the shot!

Shutter Speed: 100
F-Stop: f/2.8
ISO: 160
Camera: 35mm DSLR
Lens: 45mm tilt/shift
Light: Natural backlight

image 3.13 (right)

Shutter Speed: 100
F-Stop: f/2.8
ISO: 160
Camera: 35mm DSLR
Lens: 45mm tilt/shift
Light: Natural backlight, slight fill

not as keen to color adjustments as our eyes, we need to tell the camera what type of light we are shooting under so that it can interpret the color correctly. Flash, daylight, cloudy, shade, tungsten, and fluorescent are the light situations that our cameras allow us to specifically address. The settings will change the yellow or blue cast that a given light emits (except with florescent lights which have a green cast). A blue cast is neutralized with an yellow tint and vice versa. Fluorescent lights are neutralized with magenta. Back in the day, we had to correct color shifts with gels and filters, or by shooting different film. As nostalgic as I am about film and the wet process, it is really nice to be able to compensate with a simple setting adjustment on the camera. Take advantage of these corrective settings; chimping will be more enjoyable and processing the images will have added efficiency. And about processing…

If shooting in RAW, fine-tuning these general settings in processing our RAW file will give our images the exact color palette we are after. Fine-tuning can be done in-camera, but doing it afterwards helps save time working through this while we are behind the lens and our sitter is waiting. Besides, making these determinations is much easier on a large calibrated monitor than on a small LCD screen that shows us only a JPEG representation of the RAW data. When we use a JPEG setting the camera embeds the colorcast it recorded in the scene into the compressed file. Fixing the colorcast after the fact with a JPEG image is doable, but a lot of information can be lost in these adjustments (a decrease in bit depth). Yet another plug for shooting in the RAW setting!

We will also notice that our DSLRs have a "K" setting. This stands for Kelvin. If you have a color meter and you want to input the exact color temperature of the light falling on the scene, then this is the setting for you.

Now let's talk about the main light source and its relationship with reflective light. Obviously, we can't use reflected light if we don't have a main source. Still, we can use reflected light as a key light (the dominant light), never exposing our subject directly to the main source. In image 3.17, the child is twice removed from the main light source, the sun. She is in cove off a covered hallway. The light enters the hallway indirectly and travels past the cove. Spill light then indirectly enters the cove where she stands. Additionally, the initial indirect light bounc-

es off the wall of the cove across from the child. What attracted me to this location was as much the quality of light as the ratios between the various bounced and direct light.

Now that we've whet our appetite for lighting setups, the remainder of the chapter will be spent breaking down light into its properties and the effects of light direction. The way we form and aim our light will have a great impact on the sentiment of the final photograph. I am a big fan of simplicity; in fact it is the nuances of simplicity that create well-lit photographs.

LIGHT QUALITY
The intensity of light and shadow

The practical study of light for photographers can be split into two categories: the property or quality of light and the direction of light. What separates one photographer from the next is often their ability to see and utilize light. For the sake of simplicity this section will be focusing primarily on natural light (that produced by the sun) since it is available to all of us. One of the quickest ways to improve amateur photography is to turn off the flash and look for soft directional light. Once we understand how and when to use the power of the flash it is a great tool. Until that point, it can be a hindrance.

The quality of light can be further divided into hard and soft light. Hard light, like that on a bright sunny day, can produce hard shadows. When using a camera flash, the transition between the foreground light (lit by the flash) and the background light (lit by available light)

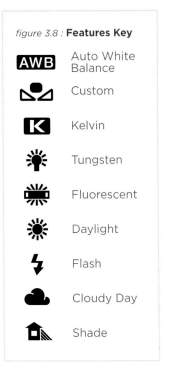

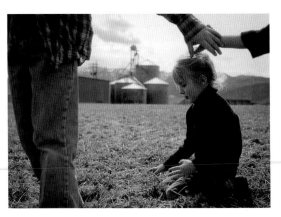

image 3.14
Take advantage of changing lighting conditions from rolling clouds. The same location and subject look very different under soft vs. harsh light.

Shutter Speed: 60
F-Stop: f/4
ISO: Kodak E100VS (chrome film)
Camera: Medium format; 67
Lens: 100mm
Light: Cloud diffused midday light

can also be very harsh. Soft light, like that on a slightly overcast day, will produce softer shadows that have more of a gradation from light to dark. As we learn to see light, it helps to observe the shadows. Try it, on a partly cloudy day when the sun is going in and out of the clouds, make a nice picnic and sit under a tree for an hour or so with a friend. While they are going on and on about their life, and supposed problems, pay attention to the shadow of the tree under which you sit. When the light is direct, with no interference from clouds, the shadow of your tree will become very defined, with almost a razor sharp edge. You will nearly be able to make out the shapes of the leaves where the light has broken through the foliage. Then, as soft fluffy clouds obstruct the sun, notice the distinct shape of the shadow blurring until it becomes almost edgeless. The more dense the cloud is, the more subtle the definition of the shadow. This pattern will repeat over and over as the clouds drift across the sun. This is a predictable variable that you have now witnessed; so let's apply it further.

Lets now look at soft and hard light in terms that more clearly define the type of soft or hard light. Hard and soft light wrap our subjects very differently: there are specific qualities within them, produced by different scenarios, which further describe the transition.

What makes cotton candy overcast days beautiful and soft is a direct result of what has happened to the light by the time it reaches our subject. It starts as a light source that is small, relative to the subject. The sun, because it is so far away, is a mere pinpoint in the sky. Small sources will always cast hard shadows, which translates to an abrupt light-ratio difference (transition from light to shadow areas) on our subject. A bare bulb, flashlight, or flash will have the same effect, intensified by its close proximity and small size relative to the subject.

The softer our source, the less we'll have to think about these ratios, and the possibility of losing details in the shadow areas of our images. The way to transform harsh into soft light is by converting a pinpoint into a larger light source. Let's go back to our picnic. When a cloud covers the sun, the cloud does not completely obstruct the light of the sun; rather, the cloud becomes the light source, a much larger one at that. It diffuses the light, therein spreading the light from a single point (the sun) to a larger, softer source (the fluffy cloud). The larger the cloud is, the softer the light falls.

Sometimes God hands us natural light that is shaped or filtered beautifully, like northern window light or a cotton candy overcast day. When this happens, go with it! Never fix something that is not broken. When a light catches our attention, appreciate it for what it is. We may consider adding a *subtle* fill, or bounce light, to preserve information in a scene that might otherwise fall into dark shadows but keep it simple. Fill and an added bounced light can really enhance the scene, but be warned: fill light is like salt when cooking, a little bit enhances, but too much destroys!

Direct light

As discussed earlier, direct light has not been shaped or diffused from the original light source. This is considered "hard light," in that the light has traveled straight from source to subject. The light on the subject is harsh and becomes increasingly more so the smaller the source relative to subject. There is nothing particularly flattering about this light. Direct light, especially when raking from the side, emphasizes texture, skin texture included. Luckily, with small children, their microscopic pores have no texture, but as they become teens this type of

image 3.15

Shutter Speed: 200
F-Stop: f/4
ISO: Fuji Provia 100f (chrome film)
Camera: Medium format; 67
Lens: 100mm
Light: Direct midday sidelight

Direct Light

figure 3.9
Top view (exterior):
Direct light produces harsh (sharp) shadows.

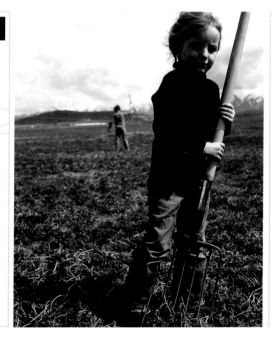

light will emphasize blemishes on the face. If this is our light source, consider how to best use the inherent contrast in the scene.

When confronted with direct light, I like to face my subject away from it (this also helps them not squint), and hide them in their own shadow. I add a fill by bouncing some of that same light back at them, therein illuminating the shadow. The great thing about this light is that the fill can be angled to come from anywhere, giving a directional quality to our backlight (image 3.xx). We can also work with the severity of the light and utilize its contrast to convey a harsh environment. Image 3.8 the child faces perpendicular to the harsh frontal light. This creates a strong, graphic profile. Images 3.14 and 3.15 were shot on the same day with the same light. The child is lit directly from the side and the shadow created cuts her in half. A light fill is added from the left side to maintain detail in the shadow (but not so much that the contrast is lost). Direct light can be very hard to work with and may limit options on set and it can also make a powerful statement. In image 3.22, I moved to have the child backlit. A large bank of clouds were also present to diffuse the light. Although direct light has its place, light is much easier to work with when it is diffused and able to more subtly wrap the child.

Diffused light

Diffused light passes through a translucent material before reaching the subject. The diffusion material can be a cloud, or manually supplied by a fabric scrim or a lucent panel of plastic or glass. When the light travels through this material, the direct rays of light are redirected in a plethora of directions, illuminating the panel or scrim. The light source becomes large and soft. The closer this diffused light gets to our subject, the larger it is relative to the subject and the softer the light becomes. When a large window (let's say a sliding glass door) is directly receiving light, try putting up translucent curtains and watch the light transform from a hard singular pointed source shining through the glass into a large soft bank of light. Facing your subject into this light is remarkably pleasing, especially for frontal light.

Indirect/filtered light

Filtered light will wrap and redirect primary luminance.

Direct light, especially when raking from the side, emphasizes texture, skin texture included. Luckily, with small children, their microscopic pores have no texture, but as they become teens this type of light will emphasize blemishes on the face.

It has made a journey to reach our subject, and has characteristics shaped by that journey. Think of it as sunlight that passes by our window, rather than into it. The light simply spills its superfluous rays in our direction. It might then reflect off the window well, and yet bounce again in another direction. At some point, this light has become so exhausted by its journey that it has little or nothing to offer, but a room that is lit exclusively by filtered light, is as cozy as a favorite pair of well-worn jeans. The light wraps gently and doesn't bind movement.

image 3.16
The use of a tripod will force you to slow down and be deliberate in your composition.

Shutter Speed: 60
F-Stop: f/4
ISO: Fuji Provia 100f (chrome film)
Camera: Large format; 4 x 5 in.
Lens: 150mm
Light: Indirect/filtered natural light

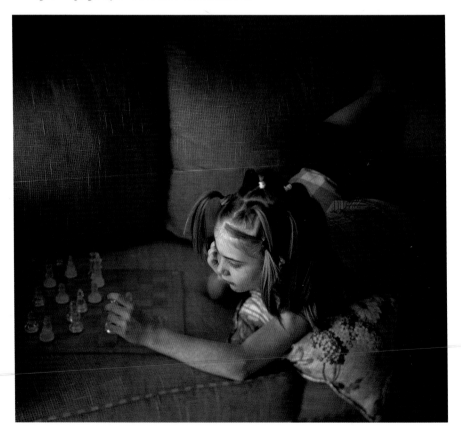

Indirect/Filtered Light

figure 3.10
Top view
covered alcove (interior)
Shadows "fall off" resulting
in a very soft shadow edge.

image 3.17

Shutter Speed: 60
F-Stop: f/4
ISO: Fuji Provia 100f (chrome film)
Camera: Large format; 4 x 5 in.
Lens: 150mm
Light: Indirect/filtered natural light

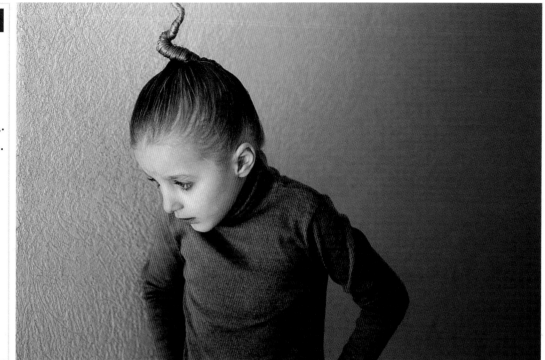

The size and direction of the filtered light source will determine how harsh the light appears. For example, when a window becomes our light source, supplied by indirect sunrays, the window is transformed into a large source (the size of the window). It differs from light coming directly through a sheer in that the indirect quality of this light allows us to shoot at the window, or to include the window in the shot without it being blown too far into another light zone. This type of scene is not overly dramatic, with sharp shadows, but rather provides a softer drama.

The effect of filtered light, known as *chiaroscuro*, was popularized by Rembrandt and other Dutch Masters. These men savored the transition between light and dark. Because the light to dark ratios are so severe, and yet the transition so soft, the light maintains subtle detail while shadow areas remain pronounced. Since northern light rarely shines directly into our windows, it consistently offers indirect light. A fill from a white card or disk, properly aimed at a subject lit by this light, can additionally soften the transition into shadows by decreasing the light ratios.

Fill light from bounce or flash

When we take light from one place and redirect it to another, we are bouncing light. Different than filtered light, though acting similarly, a bounced light is generally redirected at our subject, rather than spilling onto it, as in a filtered situation. Because perfectly shaped and directed light isn't always packaged up and delivered to us by the powers of the universe, 99% of the time we need to shape available light to suit our objectives. Sometimes the light is nearly right and we just need to add a little fill to have perfection. This works on most days, but not well at night in a studio without natural light. If we must create light from scratch, we might consider using one light source, then shaping and bouncing that source. Keeping it simple will limit the mishaps and an "over-lit" look. Observe natural sunlight and how it falls and reflects off objects. The surface we bounce the light off of will also directly influence the quality of the bounced light. A silver reflector is more specular and harsh, whereas a white matte board is subtler. Extreme

fill can be effective; just understand that an intense fill can dominate and become the key light

Dappled light

A dapple is a patch of light that usually occurs in a

group. Generally, dapples are created by foliage and have a natural randomness in their pattern. Dappled light is included here as a "quality" of light because of how it feels. Dappled light suggests summers in the shade, like the picnic we discussed earlier. It also can be direct, diffused, filtered, or bounced before it travels through the object that creates the dapple effect. Image 3.19 is an example of a diffused dappled light. The soft pattern on the child's face gives the shot a feeling of atmosphere and place. The dapple indicates the environment out of frame that we don't see. Dappled light requires that the subject or photographer make adjustments to strategically place the highlights of the dapple where they are the most effective and least distracting.

LIGHT DIRECTION
Defining shape by wrapping light

Dappled Light

figure 3.11
Top view (exterior);
soft fill (pulled back)
Dappled light creates
patterned shadows.

Light can come from the back, the side, or the front of your subject. Although only three lateral directions exist, variations on each of these directions are significant, from top to bottom, side to side, and everywhere between. The direction of our light, like the quality of light, can articulate the mood of our image. Usually, we only want to emphasize one direction so that we are clear and eloquent in our visual communication. Multiple key light directions will produce multiple shadows and can be confusing to the viewer. That being said, this can be an interesting effect but can easily come across as gimmickry.

When considering light direction, think of the key light as a cue ball in a game of pool. It travels in one direction until it meets another object. When we use a fill card, it's like using the rails or cushions of the pool table. In this metaphor, our subject is the pocket. The purpose for equating light direction to a game of billiards is that with both the path to the goal is of significant importance. With light, the fill card redirects the light to land right where we want it, on our subject, and consequently

forces us to strongly consider the direction of the key light as well. Redirection is especially important when we backlight our subjects and light ratios are severe.

Frontal lighting

I used to be very averse to using frontal lighting. It seems to flatten shape and, if it's too low, it can look like a horror movie, yet if placed too high can suggest an interrogation room (both of which are creative controls irrespective of how beautiful they do or do not look). But lately I've decided to embrace it. If the quality of frontal light is soft enough, there are few things more beautiful or ethereal. The one-dimensional quality of its flatness can almost be painterly. Not like thick oil paint, but rather smooth and yielding as watercolor, and the closer the soft, diffused light is to the subject the more the subject seems to glow! In this, these photographs can suggest a foundation almost outside of photography.

Sidelit images

Frontal lighting

figure 3.12
Top view (interior) using a black card to add definition; otherwise frontal light is nearly shadowless.

black card (light absorbing)

7 ft. strobe bank

Nothing creates dimension like a three-quarter light raking across a subject. The resulting shadows from sidelight naturally accentuate form.

Holding a hand out in front of ourselves, and rotating it, can help us see the intensity and effect of light direction, especially sidelight. If we are providing the light source, rather then utilizing sunlight, consider moving the source around the subject in a half moon shape to notice how the definition of form changes with the cast shadow. If the shadow appears too sharp, scrim the light. A softer sidelight will wrap the sitter and add a beautiful directionality to light while a harsher light will trip across a form. Sidelight, like backlight and frontal lighting, can have very different visual effects influenced by the quality of the light. Still, nothing creates dimension like sidelight.

Backlight

I am a huge fan of backlighting. I will often walk around my subject just to get a backlit scene. The beauty of backlighting is that our subject isn't squinting and they glow like an angel. That being said, one has to be very careful not to silhouette their subject if that is not the intended effect. Backlighting adds freshness to an image but can also blow out the information in the scene (resulting in clipping on our histogram). Balancing the foreground and background with the proper ratios is the secret to successful backlit images.

When backlighting, fill light is always our best friend. This fill can be from either a flash or a reflective surface. When using a flash be sure to "dial down" the power in order not to turn a backlit images into front-lit ones. Fill cards, on the other hand, can be wonderfully subtle because there is not an introduction of another light source, merely redirection of the original source. Fill cards can require another set of hands, or a stand, but are well worth the trouble. Another nice thing about using a card is being able to see exactly the light reflecting onto our subject when capturing the image. If able to recruit someone to hold the fill card, have them angle the card to redirect the light just to the side of your subject so it can draw-in the light from the behind and angle it toward the subject. With this we are simply bouncing the light from the back toward the front of them. Inherently

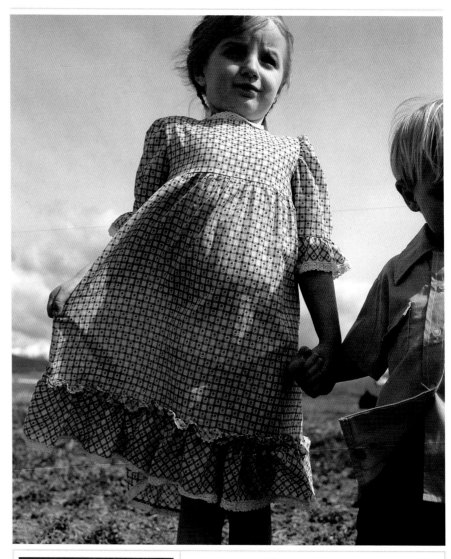

Sidelit Light

figure 3.13
Top view (exterior); razor sharp shadows cut subject in half.

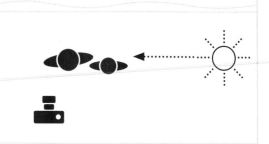

this light will be less severe than the backlight and that is exactly what creates a successful backlit image.

Another trick is to instruct your card-holding assistant to angle the card just enough to see the light in the child's eyes but not so much that it will blind or distract them. Be wary of over lighting and move the card back 2 ft further than you think it should be. When you see your image on the LCD of your camera it may look a little dark or bright. Remember that your LCD is an estimate of the final image and as you get to know your camera you will better know how to read your LCD. We are smarter than our LCDs. Once you know how it lies to you, adjust for that. If it's nothing, it is predictable.

The ability to shape and mold light is a valuable tool that allows many creative options for photographers to express themselves. Understanding the emotion and impact of each type of light quality and direction, can open a plethora of ways to communicate photographically. When we understand light and couple it with an understanding of the functions and creative controls of camera settings (as well as lens choices), we can truly become well-rounded photographers.

Do we need to memorize all the details of these rules and guidelines? The answer to that is a resounding *no*. Memorization and a technical approach can help with camera settings, yet without verbatim knowledge of this chapter, we can still test our assumptions and observe the characteristics of light and camera. These observations furnish evidence of basic photographic truths. With personal experience these facts and figures become part of our lexicon, and unconscious aptitude. Practice and observation is the best way to learn to "feel" when a rule can apply to support our creative vision or not.

As artist-photographers, we'll always press beyond directions and mere good exposures, and seek to be the creators of meaningful photographs. To do so we find sovereignty in knowing our tools, understanding our medium and exploring our intent.

image 3.21

Shutter Speed: 200
F-Stop: f/4
ISO: Kodak E100VS (chrome film)
Camera: Medium format; 67
Lens: 100mm
Light: Direct midday side light

image 3.22

Shutter Speed: 640
F-Stop: f/2.8
ISO: 100
Camera: 35mm DSLR
Lens: 45mm tilt/shift
Light: Backlight, hazy day

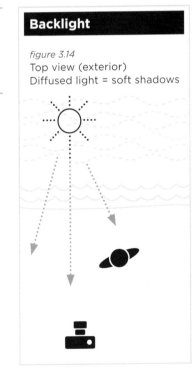

Backlight

figure 3.14
Top view (exterior)
Diffused light = soft shadows

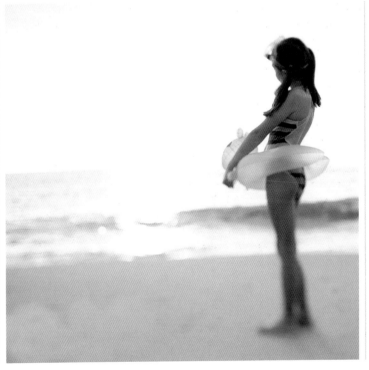

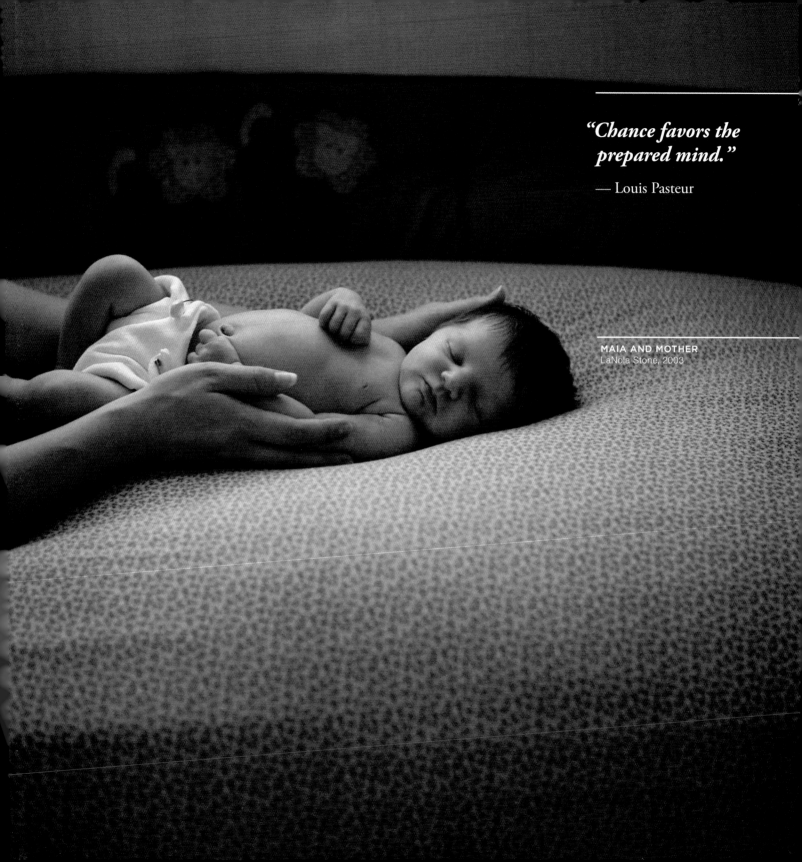

"Chance favors the prepared mind."

— Louis Pasteur

MAIA AND MOTHER
LaNola Stone, 2003

TIMELINE OF CHILDHOOD

4

7–9 MONTHS

10–12 MONTHS

1–1.5 YEARS

- Sits without support
- Crawls
- Begins to control their core and hands
- Starts to pull-up/stand with support
- Puts everything into mouth

▶ *This is the first chance to photograph a child sitting up and crawling; both are very photogenic milestones!*

- Control of limbs/stands
- Says one or two words
- Eats 3 meals and 2 snacks per day
- Sleeps 12 hours and couple of naps
- Walks with assistance

▶ *Treats can be rewards but once seen by the child should be provided rather quickly. Other rewards can be blankets and toys that can also serve as props during a photography shoot.*

- Walks and will cautiously go up stairs
- Drinks from a cup and eats without assistance
- Sleeps mostly at night with 1–2 naps (starts to wean to one nap)

▶ *Pull out the photo album and review that amazing first year! If the album is thin, recommit to photographing your child. There are a lot of great milestones coming up.*

- Specific emotional attachment to most nurturing parent
- Unhappy when something is taken away

▶ *Provide a change of atmosphere if baby starts to fuss.*

- Shows affection
- Fear of strangers
- Curious and explores
- Starts to show anger
- Reponds to simple commands

▶ *Baby's awareness is increased and their willingness for change is decreased. Ease them into new situations, especially those with strangers, like new photographers.*

- Separation anxiety
- May fear bath time

▶ *If you stay calm, your child will too. Children at this age will continually look to you for how they should respond in a given situation.*

- Distress when separated from the more nurturing parent
- Excitement at a game of "peek-a-boo"

▶ *Prepare yourself for the manipulation game. Babies learn quickly that a mere squawk can send you running.*

- Responds to own name
- Waves "bye-bye"
- Motor interaction: plays "pat-a-cake"
- Understands "no"
- Gives and takes objects

▶ *Because the child now has an interest in games, this is an opportunity to record these interactions and their excitement.*

- Sharing isn't a developed concept for any child this age, redirect attention verses attempting forced compliance
- Repeats words back
- Interested in mirror image

▶ *Children respond to your cues. Direction is best given by example.*

- Normal, loving, responsive caregiving seems to provide babies with the ideal environment for encouraging their own exploration, which is always the best route to learning

- Infants and children who are conversed with, read to, and otherwise engaged with lots of verbal interaction show somewhat more advanced linguistic skills than children who are not as verbally engaged by caregivers

- Begins to respond to direction, suggestion, and simple commands
- Responds to counting games
- Vocabulary is growing!

AGE	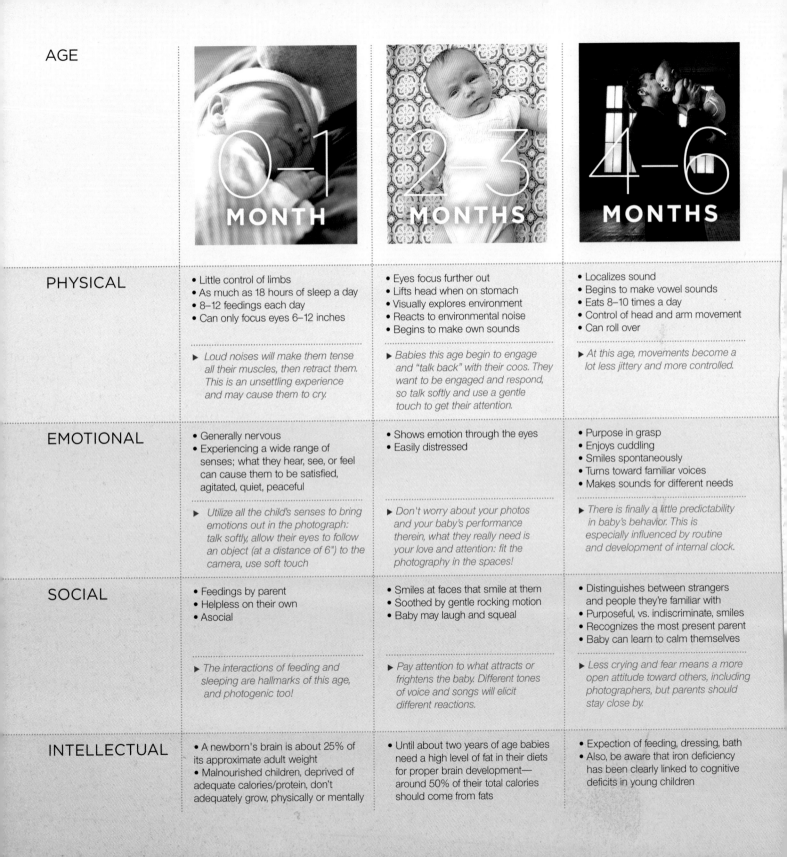 0-1 MONTH	2-3 MONTHS	4-6 MONTHS
PHYSICAL	• Little control of limbs • As much as 18 hours of sleep a day • 8–12 feedings each day • Can only focus eyes 6–12 inches ▶ *Loud noises will make them tense all their muscles, then retract them. This is an unsettling experience and may cause them to cry.*	• Eyes focus further out • Lifts head when on stomach • Visually explores environment • Reacts to environmental noise • Begins to make own sounds ▶ *Babies this age begin to engage and "talk back" with their coos. They want to be engaged and respond, so talk softly and use a gentle touch to get their attention.*	• Localizes sound • Begins to make vowel sounds • Eats 8–10 times a day • Control of head and arm movement • Can roll over ▶ *At this age, movements become a lot less jittery and more controlled.*
EMOTIONAL	• Generally nervous • Experiencing a wide range of senses; what they hear, see, or feel can cause them to be satisfied, agitated, quiet, peaceful ▶ *Utilize all the child's senses to bring emotions out in the photograph: talk softly, allow their eyes to follow an object (at a distance of 6") to the camera, use soft touch*	• Shows emotion through the eyes • Easily distressed ▶ *Don't worry about your photos and your baby's performance therein, what they really need is your love and attention: fit the photography in the spaces!*	• Purpose in grasp • Enjoys cuddling • Smiles spontaneously • Turns toward familiar voices • Makes sounds for different needs ▶ *There is finally a little predictability in baby's behavior. This is especially influenced by routine and development of internal clock.*
SOCIAL	• Feedings by parent • Helpless on their own • Asocial ▶ *The interactions of feeding and sleeping are hallmarks of this age, and photogenic too!*	• Smiles at faces that smile at them • Soothed by gentle rocking motion • Baby may laugh and squeal ▶ *Pay attention to what attracts or frightens the baby. Different tones of voice and songs will elicit different reactions.*	• Distinguishes between strangers and people they're familiar with • Purposeful, vs. indiscriminate, smiles • Recognizes the most present parent • Baby can learn to calm themselves ▶ *Less crying and fear means a more open attitude toward others, including photographers, but parents should stay close by.*
INTELLECTUAL	• A newborn's brain is about 25% of its approximate adult weight • Malnourished children, deprived of adequate calories/protein, don't adequately grow, physically or mentally	• Until about two years of age babies need a high level of fat in their diets for proper brain development—around 50% of their total calories should come from fats	• Expection of feeding, dressing, bath • Also, be aware that iron deficiency has been clearly linked to cognitive deficits in young children

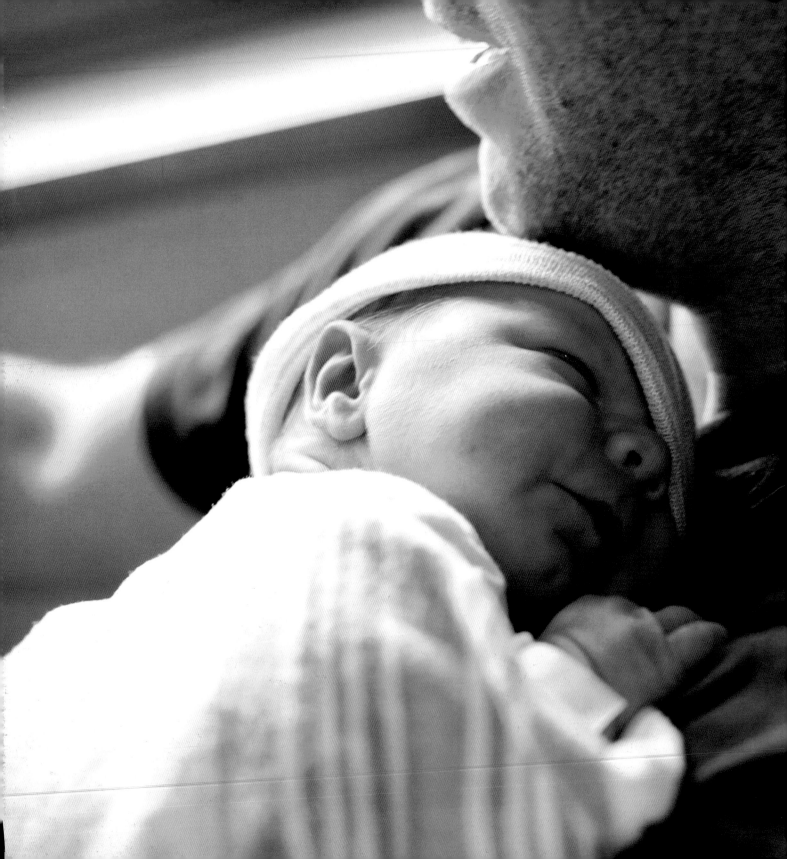

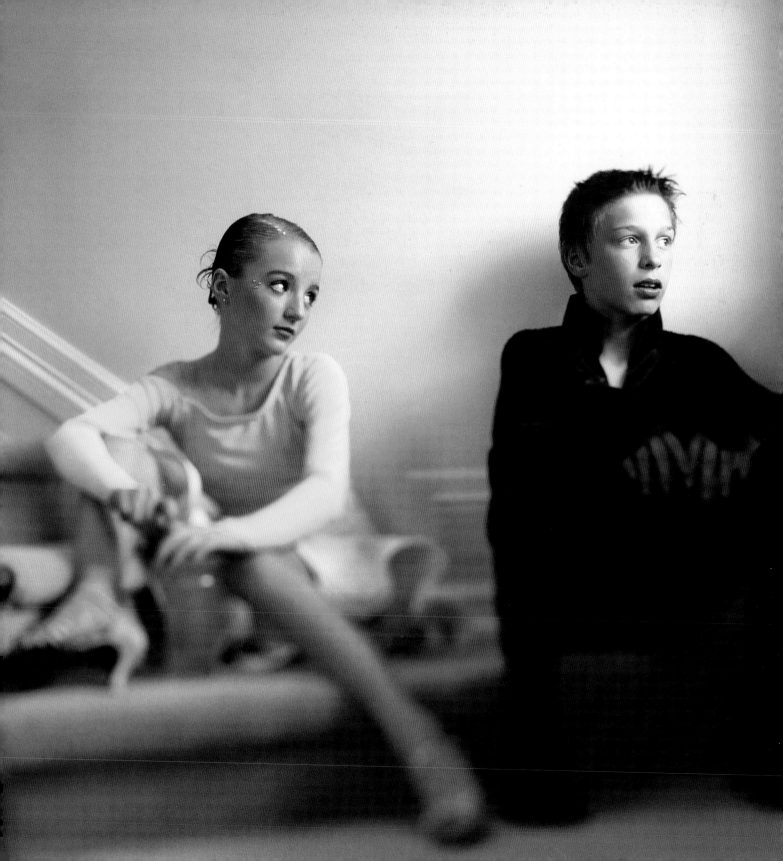

5-7 YEARS

- Good balance: hops, skips, skates, rides bikes
- Dresses without help
- Prints letters, handedness established
- Ties shoes

▶ *This is a magic age when children want to be "little helpers." Take a chance and give them a task, it might surprise you what they can do!*

- Self-assured/well-adjusted
- Home-centered: likes to associate with caregiver
- Starts to process criticism
- Enjoys responsiblity
- Likes to follow rules

▶ *Logical rules and structure provide a sense of safety and security for children.*

- Has "best" friends
- Very organized
- Feels pride in clothing and accomplishments
- Highly cooperative play
- Eager to carry out some responsibility

▶ *School becomes important at this stage. The friends your child has at this age will forever be remembered. Don't forget to get photographs of your children with their "best friends!"*

- 2000+ words, tells long tales
- Carries out directions well
- Reads, counts, asks meaning of words
- Interested in environment, city, stores, etc.
- Learning difference between fact and fiction/lying

7-11 YEARS

- Hand-eye coordination: ball sports, video games, cutting and pasting
- Increased gracefulness in movements

▶ *Be sure to document the pastimes and hobbies as your children seek to master new sports and other pursuits.*

- Begins thinking logically about concrete events, but has difficulty understanding abstract or hypothetical concepts

▶ *Be specific in your directions. The child still looks to please when they understand the requests given by photographer or parent.*

- Clasifies objects and people
- Can learn there is value in differences

▶ *This is a great age to invite friends over for a photoshoot party and teach responsibility with cameras and images.*

- Fairly good at the use of inductive logic
- Can have a specific experience and derive a general principle, but has a harder time applying general principles to specific experiences

11-16 YEARS

- Growth spurts of 8–12 inches in a period of 2–3 years
- Body hair and acne
- Voice changes
- Physically strong, sharp senses, and stamina

▶ *Physical changes can feel awkward to the child. Always be encouraging about physical appearance on set. Parents should stress hygiene needs over looking beautiful.*

- Absolutist; has a hard time thinking that situations in the *now* can ever change
- Often think about who they "will be" and unsure how to get there

▶ *Talk about things of importance to the child. If nothing else, allow them to be and express themselves in images. Ask the child what pictures they like, have them pull tearsheets out of magazines (this is very insightful).*

- Believes that everything centers around one's appearance, thoughts, and behavior
- Search for independence can result in conflict with authority and risk-taking/recklessness
- Belief of invulnerability

▶ *Involve friends and props from their lives when photographing, as it takes pressure off the individual child. Shoot at important events and use different angles while there.*

- Able to participate in abstract thinking
- Able to understand complex situations, yet not sure how to deal with them, which can lead to anger or frustration

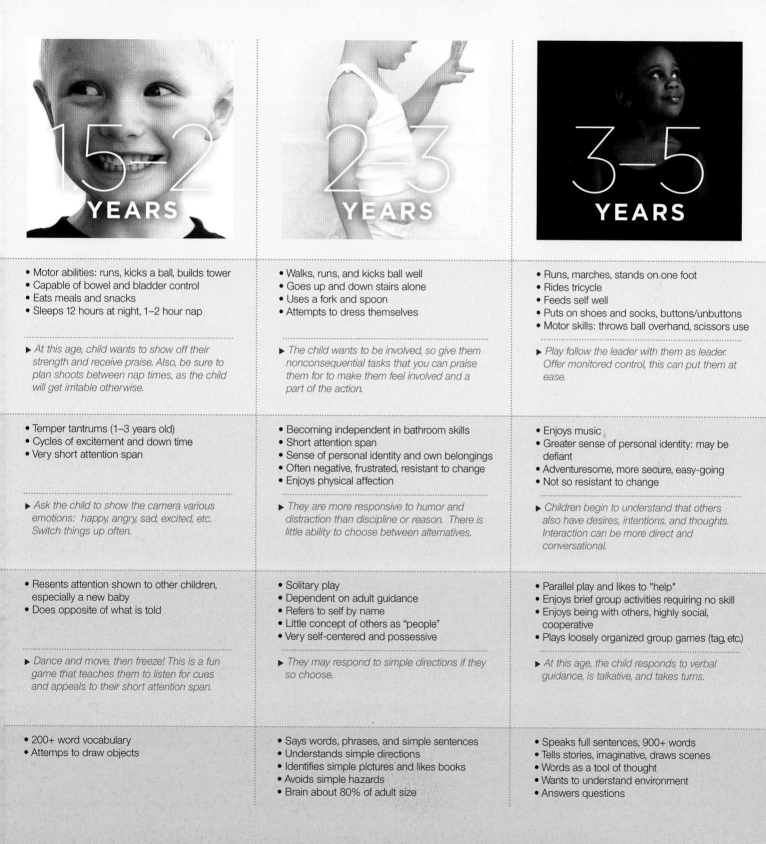

1.5–2 YEARS

- Motor abilities: runs, kicks a ball, builds tower
- Capable of bowel and bladder control
- Eats meals and snacks
- Sleeps 12 hours at night, 1–2 hour nap

▶ *At this age, child wants to show off their strength and receive praise. Also, be sure to plan shoots between nap times, as the child will get irritable otherwise.*

- Temper tantrums (1–3 years old)
- Cycles of excitement and down time
- Very short attention span

▶ *Ask the child to show the camera various emotions: happy, angry, sad, excited, etc. Switch things up often.*

- Resents attention shown to other children, especially a new baby
- Does opposite of what is told

▶ *Dance and move, then freeze! This is a fun game that teaches them to listen for cues and appeals to their short attention span.*

- 200+ word vocabulary
- Attemps to draw objects

2–3 YEARS

- Walks, runs, and kicks ball well
- Goes up and down stairs alone
- Uses a fork and spoon
- Attempts to dress themselves

▶ *The child wants to be involved, so give them nonconsequential tasks that you can praise them for to make them feel involved and a part of the action.*

- Becoming independent in bathroom skills
- Short attention span
- Sense of personal identity and own belongings
- Often negative, frustrated, resistant to change
- Enjoys physical affection

▶ *They are more responsive to humor and distraction than discipline or reason. There is little ability to choose between alternatives.*

- Solitary play
- Dependent on adult guidance
- Refers to self by name
- Little concept of others as "people"
- Very self-centered and possessive

▶ *They may respond to simple directions if they so choose.*

- Says words, phrases, and simple sentences
- Understands simple directions
- Identifies simple pictures and likes books
- Avoids simple hazards
- Brain about 80% of adult size

3–5 YEARS

- Runs, marches, stands on one foot
- Rides tricycle
- Feeds self well
- Puts on shoes and socks, buttons/unbuttons
- Motor skills: throws ball overhand, scissors use

▶ *Play follow the leader with them as leader. Offer monitored control, this can put them at ease.*

- Enjoys music
- Greater sense of personal identity: may be defiant
- Adventuresome, more secure, easy-going
- Not so resistant to change

▶ *Children begin to understand that others also have desires, intentions. and thoughts. Interaction can be more direct and conversational.*

- Parallel play and likes to "help"
- Enjoys brief group activities requiring no skill
- Enjoys being with others, highly social, cooperative
- Plays loosely organized group games (tag, etc.)

▶ *At this age, the child responds to verbal guidance, is talkative, and takes turns.*

- Speaks full sentences, 900+ words
- Tells stories, imaginative, draws scenes
- Words as a tool of thought
- Wants to understand environment
- Answers questions

WHAT TO EXPECT AND WHEN TO EXPECT IT

Although children are unique and develop different talents and social and motor skills at different times, they tend to hit developmental milestones in roughly the same order. The secret to photographing childhood is to understand and work with known variables, while still going with the flow of the unexpected. In the spirit of understanding known variables, the fold-out on the back of this and the previous page presents a chart of developmental checkpoints to consider when photographing children of a certain age. It was created to avoid lumping all children (0–16 years) together in one category. Out of respect for their graduation from one stage of childhood to the next, this chapter suggests certain things to look for, and others to avoid, at various junctures in childhood.

AFTER BIRTH
Infant to adolescent

Our own memories of childhood can give us clues as to what one might expect from children today, but they can also deceive us. Since our own childhood was quite some time ago and influences differ today from those of our past, and because our memories of childhood don't generally begin until around 2–5 years of age, it helps to observe and note bona fide child development milestones. There are countless books on this subject and they are full of well-documented attributes of the "general child." They are good points of reference when we are approaching a new situation. However, mostly the information stays in our metaphorical back pockets. Knowing what to expect, and when, helps us manage our expectations and anticipate behavior. If you are not around children a lot there is almost no way that you can predict the path of their development. This naivety can lead to unrealistic requirements of children, which places unnecessary stress on both the children and us.

Expectations grow out of our experiences. When experience with children is limited, our expectations can be uninformed and misaligned with a child's behavior. For example, one evening I was having dinner with some of my friends. After dinner we were sitting around talking about my sister's son, who was teething. For those who have experienced this phenomenon, we know that everything goes into the child's mouth, and that the child is miserable and drooling constantly as their teeth endeavor to push through the child's gum line. Indeed, my poor nephew was miserable.

As the conversation progressed, I looked over at my friend, who had a completely bewildered look on his face. I asked him about it. Without skipping a beat, he explained that he thought that he must have misinterpreted our conversation. My nephew was losing his baby teeth, not acquiring them, right?

Now I was confused. I asked for him to clarify his last comment. He explained that he thought children were born with all their "baby" teeth, so he couldn't be getting them and must be losing them. Although this comment was amusing to the parents in the room, it gave me cause for thought. Of course I understood teething. I am from a large family and began babysitting at age ten.

By contrast, this friend was an only child with no younger cousins and little exposure to children younger than himself. He had no idea that babies were born without a full set of teeth (which is a horrifying prospect for any breast-feeding mother). My friend is a very well-educated man who teaches law at Georgetown University. He just had not had the opportunity to learn much about babies before his exposure to my nephew. Childhood has a learning curve to be sure. However, it's a learning curve that photographers must be aware of before placing expectations on a child.

Expectation management is essential when working with children. For instance, we mustn't expect a newborn to sit up, or an eight-year-old to play peek-a-boo—and we certainly can't expect an adolescent to pay attention when their nearby cell phone indicates they have a text message. Being age-appropriate with children is a signal to them that we have an unspoken respect for who they are, at any age.

There are other considerations that shape our expectations for the child subject. Among other things, we must remember to consider their personal character and personality and the kind of day they are having, and yield to these as well. Photography is a collaboration between subject and artist. If we wish to capture authentic images of childhood it is never just about the photographer and our ideas.

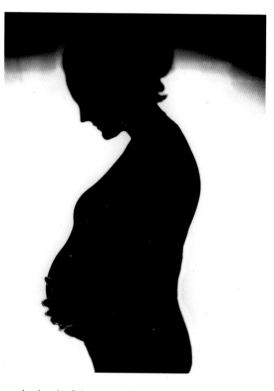

image 4.4
To create a strong silhouette, underexpose your subject by three stops by metering the light behind your subject.

Shutter Speed: 60
F-Stop: f/4.5
ISO: Polaroid Type59 (+/- film)
Camera: Large format; 4 x 5 in.
Lens: 150mm
Light: Back/metered for silhouette

Every successful photographer will arrive at a photo shoot with realistic expectations and objectives, yet is willing and ready to be flexible so as to capture the spirit of the child before our lens.

Of course, it goes without saying that personal drama, illness, or moodiness are inappropriate when working with children. If the photographer is experiencing emotions such as fear, caution, or frustration, they will pass from the photographer to the child and will have a negative impact on the shoot, including the flow of creative thought within ourselves. The reason that so many photographers avoid working with children, or lament having to do so, is because of an inability to put the child's

needs ahead of their own. It can be exceptionally frustrating when we enter the shoot with an objective only to have it derailed by someone so small. How the photographer handles those difficult moments determines our success or failure. Every successful photographer will arrive at a photo shoot with realistic expectations and objectives, yet is willing and ready to be flexible so as to capture the spirit of the child before our lens.

Yes, it's all about expectation management!

One last thought. With our own children, or children close to us, we might consider making photography a long-term project or a tradition. A child will respond very differently to a camera when they are accustomed to photography in their lives. Use photography as an opportunity to capture milestones that are both meaningful to you now and will be significant to the child later. However, don't just capture cliché moments. Our children are much more than prescribed milestones. For some, a long-term project is apropos to childhood and can organically take shape, like Robin Schwartz's project

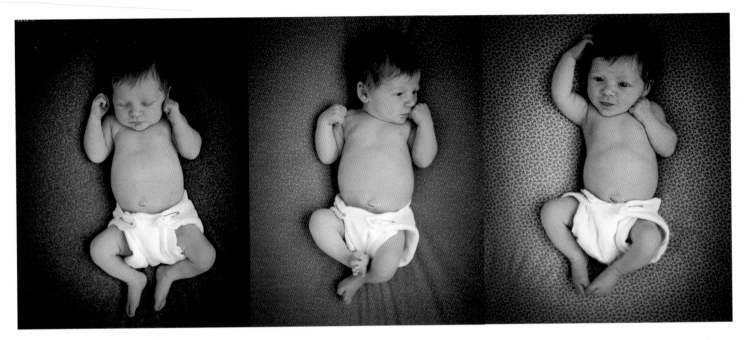

of her daughter Amelia (p.148). Yet for everyone, photographing deliberately and with a constant effort can heighten our skills as an artist-photographer. We will learn to see light better, composition will come more quickly, and we'll be increasingly more comfortable with our camera.

READY, SET, GO!
A child's first year

After all the waiting, at last arrives the precious little bundle. This is indeed a momentous occasion and an obvious moment to get out the camera. The first day is the first benchmark of documenting the growth of a child and begins a tradition of capturing special moments. With newborns nothing has to be clever or produced, mom is glowing (although exhausted) and baby is adjusting, nuzzling, and settling in. Often, however, because it has been an exhausting day for both mother and baby, photography can be relegated to chance pictures on camera phones and other snapshots. One way to assure that this day gets captured with intent is to make photography part of the birthing plan. We are long past the days of babies exclusively behind glass; now father, mother, and family can enjoy this experience together. Although the camera may or may not be a part of capturing the memory of the actual delivery, there is something beautiful about photographing the first 24 hours. The baby will do two predictable, photo-worthy actions: sleep and eat. This is a time of bonding, cuddling, and acquaintance. Exhaustion is overshadowed by the joy of arrival. It's a magical time for candid and sincere emotions—and a magical opportunity for the artist-photographer.

Then comes day two, three, four... and the realities of parenthood settle in. Welcome to the first year, the year to hone our skills and make photography a priority. The tradition of recording an image is a beautiful thing, especially with respect to the child and family. Because the child spends a lot of time sleeping at first, this is a great place to start. Try experimenting with lighting. Photographing the sleeping child with a backlight, sidelight, and even frontal light can offer variety to the shots. It helps us know which lighting we feel is successful, and which lighting scenarios we like less. Remember that light doesn't have to be coming directly through a window to light the baby; indirect light (as used on the three images above), though less intense and requiring slower

image 4.5
When photographing with an "idyllic" objective I always swap out plastic diapers for cloth. But have a few extra on hand—they are merely for fashion *not* function.

Shutter Speed: 60
F-Stop: f/4
ISO: Kodak 160NC (film)
Camera: Large format; 4 x 5 in.
Lens: 150mm
Light: Indirect window light

Welcome to the first year, the year to hone our skills and make photography a priority. The tradition of recording an image is a beautiful thing, especially with respect to the child and family.

shutter speeds, spills beautifully. After all, quick shutter speeds are not necessary for sleeping children. As we utilize this quiet-time to improve our light comprehension and build our photographic muscle, we can both capture fleeting experiences and, at the same time, become better photographers.

Don't forget to focus on details in some of your shots: face, belly, feet, and the hands of parent and child. These close-up photographs not only capture fleeting traits, they will teach us about lenses and depth of field. While wide lenses have their place, when photographing close to our subject the distortion created is often too severe. Try it. Is the distortion of near and far a creative tool or an annoyance? Likewise, when experimenting with a shallow depth of field, notice how it can isolate nuances with focus. You will decide whether these lens attributes work visually toward your visual objectives or not.

With infants we often spend most of our time waiting for them to do something! In Piaget's theory of cognitive development, this time is considered the *sensorimotor* stage. Infants receive information about their environment through their senses and best react to isolated stimulation because they can only really focus on one thing, to the exclusion of everything else. So choose touch or soft words to help focus their attention in a photograph. In the meantime, get in close, pull back, experiment with various types of light, and enjoy the ability to observe. This is a great time to slow down, hone our craft, and bond with our child. Since a child's daily routine is fairly predictable, we have the advantage of anticipating photographic moments and even placing the child where we'd like to photograph them. At this age we know that they'll stay put. There are always a variety of options for settings and locations for photographing. Although the child contributes expressions and moments, the photographer controls everything else—lighting, angle, composition, lens, and other factors. As a baby grows, we learn that we can't give direction to a six-month-old's crawling or a one-year-old taking its first steps, but we can provide the structure for their movement. Always remember "safety first" and then have fun. The fun doesn't have to come from an overly produced shoot. Through the use of a variety of angles, which add interest, and the successful use of that all-important element of light, we add energy and style to our images. These photo shoots will increase our repertoire of skills. As you become more comfortable, include and incorporate the reactions of other children, especially cousins, siblings, and lifetime acquaintances. Don't neglect the pets in the photographs as well, but only those that are friendly to the new child.

As the baby grows, so will the requirements for quick decision making with regard to lighting, exposure, and composition. Take advantage of the quiet-time of babyhood to improve your skills, because before you know it, baby will be showing expressions, rolling over, lifting itself up, crawling, and then standing and walking. This will all happen in the first year. Once they get their feet underneath them, watch out! Think of the first year like the steady climb of a rollercoaster. Click, click, click; the anticipation is growing and the drop is looming. Unfortunately, we are often too tired and overwhelmed to recognize the opportunities in the calm of the first year. Throughout the ride there will never be a moment that

will progress so incrementally as the first climb. Children methodically and steadily grow during this time and then, they are off to the races and we'd better be ready.

One last parental note concerning the first year. The experience of photographing one's child can reinforce our participation in the child's continual development. Photography can be a great bonding experience because it forces us to slow down and observe. As we are looking for "the ideal shot," we'll notice details in the moments—teething children with objects in their mouth, or the concerned confidence on a child's face as they stand on wobbly legs to take their first steps. We might not always "get the shot," but we'll be able to capture the memory of the images, and perhaps be better prepared when the opportunity to photograph a similar moment presents itself again.

WHAT'S SO TERRIBLE ABOUT TWO?
Growth and independence in toddlers

The "terrible twos" can start as early as the second year and for some it lasts into the fourth year. This is an exciting phase of discovery and exploring boundaries. To adults, toddlers' actions can seem completely defiant, since the boundaries that they're exploring are the boundaries we've set. Yet, we need to understand that physiologically their brains have not developed the reason function, and these actions are of discovery, not defiance. As we consider these facts we realize that their actions are not personal and obstinate. This perspective allows us to enjoy being a witness to, and participant in, their discoveries and exploration.

The reason the word "terrible" is often linked to this age is because children often spend this time getting into everything! They have little hands that reach and feet that walk and they travel quickly. This new-found aptitude is exciting for them and really only terrible for us. It is also a time in which their comprehension of the world is very insular. The following scenario is a great example of this: A two-year-old walks in front of the television and stands directly between it and you, obstructing your line of sight. You ask the child to move and he wants to know why, since "why" is his favorite question and, after all, it is a sincere one. You might respond, "Well, I can't see the TV." The child looks at you and then looks at the televi-

sion and back at you. He looks confused. The child truly tries to understand what you are talking about because he can see the television just fine and doesn't understand why you cannot see it. This level of comprehension does not physically develop in the brain until the child is a bit older and, since it is a matter of development, we needn't get any more frustrated than when, as an infant, he couldn't hold a bottle to feed himself. At a certain point he will understand, and when he does, it is like a light switch—he fully gets it! Until this point the synapses have just not fully developed in his brain. This is the most important thing we need to understand about this age group. It doesn't mean we don't try to reason; reason needs to be there when they are ready for it, but we mustn't take the child's disregard for our needs personally. That includes our needs when photographing them. Although this can be a challenging age to photograph, our approach can ease the difficulty.

Because this age group is so curious, they get into everything and dissect it. Now that we know that, great! Let's embrace it. As we distract them with a project, they will naturally forget about us. When their attention is required they will look briefly, and then probably return to whatever they were doing. If we have the lighting right and the composition figured out, then this brief look at the camera will make for a beautiful portrait that captures the essence of their experience during this time in their lives.

There are many ways to keep the child involved in your image-making process. For instance, make it a game by

image 4.7

Children are always on the move. Rather then following their face, choose a composition and let the child move in and out of frame. Not every shot will be a winner but it's a fun way to capture their energy!

Shutter Speed: 100
F-Stop: f/5.6
ISO: Kodak 160VC (film)
Camera: Medium format; 67
Lens: 150mm
Light: Mixed; strobe/window light

Children push boundaries and can get hurt. They have remarkable courage to explore and are often fearless of the consequences, simply because they don't know what they are.

asking them questions that lead to your desired outcome. Remember that they love to search and find hidden surprises. It takes a little planning ahead, but they will stay attentive knowing that you have something else in the environment that might interest them.

What is very sweet is that they want to help and do things with us. Although, this takes patience and time,

there is no better way to gain their trust then to involve them in our projects. I wouldn't suggest that they hold an $8000 camera or be asked to endure long tasks, but look for ways they can "help," and as you open your world to them, they will return the favor!

Remember that a child's attention span is limited, so when we see our shot, we mustn't waste a second—get it right away. Being able to jump in and get the shot depends, to a great extent, on our preparation. Be sure that all is arranged beforehand so that the child is not getting bored while he or she waits for us to be ready. Show up ready! Understand when the time of preparation is over and when to start making images. I'd recommend making photographs as soon as possible after a rapport has been established and the child is on set.

Part of the exploration of this age is their exploration of us. When it comes to emotions, two-year-olds don't miss a beat. Children often feed off of our energy, so stay positive and attentive. Delegate the running around to someone else, like an assistant or friend. Our job is the image and that is where all our positive energy needs to be focused!

In their process of search and discovery, children push boundaries and can get hurt. They have remarkable courage to explore and are often fearless of the conse-

too long to forget that the camera is focused on them.

It is important to note, that children are people too, albeit miniature. Looking down on them gets really old and does not offer our viewer a new perspective. This is how we generally see children portrayed. Personally, I love to see the child's perspective, and this is only available at their eye level. If we want to tell their story, we ought to consider their point-of-view, their vantage point. The story of childhood is all about constantly looking up. Consider planning the shoot at slightly above or slightly below the child's eye line. An additional benefit is that if you are low, the child is instantly more comfortable. Position yourself strategically and don't overlook moments of nothingness. Doing nothing, when a child is deep in thought, always makes for a great shot because of its pure authenticity. The best images are when the child is concerned about something other than the camera.

Here are a few more photographic tips. Get out from behind the camera and don't be afraid to shoot from the hip. If things do fall apart, my advice is to go with it. Don't torture the child but don't immediately put the camera down either. Since children these days are used to seeing their images right away on the LCD screen, this too can help hold their interest. At the end of the shoot, start to "go crazy" and let them see the pictures. This will help keep them involved a little longer but un-

Almost every quality that that could possibly annoy us about a child at this age will serve them well as they get older; independence, discovery, finding out how things work, and learning from watching you are a few of these attributes.

quences, simply because they don't know what they are. We must be aware of their safety at all times and keep the heavy and expensive photographic items away from our curious toddler.

If we provide supervision, then this age can be really fun, we just need to let them explore safely. Because their actions are not malicious—to the contrary, they are eager to please and show off their new accomplishments—children love it when they can please and explore together. This is what makes the terrible twos a remarkable age for photography. The wonder of these children is omnipresent in everything they do and it doesn't take them

derstand that your time will soon be up and be sure that you captured a winning shot!

Lastly, almost every quality that could possibly annoy us about a child at this age will serve them well as they get older; independence, discovery, finding out how things work, and learning from good examples are a few of these attributes. Take advantage of your time with a terrible two, to expand these same attributes in yourself and your photography.

SCHOOL DAYS, TAKING IT ALL IN
Pre-school through elementary school

Something changes in a child as they extend their reach into the world beyond the walls of their home. They are beginning to make sense of it all through socialization and interaction with others on the periphery of the family bubble. School-aged children start to learn social norms and, perhaps, pick up a few bad habits as well (like posing for a photograph as if they are on the red carpet). Because socialization is such an important aspect of this phase of life, consider involving their friends in the photographs. This helps us capture the integration of two lives and can make for fun fantastical or candid shots!

By this time, children have grown into a measure of reason. Instead of being limited to games of suggestion and pure imagination, we can flat out ask the children to act for and be involved with the camera. "Let me see angry, let me see sad;" if in costume or a particular wardrobe, ask them to relay the emotion of that costume. Instead of just forgetting about the photographer, as they may have done in their younger years, they are looking to us for direction and guidance. The trick is to provide this structure and, at the same time, offer a place of freedom for them to be themselves!

Many school-aged children love dress-up, and their attention span is increasing. Playing pretend can be much more elaborate and involved, and games can be increasingly more direct. This is where collaboration with the child takes on a whole new dimension for the artist-photographer. Up until now, collaboration was mostly about considering the child's needs and capturing an image while maintaining safety and respect for the child and their wellbeing. Now the feedback from children is really valuable, they comprehend what is going on and understand the process a little more. We still have the responsibilities of safety, respect, and wellbeing, but we can (and should) allow their involvement a little more each year as they grow.

This is also the age when they've decided whether they like having their picture taken or not. Hopefully, we've laid the groundwork for making photography commonplace, fun, and familiar. After all, just taking the picture is a lost opportunity if it is not also about making that

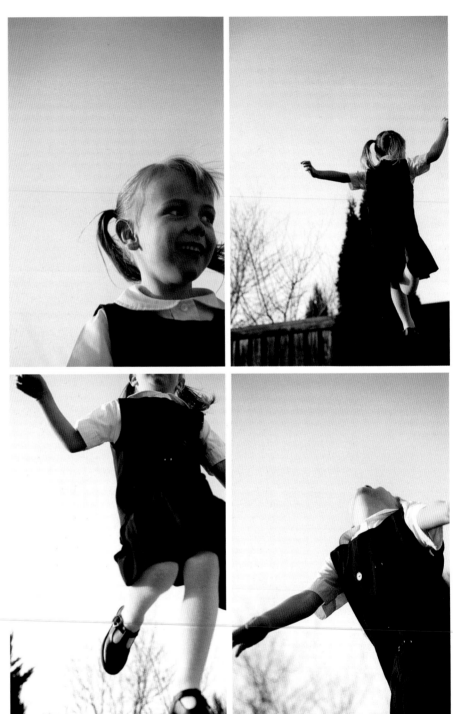

image group 4.9 (left)

When shooting with direct light one must be mindful to set the exposure in such a way as to capture details of interest (like faces) in the shadows.

Shutter Speed: 640
F-Stop: f/4
ISO: 100
Camera: 35mm DSLR
Lens: 70mm (child moved back)
Light: End of day direct side light

image group 4.10 (right)

Direct light can add drama and interest in its harsh shadows. Be sure to meter faces so that the shadows don't obscure the expressions.

Shutter Speed: 500
F-Stop: f/2.8
ISO: Kodak Ektachrome 64T (cross processed chrome film)
Camera: 35mm SLR
Lens: 200mm
Light: Midday direct light with fill

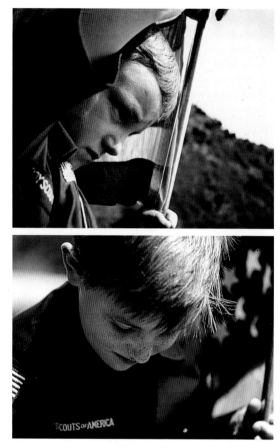

process fun, and something they'll increasingly accept and embrace. As they get older, their opinions about photography are forming. Keeping them engaged in the process is about making positive memories of the experience of photography. It's a difficult balance but it can be a successful one when we are sensitive to the reactions of the individual child. If we want to get pictures of a shy child we might have to be a bit of a sleuth, even using a longer lens and a more candid approach. This also works for the other end of the spectrum, when the child will do nothing but pull funny faces. In both cases, discretion is our friend. Never encourage a behavior we don't want. For instance, don't pester a shy child, because that will just increase their shyness. Rather, encourage them and softly help boost their confidence. As for the performer, capturing that enthusiasm on film is great, but if we feed off it too much, we will escalate that behavior and miss the whole and subtle story of that child. Remember that your disappointment can shut things down quickly. We have to gain their trust. They are bright and insightful children and as we provide positive experiences and encouragement, their comfort with photographer and camera will unquestionably increase.

I am a big fan of sharing moments while taking photographs. Yet sharing moments can only follow the proper preparation in attitude and a setting that foster positive moments. Jacques Henri Lartigue (p.58) was six years old when he began photographing with a view camera. He was allowed to explore his life through photography. Our own children may or may not have this interest, but when childhood is over, these photographs provide insight and nostalgia to a time past. Allow the child to be a participant on this journey. Whether we hand them their own camera or we capture these memories, let them explore their perspective through images. It is a wonderful thing to hear a child talk about their world with the visual aid of a photograph. It is a bonding experience that lets them expand on, and understand, time. Since school-aged children are involved in so many projects, classes, and everyday explorations, record this process. This is the time when our own memories commenced, and the image and the memory truly come together at this age.

As we prepare for adolescence, consider the age of ten the magical age. At ten they're involved and have fun modeling. It's the last of young childhood, so don't miss out on this year. Let them choose the location and spend an hour together taking some photos and making an experience out of the occasion. The more collaboration is a part of these outings, the more each involved will get from the shoot. It's a last reinforcement of cooperation before they turn the corner to their next phase of life, adolescence.

Something changes in a child as they extend their reach into the world beyond the walls of their home. They are beginning to make sense of it all through socialization and interaction with others on the periphery of the family bubble.

THE EXODUS FROM CHILDHOOD
The child prepares for adulthood

DDuring the preteen and teenage years, our children are laying the groundwork for their adult lives. The familiar appearance of childhood has seemed to disappear. They look like little adults, and want to be treated as adults. Herein childhood has almost vanished overnight. Please, please remember that this is *not* the time to stop documenting their childhood. It is still taking place before us, just in a different form. The need to photograph and capture their young lives must not change; though the approach may need to be adjusted. So far we've talked about safety, respect, collaboration, and inclusion of the child's thoughts and insights. As they get older, their thoughts and insights don't seem to flow toward us in the same way. Yet this is the all-important final chapter of childhood, and the wealth of content in this chapter can be both daunting and exciting!

If a child doesn't have a cell phone camera by this age, most of their friends do. Whether or not we've included photography as part of our family tradition, photography is undoubtedly an integral part of our teen's life. Between camera phones and the lure of Facebook updates, photographs are being taken and distributed of and by our children constantly. This calls for a little media education. Wheres we may have recorded their lives for the document; teens record their life for the instant reward and recognition and often without thought of what might result from it. This works to a parent's advantage as they may see friends on Facebook that don't come by the house, but these images can also provide a platform for conversations with our teen. Since the value of privacy and individuality is so heightened in adolescence, these conversations can stop before they've started. Let them record their own world, encourage a journal to get out their initial thoughts so that sharing them a second time, with a parent or trusted friend, will come easier. Teach them what it is appropriate to photograph and what is not. If you have been respectful in your shooting, they will have that example for their own shooting.

image 4.11

Near-far relationships lead our viewer's eye through the frame, especially when they form a strong diagonal or triangle.

Shutter Speed: 80
F-Stop: f/2.8
ISO: 100
Camera: 35mm DSLR
Lens: 45mm tilt/shift
Light: Window light with fill cards

After all, photographs can't be taken on the other side of a text message or in a chat room. Photography reinforces the experience of being together and sharing real-life encounters. Snapshots are our souvenirs of these experiences.

Images taken in the teen years will be used for profile pictures, to showcase vacations and parties, or for any number of purposes. There is generally a distinctive reason for teens' taking photographs, even if they are just messing around and taking a bunch of pictures.

My 15-year-old niece's advice to all parents is to make sure that their children know the difference between sexy and silly. "I learned by my mom telling me about the consequences and by seeing the mistakes of my friends. Even if I thought it was annoying to have this conversation at first, I am glad that she did it because it could save me from things I would regret later." There is a lot of peer pressure at this age. Just as they need to know the dangers of drugs and alcohol, teens need to know

image 4.12

Window light is preshaped
and pours into an open space
organically. Before adding
light try a slower shutter and
use the available light!

Shutter Speed: 80
F-Stop: f/2.8
ISO: 100
Camera: 35mm DSLR
Lens: 45mm tilt/shift
Light: Window light with fill cards

the proper limits to the photography they participate in. If we are not sure of where this danger line is, consider what the law deems inappropriate, and then take a few steps back. Photography is a wonderful form of expression in safe circumstances; so don't completely restrict it. Let them photograph! When children take pictures of each other and capture what's important to them, they learn about themselves and we too can learn. We might just be surprised by how this additional form of communication can benefit our relationship with them and their relationship with the outer world!

In talking to my niece about our experiences photographing her when she was just a tot, she welcomed the opportunity to explore the memories. "I want to know what I was really like back then," she explained. Teens need an anchor, and photographs and memories of the past can provide one. Although she was often the muse for my camera, she thoughtfully commented, "I wish that my mom would have just taken more pictures so I knew who I was." I thought this statement was really valuable to all parents considering the tradition of photography in their homes. Images can prove to teens that their life is built on a solid foundation.

images 4.13–23 (left)

Ah, the power of a photo booth. When I was a teen I frequented the local photobooth with my friends at the mall. There is nothing like being allowed to be silly for aiding the confidence in the portraits (left) taken just minutes after the silliness.

Shutter Speed: 125
F-Stop: f/9
ISO: 100
Camera: 35mm DSLR
Lens: 50–70mm
Light: Strobe/frontal

images 4.24–25 (right)

When using a wide angle lens to capture more information in the scene, remember that it will distort the edges of the frame. Placing the child in the center saves her from this distortion.

Shutter Speed: 400
F-Stop: f/4.5
ISO: 100
Camera: 35mm DSLR
Lens: 45mm tilt/shift
Light: Hazy, very diffused light

Teens are growing up in a much different world than we did. If we want to know about it we need to listen. Photography is instant gratification, and this is the language of youth. If they have grown up with the experience of photography, we've passed down a gift. The tradition of making photographs can teach patience, planning, sharing, and personal contact. After all, photographs can't be taken on the other side of a text message or in a chat room. Photography reinforces the experience of being together and sharing real-life encounters. Snapshots are our souvenirs of these experiences. When we hand over the control of the camera to our children, we are continuing a legacy of communication and collaboration. They are now continuing the documentation of their own life!

As our teens prepare for their life as an adult, one of our best gifts to them are their experiences of a shared life in images. These tangible photographs show that we cared enough to make images. It can show that our caring was sustained from infancy through the terrible twos, and on through their teen years. When our teens ask us, "What was I like back then?" they are looking for a foothold in an uncertain world. To be able to open a book and share

images that represent who they were (and in a large part who they still are), is a great gift, for us both. And perhaps fodder for deeper conversation.

The timeline of childhood is brief, yet our influence and impact therein is immense. Photographing childhood is not merely about creating the final image, it's an opportunity to create relationships and memories, and to be a part of this ever important one-time experience, the experience of childhood.

"It's unbelievable how time flies."

— Marcel Proust,
Swann's Way

BABY BROTHER: DAY ONE
LaNola Stone, 2008

BEFORE
NOSTALGIA

5

DOCUMENTING THEIR WORLD: NOSTALGIA-MAKING

A photograph allows for consideration in the meaning of quickly passing moments, which might otherwise vanish without any contemplation. In essence, photography offers us visual history and reflection. In pressing the shutter, we take the image before us and record the time-present, which instantly becomes time-past. The significance of this is immense. Photographs mentally take us back to precise moments in the past, and the detachment of the now and then can be both melancholy and satisfying. This engagement, that transcends time, is nostalgia.

APPROACH
The image and the memory

Nostalgia describes an inner longing for what has passed. It typically idealizes a memory, framing it with romantic notions. Much like a photograph, nostalgia can beautifully present an experience, yet doesn't tell the whole story. When confronted with facts, nostalgia can plague the possessor with doubts of its authenticity; "It seemed so once," we suppose, and although the emotion is deeply held, it is hard to explain or justify the potency of the feeling. Just as nostalgia seems to outlast the significance of the experience, it conversely preserves it, albeit in a different form.

"Strictly speaking," explains historian Christopher Lasch, "nostalgia does not entail the exercise of memory at all, since the past it idealizes stands outside time, frozen in unchanging perfection."

As a photographer of childhood and hobbyist researcher of nostalgia and time, I am fascinated by the interconnectivity of the three: childhood, photography, and nostalgia. In the above quote by Lasch, the word nostalgia could easily be replaced by either childhood, or photography, and the statement would maintain legitimacy. Whether considering a photographic document, or feeling nostalgic, we're reaching into the past. Similarly, by

the time we consider our childhood, we've generally left it in the past as well.

So, what is the purpose of any of these musings if they only represent time-past, something we can neither change nor alter?

Before time has become the past, it lives in the present; and before nostalgia and the photograph take form, the potential for their expression percolates. Nostalgia, photography, and childhood seem to make real what has passed away. In a sense they overcome space and time. In the words of Richard Bach, "Overcome space, and all we have left is Here. Overcome time, and all we have left is Now." And in the middle of Here and Now, is our ability to make a difference.

Before nostalgia is a place where time-past meets time-present and memories are made. It's the experience outside the document that becomes apart of the document.

Taken alone, time is very intimidating. Time is the constant within all things; irrespective of who we are, rich or poor, we are all subject to the same 24 hours in each day. Undaunted by circumstance, time is relentless and moves forward, yet people always seem to think that they can overcome time superficially through age-defying makeup, diet, surgery, and the like. Yet, the only way to truly overcome time is through our legacy. We

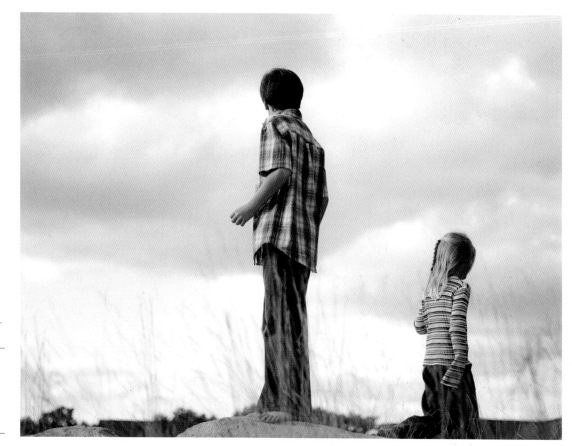

image 5.2
When you mimic childhood games, like "king of the mountain" with your camera angles it provides a childlike perspective. It's also good to experiment with camera angles that move the horizon-line within your frame.

Shutter Speed: 500
F-Stop: f/2.8
ISO: 100
Camera: 35mm DSLR
Lens: 70mm
Light: Cloud diffused sunlight

live on, our experiences live on, and our essence can live on through the contributions we leave behind. These contributions can be our interactions, stories, art, and, especially, our children. All these represent a renewal of who we are, just in a different form. It's our impact on a child's life that allows an exponential extension of our self and without our legacy in images, memories, or life, we merely become extinct.

I don't claim to be anything more than a photographer, captivated by the concepts of time's fleeting nature and its connection to memory, nostalgia, childhood, and the photograph. In these are lessons relevant for artist and nonartist alike. Yet, as a makers of images of childhood, our work impacts both the lives of our child models as well as the spectators of our work; and the ideas of *before nostalgia* can resonate in and through our act of taking a photograph.

For the artist, *before nostalgia* is the potential for expression. As we create, *before nostalgia* is a mindset for interaction, especially with children. And as we present our photographs for others to experience, *before nostalgia* is the untapped memories in the observers of our work. Today nearly all of us have the most powerful visual tool ever invented, the camera. There are as many ways to make a photograph, as there are photographers that take them. Because photography is collaboration between the photographer, the environment, and his or her subject, there are inherent unpredictable variables within every photograph. Herein lies the possibility of creative expression within the document of every image. How we respond to these variables, and what we have to show for them, is the lasting remnant of experience; the image and the memory.

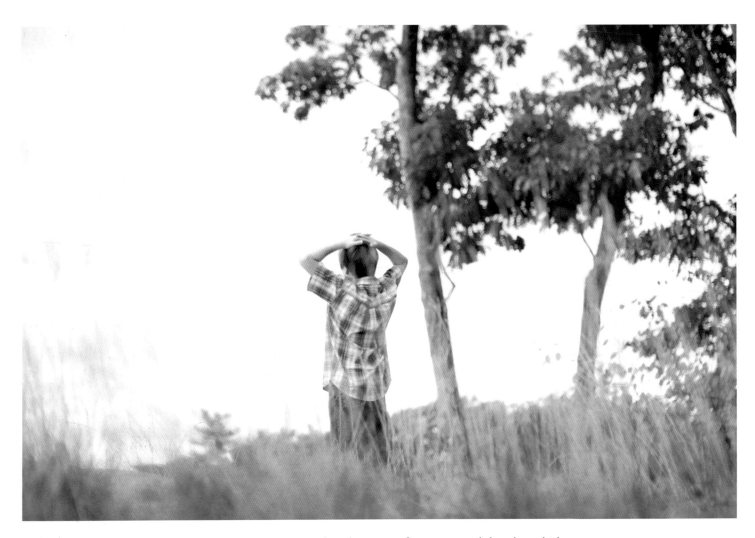

THE ARTIST AND NOSTALGIA
Incorporating our past in the image

The artist-photographer is compelled to release the shutter at an exact moment for any number of reasons. Perhaps the light feels right, or the forces of composition and/or design align, it may be the unfolding of a moment that resonates with us, or simply candid events we are compelled to document. Yet the draw to capture, which is most inherently tied to photographers themselves, is the essence of who we are responding to that particular moment with all its variables. The source of this internal pull is often the nostalgia living inside of us; that is to say, the culmination of experience and thoughts, which beg to be represented in our work. Painters layer pigment to create it, sculptors shape their medium to form it, and poets arrange words to express it, but artist-photographers, in the moment of capture, must abandon all contrivance and simply recognize, compose, and capture it in an instant!

All photography is an appropriation of an experience. Creating images as an artist is all about using available resources, including our experiences, perspectives, and access. We appropriate our life's experience to explore concepts, through images that we feel compelled to

make. Whether these images lie within the realm of the candid, portraiture, or full conceptual expression makes no difference.

Perhaps André Kertész said it best when he stated, "The camera is my tool. Through it I give reason to everything around me." This reason he speaks of is his perspective, his style, his determination of value. When we place anything in a frame, as photography intrinsically does, we are assigning value. The frame doesn't elicit value; rather it is through the choices of the artist-photographer in determining that frame that value is conveyed. The more we share ourselves, the more we tap into our own authenticity and truth, and the more valuable and unique our work will be. The more genuine our work, the more our perspective and style unfold within it.

When we photograph, we are both creating moments and capturing them. Since the mere act of taking a photograph implies significance to the moment captured, a photograph, like a philosophical statement, allows for prolonged consideration of that moment's significance. These are the moments when our philosophy and approach become a particular set of actions—when ideals intertwine with who we are making and who we wish to become.

image 5.3

Looking through plants, or framing your subject, both blends them within their environment and adds a sense of dimension to our two-dimensional photographs.

Shutter Speed: 200
F-Stop: f/3.2
ISO: 100
Camera: 35mm DSLR
Lens: 70mm
Light: Diffused sunlight

The artist-photographer is compelled to release the shutter at an exact moment for several reasons: the light feels right, the forces of composition or design align, or because there is something in the unfolding of that moment that resonates with us. When these combine, a successful image will always result.

As with their work, the artist-photographer is a work-in-progress and our choices significantly determine the final result, both in images and memories.

Before nostalgia is an approach to photography that both honors the moment, and considers the lasting outcome of that experience.

We don't have the power to change the past, and we can never accurately know what the future holds, but in the present is the wonderful opportunity to utilize the past and prepare for the future; both for ourselves, and the children we work with. Childhood might seem flippant, naive, and trite to some, but as photographers of childhood we have the opportunity to influence these perceptions. We show caring, not through placating or complacency, but through intent, purpose, and respect.

What's the secret to photographing children? Let them be children, whatever the intent of the photograph–authentic, ideal, or fantastic. To ensure successful images and memories, the photographer provides structure and known variables, which help children feel secure. At that point, we allow them to do what they do best, dance within the solid framework of the image.

NOSTALGIA AND THE CHILD
The memory of image-making

Experience is the precursor to nostalgia, and childhood is packed full of new and informative experiences. Childhood is creation; the creation of memories, experience, knowledge, skills, and the list goes on. It is like the axis of a turning wheel that remains in the same place, yet is the source of movement in our lives. In this, childhood is creativity in its purest sense. In children we create life, both through conception, and through nourishing that young life physically and emotionally. No matter our talents, education, background, or ability, we all have an influence when working with children, and within that influence is a powerful trust. To document childhood is to find its beauty in even the most mundane, because it is always there. Like physical appearance, childhood comes in various shapes, and sizes and it's what we do with its experiences that defines us, not just the experiences themselves. Adults often have a strict sense of what is beautiful, but within childhood beauty is plentiful; it shines in the optimism, fears, hope, and tenacity of youth.

When working with children we are writing our experiences together on a fresh slate. Children don't seem to see their time as significant, nor should they be bothered with this notion. As adults we realize the importance of our childhood experience in shaping who we have become. With this added insight comes an inherent responsibility. Children absorb and model their behavior

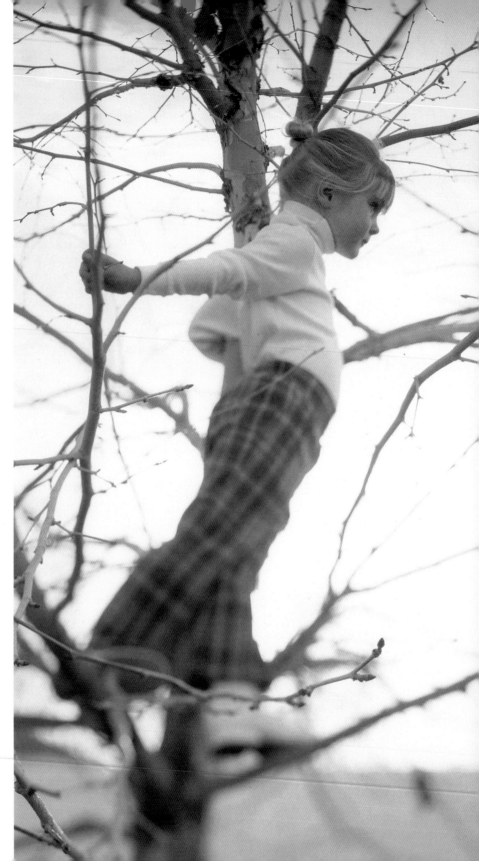

on what they've observed and learned. The experiences we share together are not just the passing of time, but also a formation of an individual's foundation and a chance to infuse our own.

Before nostalgia considers the "something magical about childhood." Our images, experiences, and memories should aim to benefit the children in our lives, as we regard our own contributions to this developing nostalgia in another.

I'm one of those people that have very early memories. I vividly remember my youngest childhood home before we left (when I was between the ages of three and four). I have these memories in spite of the fact that I do not have many pictures of that time. As each of us looks back into our lives we remember pivotal people and experiences, sources of momentum or stagnation to our developing life. Images are not necessary for remembrance, but they heighten it. As we consider our own experiences, we might seek to provide a positive and pivotal experience of our own when working with children.

When I photograph, I seek after the beauty and melancholy of my own childhood and infuse it with the child before my lens. In the series *Memories Abandoned* (p. 125), I explored the notion of "walking away." Utilizing what was available to me, I delved into my parents' storage (what we, their children, refer to as the "Garagemahal"), sorted through many boxes of my old clothes, and found artifacts from my past, all to help relay the stories that lived inside me. Through a great deal of production, my team and I worked to create a series of 24 photographs that are styled both conceptually and physically to feel as organic as the original memories and emotions that inspired the images. But for all our work, the images were not complete until my niece collaborated with the preparation. She was an essential part of the creation, not only because I needed a child model, but also because she added the spirit of herself into the images. After I shared my recollections of the space with her, I captured the moments that she created from the input of wardrobe, location, and make-believe. This is where the magic lies in collaboration with a child, and how memories and nostalgia are inherently served.

When considering nostalgia and the child, consider what's to be the child's memory of a shoot. K—, my

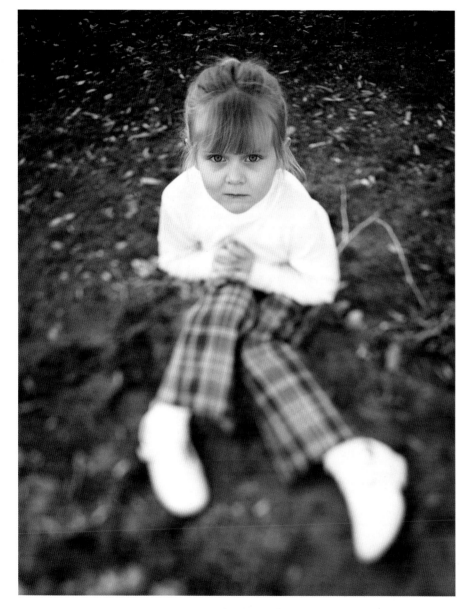

niece, often speaks of our time together, exploring a big empty house. The images we collaborated on together are a lasting icon to that experience. We can never fully know a child's background or thoughts, nor that of our viewer who will experience that image in their own way at a later time. Yet, the more positive energy we invest in both child and image, the more energy will live in that photograph. Including children in the process of image-making will not only serve the memory within the image, the photograph will own an added sense of authenticity. As much as we, the artists, desire to create, children inherently create.

THE VIEWER AND THE NOSTALGIC
The image's ability to transcend facts

Artist-photographers cannot, and should not, spend time making photographs to simply please their audience. By doing so an artist can easily become disengaged from the act of making their images as they disconnect from being fully present. There are many photographs that are made to exploit and manipulate its viewers; convincing them to believe a story, or buy into a product or idea. Photography, after all, does have the power to influence and shape perspectives, all the while implying an intrinsic honesty. And, although this is a tool available to the photographer, with its implementation, sincerity dies.

As artists free themselves from being puppeted by what they assume other want, their photographs can more fully harness the authenticity of capturing an experience. With honesty our images can facilitate an understanding; providing footholds to our past. Photographs, like other significant historical tokens, provide a breeding ground for a nostalgic experience. To the artist they provide a door of recollection to the original memory and as the work is displayed and shared, it is a door is also accessible to the viewers.

Nostalgic memories within childhood can take the viewer back to a previous perspective and serve as a place to regroup and rediscover the resilience and teachable qualities of those years. Childhood in art resonates almost universally because of those qualities. In the fullness of authenticity, childhood provides a visual space to which a multitude of viewers can attribute their own

These are perfect examples of the focus traveling through the image at an angle (because of a tilt of the lens plane) verses traveling parallel to the camera body, as it would otherwise do in manifesting depth of field.

image 5.4 (left)

Shutter Speed: 125
F-Stop: f/4
ISO: Fuji Provia 100f (film)
Camera: Large format; 4 x 5
Lens: 150mm
Light: Diffused sunlight

image 5.5 (above)

Shutter Speed: 60
F-Stop: f/4
ISO: Fuji Provia 100f (film)
Camera: Large format; 4 x 5
Lens: 150mm
Light: Diffused sunlight

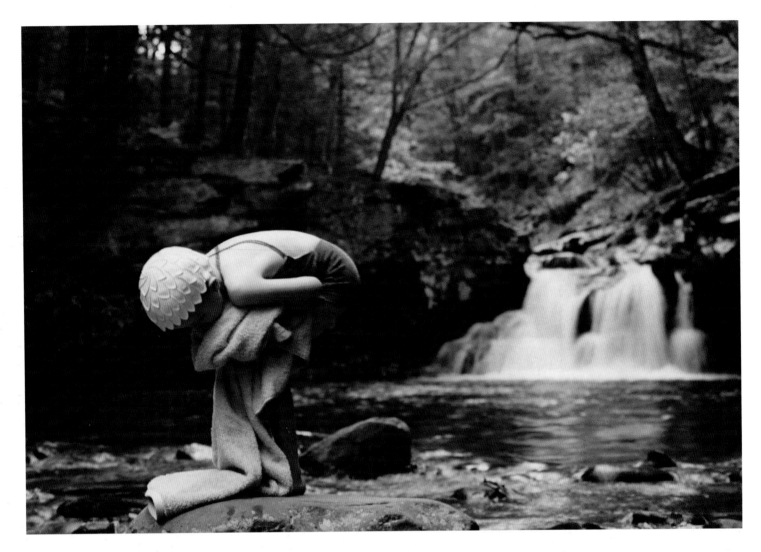

stories. In this way, art provides the portal and the viewer provides the context. One's personal interpretation of an image will say as much, or more, about themselves as it does the artwork itself. It's the convergence of one's own past memories with an image that stimulates nostalgic reminiscence. The image isn't nostalgic itself, it is simply the catalyst.

Our childhood, like the photographs, also stands outside of time, frozen and unchanging. Through childhood, the image, and the memory, our mortality is made evident.

Over time, gradual, and persistent change has occurred. We are forever connected to this path of evolution. Children remind us of our faith and optimism, the time before we became who we are. In a child's hopeful thinking we can find a viewpoint with which to empathize with others and be patient with ourselves. The potential and lasting impact of each photograph made lies in the in the connection of image and memory.

image 5.6

This is classic "rule of thirds." Vertically the waterfall and child lay on the thirds lines and horizontally the foreground and background.

Shutter Speed: 125
F-Stop: f/4.5
ISO: Kodak 160NC (film)
Camera: Medium format; 67
Lens: 100mm
Light: Mixed; strobe/filtered light

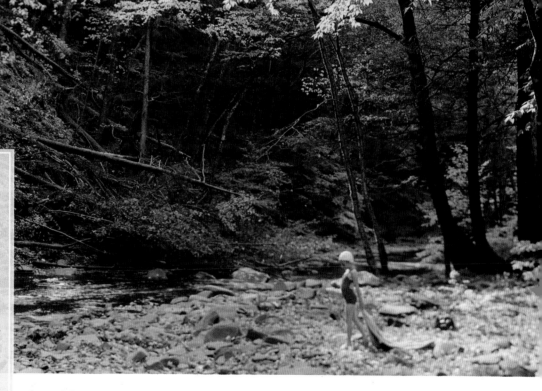

SWIMMING
by Clinton Scollard

When all the days are hot and long
And robin bird has ceased his song,
I go swimming every day
And have the finest kind of play.

I've learned to dive and I can float
As easily as does a boat;
I splash and plunge and laugh and shout
'Till Daddy tells me to come out.

It's much too soon; I'd like to cry
For I can see the ducks go by,
And Daddy Duck – how I love him –
He lets his children swim and swim!

I feel that I would be in luck
If I could only be a duck!

image 5.7

Like a tight select focus? Consider a tilt/shift lens or shooting with a camera that allows movement of the lens plane.

Shutter Speed: 60
F-Stop: f/4
ISO: Kodak 160NC (film)
Camera: Large format; 4 x 5 in.

Lens: 150mm
Lens Plane: 45 degrees
Light: Direct, dappled, and filtered, natural end of summer

image 5.8 (left)

Measuring Up is an editorial story created to fulfill an assignment to photograph my impressions of the amusement parks at Coney Island. My objective was to juxtapose the refinement of the mother's outfit with the simplicity of the child. Issues explored were based on the relationships observed while visiting the park; both mother and child trying to "measure up" to each others' expectations, both often coming up short.

Shutter Speed: 160
F-Stop: f/4.5
ISO: 100
Camera: 35mm DSLR
Lens: 45mm tilt/shift
Light: Low lightly diffused sunlight

image 5.9 (right)

Shutter Speed: 200
F-Stop: f/4.5
ISO: 100
Camera: 35mm DSLR
Lens: 45mm tilt/shift
Light: Diffused sunlight

MAKING OF
MEMORIES ABANDONED
A personal project addressing nostalgia

During the winter of 2008 I sought to intertwine time and memory more purposely into my next body of work. Immediately, questions of impermanence, the deterioration of memory and space, and the inevitability of change kneaded themselves into the process. I have always been visually attracted to abandoned structures and how a loosely enclosed space reacts to light filtered from the outside. It is within the subtle luminance of organically broken-down spaces that light reveals and questions arise.

Who lived here? Why did they leave? And, how was this place forgotten?

It was quite an experience photographing an organically broken-down space to which I intimately knew the answers. In a way, this allowed me to move beyond the obvious and explore the meaning of abandonment in general. Why it is we walk away from tangible things? Why is it that we sometimes even choose to walk away from memories? The answers are often not as evident as a passing spectator's first assumptions. The answers can be as deep and layered as the history of the deserted space. These are very personal images which draw from my own weathered memories of time spent in this home, and they are offered to the viewer as a doorway to their own seldom tapped memories of childhood, as well.

This series was a personal exploration of time's impact on a physical space. It likewise reflects my musings of time's effect on particular memories that resided in that

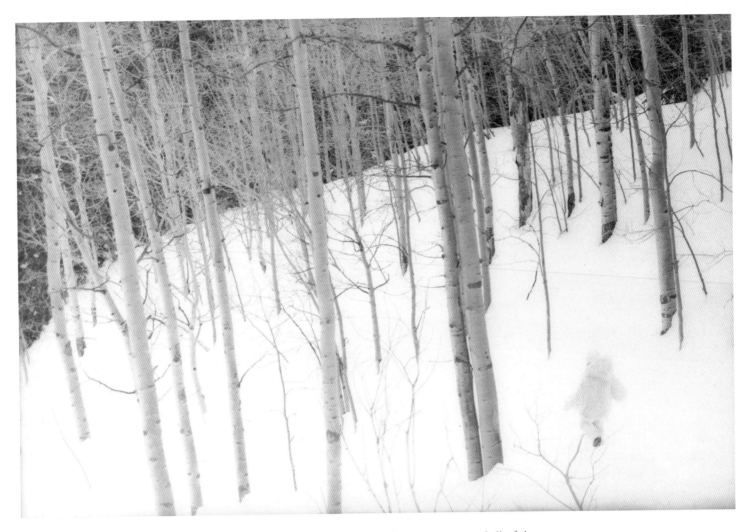

space, and the natural demolition that occurs in both memory and space. As the time between memories and experiences expand, recollection can erode, be forgotten or made obsolete through perspective. The clarity of experience is organically weathered and only certain elements, the primary structure of memory, remain intact. Memory is much like the structure of my childhood home, a standing framework swathed in remains of its former self. This location and the chosen wardrobe can't help but be nostalgic to me as I view them. The once cared for and occupied space of my childhood (which was full of life and a family of nine back then) is now a

cold, mildewed, and strangely empty shell of the past. Yet it stands firm, almost unyielding.

The child in the images represents the resilience each of us has to play in and out of our thoughts. No matter the turmoil that may surround us, we can move beyond and find something simple and pure. This is the enduring quality of resilience within each of us, asking us to be as a little child, to learn and move on.

Although this body of work includes experiences portrayed, spaces, and a wardrobe derived directly from a past that is uniquely mine, my hope was for a universal

Who lived here? Why did they leave? And, how was this place forgotten? It was quite an experience photographing an organically broken down space to which I intimately knew the answers. In a way, this allowed me to move beyond the obvious and explore the meaning of abandonment in general.

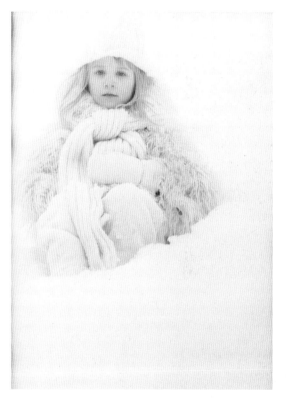

voice in the images. Childhood, in that we all have one (different though they may be), is a universal experience through which we are all connected and therein can communicate. By no mistake, the direct gaze of the child eludes us in these images and we're left to connect ourselves to the childhood, not the particular child within the frame. Similarly, the past rarely holds a straight gaze, rather memories are coy and hardly seem aware of the present. Like voyeurs, we provide the context.

It was interesting to stand back, as the unknown artist, and listen to viewers experience these images when they were first on exhibit. I listened, like a fly on the wall. The photographs were not accompanied by an artist statement or explanation of any kind. I am not particularly advocating this approach; rather it was simply fitting for the venue. Still, this lack of information left the viewer to suppose, for themselves, the context of the images, child, and space.

Considering the time past and time present, I am always overwhelmed by the universality of experience in its different forms. Photographically, I allowed myself to play and discover, to envision and conclude, and embrace the process of image-making on a purely self-gratifying level. The concept was investigated without heavy-handed client control, but rather for the pleasure of its development and journey.

The overriding conceptual objective was to create personal imagery that allowed me to explore thoughts of memory and time. I took everyday experiences I had as a child and created images around each of them. Experiences such as: sleepovers with my three sisters, "Family Home Evening" on Monday night's, getting ready for church each Sunday, and so forth. Yet, this series is more than simple anecdotes from my past. They seem to be common childhood tales, and this familiarity held the attention of various viewers with nostalgic warmth.

image 5.10 (left)

The color and treatment you give your images in Photoshop or traditional printing/processing can create a style and connect a whole series.

Shutter Speed: 500
F-Stop: f/5.6
ISO: Kodak 400NC (film)
Camera: 35mm SLR
Lens: 100mm
Light: Heavily diffused daylight

image 5.11 (right)

Shutter Speed: 2000
F-Stop: f/2.8
ISO: Kodak 400NC (film)
Camera: 35mm SLR
Lens: 200mm
Light: Heavily diffused daylight

The model in the images is my niece, K–. At six years old, K– is about the age I was when I first moved into this house. She excitedly played my role in the memories I shared with her. I told her she was the star of the show and she quickly corrected me and said, "Well, I am actually playing you so we are both the stars of the show!"

K– and I collaborated through discussion, not the way adults collaborate and discuss, but through playing and discovering in the space. We achieved an essence I could only hope would evolve. My role was to guide K–'s movements with questions and suggestions about the room. Questions like, "Tell me what you see," as

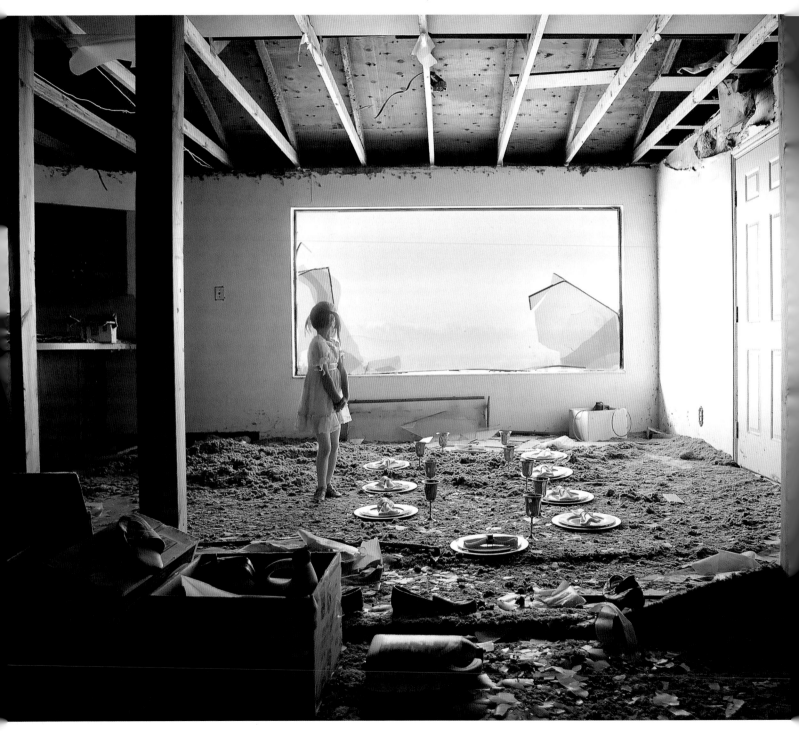

she looked into a broken television or, "Do you want to climb up there to see what's on top?" as is the case for Computer Room (p. 131). And that was my process; a question or suggestion and I left K– to explore. Heavy-handed direction is not my style. Rather, a great deal of time is spent before each shoot to assure that the styling, location, and concept are properly prepared. All this is done so the child can move about effortlessly within the scene as I photograph and collaborate with her. It's a blend of thorough production and being ready for the "decisive moments," which allow the consistent capture of childhood in a whimsical yet deliberate way. When introducing a child, or children, to a new setting (ready in their particular wardrobe), with a little suggestion, children instinctually begin to play and explore. This is precisely where the truest images of childhood lie. The child is released as a windup toy and we are simply there to capture the dance.

In these images the child is not reacting to the destruction but just getting to the tasks at hand. Resilience is taking things as they are, acknowledging our blessings and learning from the less then ideal. For me, it's appreciating parents who, as children of the Great Depression, hold onto and treasure possessions they worked so hard to obtain, even if it results in a Garagemahal. Resilience is sacrifice, giving up our pride and listening to the lessons that nature and experience seeks to teach us. Resilience is evident in a child's ability to move and exist beyond his or her surroundings and is a call to action. After all, a child's perspective can yield hope. And as we grow older, this perspective will serve us well. Hope and faith are the antithesis of, and the antidote for fear. Hope is inherent in childhood.

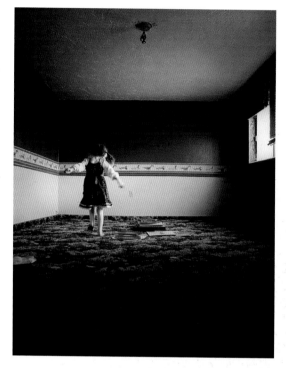

image 5.12 (left)

All of the following images in this chapter utilize mixed lighting setups. I like to take my cues from the natural light in a scene and then supplement it with strobes to enhance and fill without giving away that the scene is lit.

Shutter Speed: 40
F-Stop: f/2.8
ISO: 160
Camera: 35mm DSLR
Lens: 16mm
Light: Mixed; strobe/indirect light

image 5.13 (right)

Shutter Speed: 50
F-Stop: f/2.8
ISO: 100
Camera: 35mm DSLR
Lens: 24mm
Light: Mixed; strobe/indirect light

Time is impermanent; deterioration of memory and space will occur, and all we are left with are fragments. This needn't feel like a loss, rather there is an optimism and hope within the inevitability of change. Time and energy may be required, but organically, nature will renew itself. Perhaps this is why I find older, "broken down" spaces so beautiful. They are in the process of renewal.

Memories Abandoned accurately represents my thoughts on remembrance as I considered my own childhood home, spaces, wardrobe, and experiences. The hope is, however, that there may also be potential for a collective voice in the imagery as others view it and apply self-interpretation to the images.

We needn't live in our heads or in the past, rather, our past is there to be utilized as a springboard in the present as we move into our futures.

Heavy-handed direction is not my style. Rather, a great deal of time is spent before each shoot to assure that the styling, location, and concept are properly prepared. All this is done so the child can move about effortlessly within the scene as I photograph and collaborate with her. It's a blend of thorough production and being ready for the "decisive moments," which allow the consistent capture of childhood in a whimsical yet deliberate way.

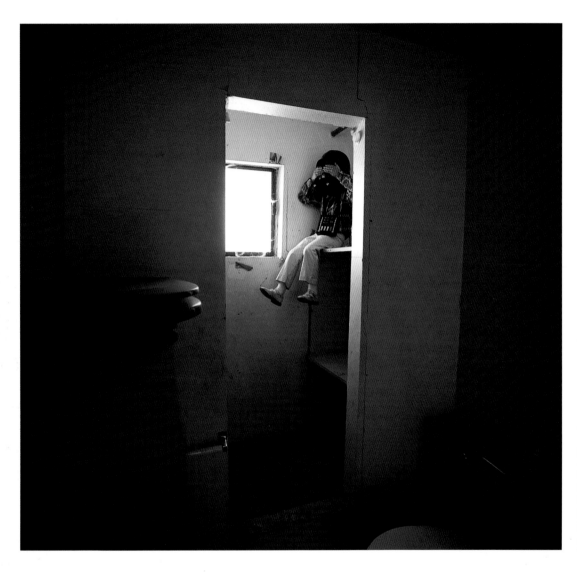

In the Nobel Prize winning words of T. S. Eliot:

"Time present and time past

Are both perhaps present in time future

And time future contained in time past..."

The constant within everything is time. Undaunted by circumstance, time is unyielding and moves forward. These thoughts were the catalyst for *Memories Aban-doned*. Visually, as I explore time's effect on a physical space, I am intrigued. Intellectually I am fascinated with the similarities in the deterioration of recollection, memory, and space and how they produce nostalgia (the love for a moment), which seems impervious to time. Ultimately, these musings leave me inspired for the future; a future of living in the present, therein bonding the past to possibilities.

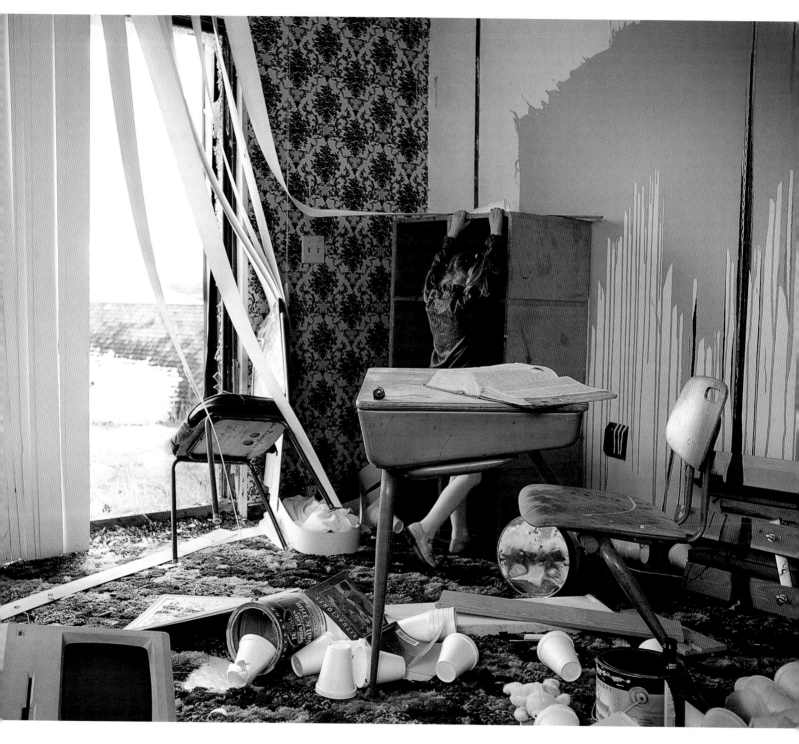

*"Fashions fade,
style is eternal"*

— Yves Saint Laurent

HIDE AND SEEK
LaNola Stone, 2002

ARTISTS & IMAGES TO INSPIRE & INFORM

6

TEN CONTEMPORARY PHOTOGRAPHERS

As we collect, create, and examine contemporary image-making, we become our own curators as we connect to some works and dismiss others. Our sensibilities are inevitably refined as we survey various contexts of photography–documentary, fine art, photojournalism, editorial, commercial, and/or personal work. As we examine this work closely and become more personally acquainted with the ambiguity inherent in all photographs, we might ask, "What is real and what is artifice?" The simple answer is that all photography is both real and packaged, yet what feels real to us is our personal connection to that art. Exposure to these images inevitability influenced who we are and the work we create.

CONTEMPORARY ART AND STYLE
Conversations with artist-photographers

One of my favorite things about writing this book was having an excuse to pick up the phone and talk to other photographers whose work I deeply admire. My hope is that it will provide you, the reader, with the kind of exposure to their art and insight that will lead to a broadening of your world, just as it has for me. After querying many of these artists about their work, processes, and insights into photographing childhood, I've pared those conversations into bite-sized morsels that I hope you will find delicious and manageable.

As previously discussed, producing photography is one of the easiest yet most complicated undertakings in art. Understanding photographic works can be described the same way. Photography seems very approachable and self-explanatory. It's a picture of this or that at a certain time; what more can it be? Photographs are omnipresent, and this saturation often leads to a lack of appreciation for the photographic image. Yet, memorable images still seem always to rise above the many, like cream from milk.

Contemporary art is full of memorable images. They are made by journalists, educators, commercial artists, gallery artists, and perhaps, even us. Contemporary art is defined as art that is produced at this present time, by our contemporaries. The Museum of Modern Art in New York describes it as art that "originated in the exploration of the ideals and interests generated in the new artistic traditions that began in the late nineteenth century and continue today." I love this definition because it espouses the making of whole art; art that embodies exploration, tradition, and personal ideals.

Style, as we've also previously discussed, develops naturally in an artist. It identifies the work of a particular artist and distinguishes it from all the other work out there. Style can be found in the color palette or process of an image, it can be evident in the subject matter and issues addressed, but most potently it is the confluence of art and medium with the person, the artist. In this way, style is as unique as the artist expressing it. There are some that are uncomfortable with the comingling of art and photography, as if to suggest that they should be addressed separately, or that one might have merit over the other. This is a question as old as the medium itself. Art is not contrivance that mimics what's come before. It's an expression of our response to the world around us.

Photography can be art, make no mistake. The photographers in this chapter are unified in their commitment to personal expression and artistry. Their camera work shares their personal insights, generously contributing their perspective to the world in which they live.

Not all these photographers focus on children exclusively, but the representation of childhood in their images has brought acclaim to each. As we, too, explore the offerings of childhood with our own lens, let's learn and gain insight from these established photographers. They are diverse in locality, nationality, and audience, but they all transcend these boundaries rather then being defined by them.

A dialogue of established and experimental, past and present, and the input of people we trust, will surely enable our own development in, and appreciation for, the contemporary art of photography.

VIEWING QUALITY WORK
Taking it all in

It's natural to want to find a formula for successful images, and there is one. The formula lives within each of us. In fact, it is the best way to inform our personal technique! We must survey the world around us and what has been done, then seek to understand our personal connection to that work. Why do we feel connected? When viewing photographs ask yourself why you do, or do not, like it and if others like it, and why? Asking questions and spending a lot of time looking can help fine-tune the most important tool in our own work: Us!

As in Chapter 2, the photographs presented here are an appetizer, not a main course. Think about this section as a tasters menu of fine cuisine. When we taste, we go beyond the appearance and initial smells of a plated dish, we invite the food inside ourselves and commit to internally process what we've consumed. Good photography, like any good meal, attracts us on one level and holds us on another. When we take a third step and really spend time with the work, only then can we truly incorporate it into who we are becoming.

Not all photography has this power. Some is merely cute and nourishes like fast food. It provides some substance, but doesn't really support us in the long run. Still other

work is a bit on the spicy side and catches us with a jolt, but too much of it can give us heartburn. Actually, what qualifies as "too much" is subjective, and something we ultimately determine ourselves. Only as we search and taste will we truly find the substance, and the images that will actually quench our inner hunger for good work. At first we might have one impression of an art work, yet as we increase our understanding of the work, a comprehension of the broader art world opens to us.

The process of viewing fine art can be likened to tasting fine wine. We pour a small amount into a glass, look at its characteristics (its color, clarity, and saturation) then swirl it. For art this means that we let our questions flow and allow the aroma of the art to unfold. What do you "smell?" Describe the bouquet to yourself, then taste it, don't devour it! As we allow the art in, what is the flavor? Is it sweet, sour, salty, bitter, or savory and why do we feel this way? Is our reaction different than our first reaction to the piece? Then, as we set down our metaphorical glass and pick up another, or rather turn the page or walk to the next piece of art at an exhibit, what impressions linger from our last experience? How do

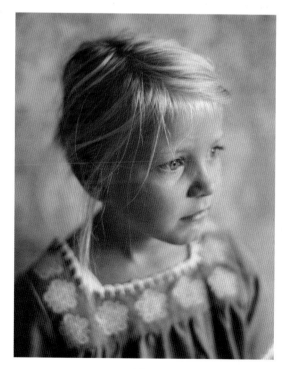

Anders Hald
PETIT BY SOFIE SCHNOOR–SS10

August 2009
Digital capture and delivery
11 x 14 in.

we define the aftertaste of the art? Often it is helpful to write down our thoughts and impressions as we develop our understanding of art. If we truly crave acquaintance with our inner thoughts, write them down. This creative journal can nurture our own creations as we broaden our insight, and honor our internal impressions. If we feel that all photography is not created equal then we, as artist-photographers, must ask ourselves why.

When I was very young, I used to think that if I were to spend too much time looking at the work of other photographers I would instinctually start to make work like someone else, not like me. I couldn't imagine any other outcome. In my pompous striving for individuality I thought I could leave it to myself to reinvent the wheel, my way. But if the end point is a wheel, why not start where someone else ended? Why not collaborate with history by simply knowing it? Obviously, this was a fear and misconception I had to overcome. We are the creators of our images and "who we are" will inevitably come across by our motivation to click the shutter, not because that is the way someone else shot it. Don't ever miss an opportunity to view quality work of the past and present, work that inspires, work that feeds ideas, and work that motivates us to reach further within our own work.

The great thing about contemporary artwork is that it is still being made and spoken about by the actual artist. This is a huge advantage. The photographs on the following pages are pared down, to be sure. It was an extremely difficult task, considering the bodies of work by these artists, but I've only featured one image for each photographer. There is a power in focusing our attention on one image, spending time and truly seeing it. It has been said that the average museum-goer spends around 1.5 seconds per canvas. The time is usually shorter for photographs simply because we are so inundated by photography that we don't really spend time looking at individual pieces. It's just too ubiquitous in our world. I've featured ten contemporary photographers and ten images for you to consider as well as a few supplementary images, which can help the understanding of the overall work or intent of the artist. All have text for thought. As you read each of the blurbs and spend time with each photographer, ask yourself questions that will help you personally identify with that piece:

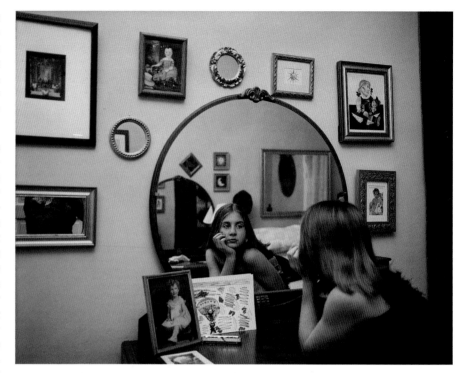

Where is it?

Why was it taken?

When was it taken?

Who is the child or children in the image?

What can I personally take away from the opportunity I've just had in viewing this image for more than 1.5 seconds?

Melissa Ann Pinney
AT THE MIRROR, EVENSTON, IL

2006
Color c-print
20 x 24 in.

The short article adjacent to the images will help you answer some, but not all, of the questions. Hopefully your curiosity will inspire further investigation into the work and artists. I keep a small "thought book," or creative journal, wherein I write what inspires me and why. I love to have it with me often, even in my purse at an exhibit or show. When I am struck with an idea, I write it down. When I read a good book or look at great images I write the reference down. If I am fortunate enough to attend a lecture or workshop with an artist I admire, I write a lot down. So, buy a blank book (I prefer the kinds without lines), and start being inspired. If you haven't already, write in the margins of this book (that is, if you own

it); a book is only as precious as its usefulness. Writing down personal insight maintains ownership of thoughts that otherwise might pass, and may never be seen again. Owning our thoughts is a vital part of the creative process! I am always inspired when I think of the instinctual creative process of a six-year-old boy who did just what I've described. Because of his passion for documenting and acknowledging thought, young Jacques Henri Lartigue (p. 58) is a perfect example of the power of seeking to understand one's own creative process. He constantly acknowledged his thoughts and impressions with both his cumbersome camera and a pencil and paper. There is no better way to get to know our individual creative process than to keep and reference our own creative meanderings.

THE ARTIST'S CONTRIBUTION
The individually of each artist

Individuality is the best quality one can possess, but only if it is real, not manufactured. When Emmet Gowin (p. 140) began shooting he was shown the catalogue (a book published of an exhibit) for the 1955 landmark exhibition *The Family of Man* held at the Museum of Modern Art in New York. This exhibit was ground-breaking in many ways: it was the first major art show at a renowned museum that solely featured photography, it was curated by Edward Steichen (legendary photographer and the director of photography at the time, p. 54) and it was a group show that represented 273 photographers from 68 countries. Steichen's goal was to showcase our

Writing down personal insight maintains ownership of thoughts that otherwise might pass, and may never be seen again. Owning our thoughts is a vital part of the creative process!

shared humanity through images. He felt that only photography could truly show the universality of the human existence.

Gowin flipped through this catalogue quickly. He felt it was given to him to induce humility and to put him in his place, but he doesn't remember being particularly moved by the catalogue. Sure, the exhibit was ground-breaking, but within the catalogue the pages were crowded with images. With nothing really featured, they all begin to blend together. When Gowin reached the end of the catalogue he was struck by the realization that an image in the last few pages reminded him strongly of an image at the beginning of the book. He flipped back to that other image to see why the two seemed to connect. What were their similarities, and how was it that out of 503 images from 273 photographers from 68 countries, these two seemed, not really to mimic each other, but to belong together (at least to him)? He discovered the connection was not the content of the images, which varied greatly, but the emotion he felt from them. The tangible link was that both the images were made by the young Robert Frank, now a renowned and celebrated photographer.

This was a turning point for Gowin. He realized that it wasn't only a subject that connects images, but also the intangible essence of the photographer who took the image. It wasn't something he could describe or index, but he couldn't deny that he felt it; and this information was just as valid as the subject matter in the image itself. Gowin recognized that Frank had the gift of emotionally placing himself in each of his images, and he allowed that gift to influence his own work as an artist, rather than merely mimicking the composition, lighting, or subject matter Frank chose to photograph. This is the Great Intangible, the "it" factor, and it derives from authenticity. In his own words, Gowin explains:

"I had intuitively understood the feeling of the picture, which was much better than understanding who took it, an intellectual thing. So, I, right then, felt that this person carries that feeling with them wherever they go. And I must have some of that feeling in me, because I got it the first time. I knew that that would be a basis for me. I couldn't have told this then; I'm telling you this 30 years later. I knew intuitively right then and there that that's how you know. If you can feel that two things are made by the same personality, then you can recognize when something matches your personality. It is yours, and it doesn't have to be yours."

I love this story for many reasons, mainly because he placed a sense of tangible ownership on feelings. In a world that can be very critical of the intangible, Gowin describes the power of what we can only know inside, if

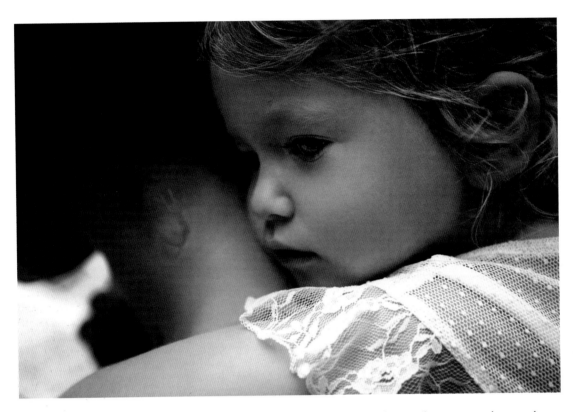

Achim Lippoth
A NIGHT LIKE THIS

2007
Digital c-print
100 x 66.6 cm/39.4 x 26.2 in.
Fahey/Klein Gallery, L.A.

we allow ourselves to see with more than our eyes. The great thing is that this knowledge, born from inside you, is very hard to duplicate. It's often hard to repeat in even ourselves.

Another great quote from Gowin, 20 years earlier:

"There is something really important at stake here. If things happen to our advantage, if we find ourselves in a situation that we really love, and cherish and it nourishes us… *it would be a mistake to* hope that you would find that situation the rest of your life in that form, in that way. If something good happened, it happened in that peculiar way and it belonged to a particular time. Don't make the mistake of wanting that same thing to happen again because you won't find that thing again. Everything belongs to its season, to its place."

This is where uniqueness emerges, from owning who you are, at a particular time, in a particular place, and making work that is meaningful and relevant to who you are. The better we get at this, the more successful we will be in speaking with our viewer, heart to heart, present with the image or not. Artifice just won't get us there. I believe that we were each given our gifts and insight for a reason, and it seems precisely the reason we are compelled to create art. Capturing images that speak to us allows us the possibility of sharing that fulfilling essence with another. It is different than decorative images, which simply match with our décor. Art digs deeper, and photographic art adds an additional level of documentation. We assign importance to what others may have passed over as mundane, by simply assigning a frame to it. Photography is captured in an instant, whether 30 seconds or 1/300th of a second. Who we are at that instant is recorded, just as is our subject on the other side of the lens. Herein lies the powerful gift of the photograph. Whatever went into that moment, is recorded and singled out from all the moments on either side of it. The ability to know when moments speak, and hear their plea to be captured, is irrevocably linked to the individual artist-photographer. This is his or her gift in the final image. It is the gift of self.

Robin Schwartz
MIKEY WATCHES CARTWHEEL

2009
Digital chromogenic print
20 x 24 in.
image courtesy of M+B Gallery, L.A.

A VARYING APPROACH WITH...
each child, photographer, and situation

Just as every photographer is unique, so is every situation and every child. In Chapter 4 we reviewed cues and signals that are generally systematic for children. The data has been observed and studied time and time again to help us know what is "normal," but as a true observer of the world we know that "normal" is elusive. Even within "normal" there are variations.

The wonderful thing about art is that it celebrates the outliers. Childhood, in and of itself, is a beautiful outlier. Society isn't built around children. Politicians don't speak to them. They exist primarily in a world that is built for what they will be—adults—and not for who they are. It is no wonder that childhood is so fascinating to observe; it's incredibly familiar yet wholly foreign.

The following gallery is full of diversity in approach, style, intent, and insight. There are photographers who work commercially and others who are artists in the strictest sense of the word. Included are men and women, those that have photographed for decades and others for years, but all are, in a sense, educators, whether formally or not. They follow their inner pull to create and then they share their work with the world. In the context of this book, childhood is their shared link. Other connections may also exist but they are more elusive, and have as many variations as these artists have intent.

It is with pleasure that I introduce you to the work of these artists. Some may be familiar, others not so. As you are inclined to explore the work further, a website is provided for the commencement of that exploration.

In addition to web searches, visit your local museums, and make those farther away part of your vacations. If there is one thing that is spectacular about living in New York City, it is having the privilege of knowing many talented photographers and artists of every genre, and gallery openings and museums aplenty. Yet, as privileged as New York is, it houses only a fraction of the amazing talent out there. There is a whole wide world of remarkable artists. If you are unable to travel, virtually visit museums and be inspired by all types of art, photographic or not. The Google Art Project allows viewers to examine the works up close or to just virtually stroll the world's museums. Of course, it is not the same as seeing the art in person but it's a great resource. And don't forget to explore the work in your own community and contribute to it! Explore art with the same childlike enthusiasm we seek to capture in our images.

Within each of us is an open-ended series of arguments and counter-arguments to be explored. As we take time from our busy days to validate our creative pull, our openness and willingness to evolve and change will yield results in our development as photographers. Our work may represent a range of purposes, from documentation to conceptual imagery, but as we seek to inform our work, all art can be made authentic to ourselves.

> The wonderful thing about art is that it celebrates the outliers. Childhood, in and of itself, is a beautiful outlier.

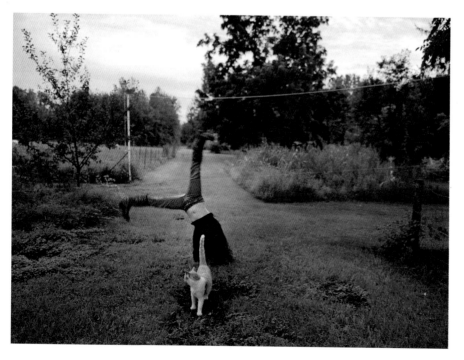

EMMET GOWIN *American, b. 1941*

AUTHENTICITY

Emmet Gowin is one of the most respected Artist-Photographers and art educators of our time. His work is consistently sincere and his unwavering aptitude is tangible as we view his photographs. They are raw, yet skillful and honest. They invite us into his world, his images.

Emmet Gowin has an impressive résumé. He has the soul of an articulate, conviction-driven minister's son tempered by a gentle Quaker mother, a heart born of small-town living, and eyes that truly see things as they are in the present and recognize the significance therein. Gowin's childlike curiosity about the world, shaped by an education at one of the most prestigious art schools in the United States—The Rhode Island School of Design under the tutelage of Harry Callahan—combine seamlessly in his images. Perhaps his most poignant gift is the pure love of family that he holds and shares. All of these qualities simmer within him and have created a sensitivity to potential images and the drive to create and capture them.

For 43 years Gowin has been a formal educator, mainly at Princeton. This experience has allowed him to both inspire and be inspired while facilitating the artistic growth of his young students. His approach to teaching is as authentic as his work: asking questions, hoping to help his often overly academic students find their artistic selves.

The image to the right is Gowin's niece Nancy. She had come to him as he was under his dark cloth, intent on composing a very different photograph than this one. Nancy wanted to tell Uncle Emmet about the two eggs she had found in the barn. When Gowin appeared from under the dark cloth, she spontaneously presented the eggs to him with this gesture. Gowin explains, "Until this moment she was just standing there in an ordinary stance. But as soon as she had my attention she embellished what she was telling me by crossing her arms and making a wonderful presentation of two eggs."

"Like all real discoveries, it was the wisdom of her own body that taught her to make that gesture. Something she could not have explained to herself, no more than I could have explained to myself why it seemed so appropriate when she did that." The lesson of this image is to be receptive to the gifts of the world around us. When children share themselves with us or let us into their fantastical world, pay attention.

Gowin's advice to his students is priceless wisdom for all artists. "As artists, the more we think about our audience and what we are trying to present, the less, perhaps, we are in touch with the physicality of experience, the particulars, the minute details of our experience."

Emmet Gowin Photographs was rereleased in 2009, allowing the past generation another look and present generations the privilege of first exposure!

More images at: **paceMacGill.com**

"It might take us a lifetime to find out what it is we need to say."

— Emmet Gowin

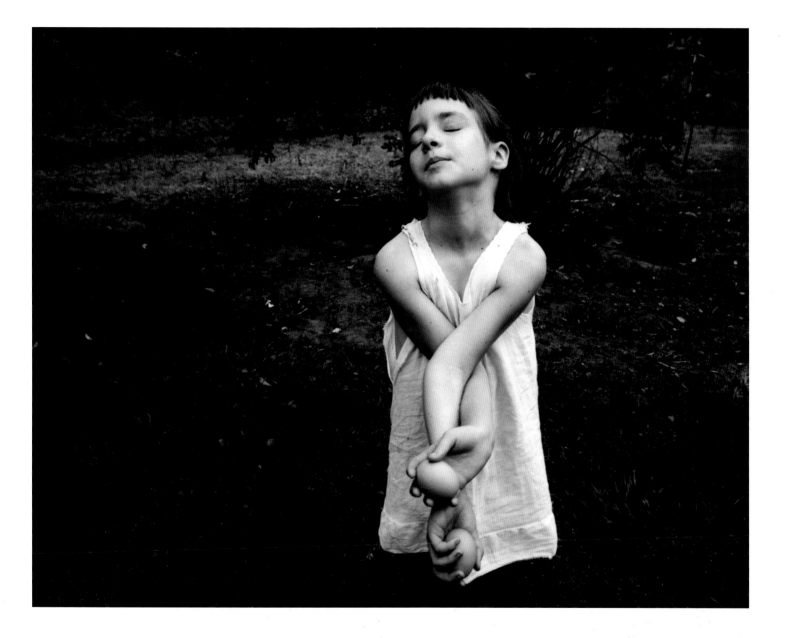

NANCY, DANVILLE, VIRGINIA, 1969
Copyright Emmet and Edith Gowin

Gelatin silver print
5.5 x 7 in.
Courtesy of Pace/MacGill Gallery, New York

SEBASTIÃO SALGADO *Brazilian, b. 1944*

THE SOCIAL DOCUMENT

Although formally trained and employed as an economist, today Sebastião Salgado is one of the world's most respected photojournalists. Because of his consistent activism through photography, since leaving his economic career in 1973, he has been appointed as a UNICEF Special Representative, been awarded many honorary doctorates, and won a numerous international awards for his images.

The documentary images of Sebastião Salgado are not simple depictions of sad children in horrible conditions, although many times this is part of the story of his subjects. He'll consistently move beyond simply presenting shocking images of the world's dispossessed and captures individual stories, the true narrative of our planet and its people. Salgado's work consistently captures the spirit, warmth, and humanity of his subjects, both young and old. The faces that look out from his work do so with a dignity that both lays personal claim to the environment that surrounds them and simultaneously declares it to be a part of the world we all share and are responsible for.

Salgado's photographs are a testament to the inalienable rights of all humanity (especially children)–that despite circumstances, they oughtn't be victimized. As viewers we can't help but be touched by the humanity that shines through his subjects' eyes. No matter what disparities may exist between their lives and ours, our humanist response can only see them as our equals and asks that we seek to find the oneness in our stories. Although neither he nor we can ever fully identify with the plight of each refugee and his or her everyday life in a war-torn country, his impassioned, time-invested work is evidence of his empathy and care. Salgado's photographs seek to elicit those same emotions from us, the viewers. There is a call to action in the awareness his work evokes.

Beautifully crafted and composed, his photographs contain a mystery, something that we feel pulled toward, yet have not had the opportunity to know until that point of encounter. They leave the viewer wanting to know more, and that is exactly the intent. "I believe that the average person can help a lot," says Salgado, "not [only] by giving material goods, but by participating, by being part of the discussion, by being truly concerned about what is going on in the world."

In 2012, Salgado will begin to exhibit *Genesis*, his most recent long-term personal project. He has sought out places that are still as pristine as they were in primeval times, places that provide hope for our future. With this project, he continues to dedicate himself to work that seeks to provide understanding of the present conditions of humanity and our environment.

More images at: **amazonasImages.com**

"When you spend more time on a project, you learn to understand your subjects. There comes a time when it is not you who is taking the pictures. Something special happens between the photographer and the people he is photographing. He realizes that they are giving the pictures to him."

— Sebastião Salgado

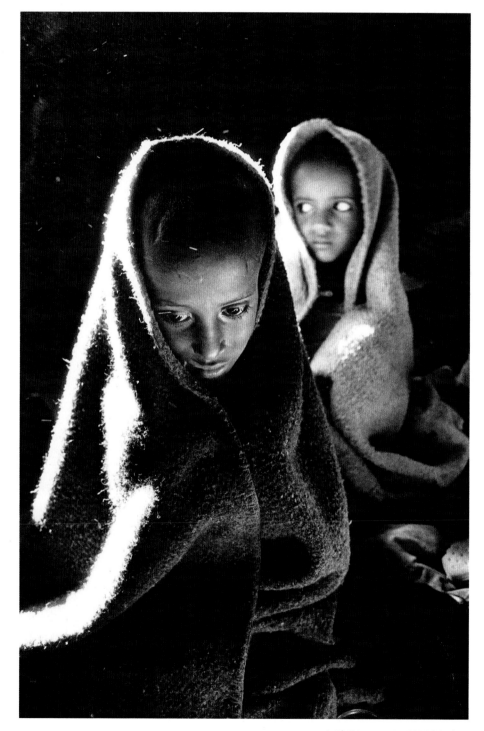

**KOREM CAMP FEEDING CENTER.
SECTION FOR ORPHANS.
ETHIOPIA**
Sebastião Salgado

1984
© Sebastiao Salgado/Amazonas/
(Contact Press Images)

JOYCE TENNESON *American, b. 1945*

A PORTRAIT OF SELF

There is a bit of Joyce Tenneson in each of her images. Tenneson's first book, *Insights*, was literally an exploration of self through exterior views. The images allowed a level of introspection that merely turning the camera outward does not directly produce. Subsequently, her work grew with a desire to "show emotional equivalents, to distill emotions and feelings, to somehow bring that sense of who I was on a deeper level than just the surface."

Tenneson's portraits of *Light Warriors*, *Wise Women*, *Amazing Men* and her whole collection in *A Life in Photography* reflect her, the artist, as much as her sitters. She always allows the time to connect to her subjects and their deeper selves. The images would not be possible without this rapport. This was especially true as she photographed her son.

Tenneson and her son have a special bond. He was present for much of her development as an artist. The image to the right is true to the style of Tenneson's work. She has pared down the subjects (her and her son) to what is essential by eliminating hairstyles, clothing fads, and the suggestion of location. What is left is an immediate connection to their eyes, and the stories therein. The juxtaposition of this image with the one to the left (which differs by little else than the passage of 25 years) offers an increased potency to both portraits.

They are holistic self-portraits with which others can identify. They become a sort of universal self-portrait in that we all are subject to the variable between the two images, the passage of time.

True portraits hold one's interest long after the first viewing. Since Tenneson's portraits are without distractions, they allow the viewer to connect with new and personal meanings of their own. With her viewers, as well as her sitters, she doesn't ask for anything. She's just interacting. This is at the heart of Joyce Tenneson's work, and ultimately reflects the true artist as she is.

More images at: **JoyceTenneson.com**

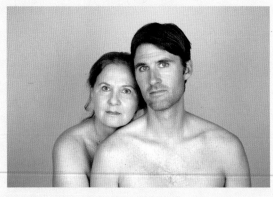

"People say that a lot of my models look like me. I don't see it. Other people see it more strongly. I guess it's that connection [we have]."

— Joyce Tenneson

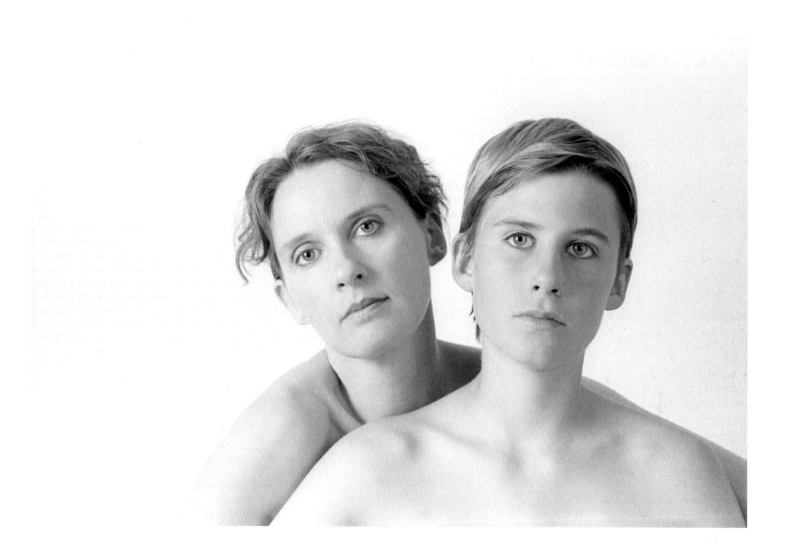

SELF PORTRAIT WITH ALEX, 1982
Joyce Tenneson

Silver gelatin print
11 x 14 in.

SELF PORTRAIT WITH ALEX, 2007
Joyce Tenneson (image left)

Archival pigment print
16 x 20 in.
Courtesy of Joyce Tenneson

MELISSA ANN PINNEY *American, b. 1953*

ADOLESCENCE

The dynamics between photographer and child will inevitably change as time envelops children in adolescence. The once sure and unhindered attitudes of their youth become uneasy and highly self-conscious. Teenagers are increasingly aware of the expansiveness of the outside world and, simultaneously, left to grapple with the changes occurring inside of themselves. Unsure of their own power but unwilling to expose their weakness, adolescent uneasiness is often exhibited as a dismissal of those once closest to them. This indifference can cause many photographers of childhood to retreat; after all, the teenage resistance to focused observation can be palpable. Yet, because this time is such a critical bridge to adulthood, it holds invaluable insights into the development of their identities and emerging stories. Mellissa Ann Pinney captures this narrative beautifully in the photographs of her most recent book, *Girl Ascending*. This series of work is an extension of her decades-long work, addressing feminine identity.

"Right now, I am less interested in young children and more intrigued with teens, who are self-conscious about everything," Pinney explains. "This is a challenge. It's much harder to be the unobserved observer, the fly on the wall."

Pinney, in her youth, had many of the same experiences that we see in her photographs: ballroom dance class, a love of beach life and water, and the intimacy of sharing of "girl's world," with her sisters. She uses her artistic, photographic, and physical experiences to navigate the unpredictable world of adolescence. Teens offer a sort of push and pull. They can give strong resistance, yet long to feel close. This dichotomy is highly photographic, but can only be captured on the adolescent's own terms. Meeting them on their turf can offer them the security they need to be themselves.

"Planning a shoot for me means looking for an interesting event, such as a party, or a place, like the pool or beach." Within these situations, Pinney observes and locates the moments that tell both the story of the girl and the tale of the experience. Her images can be both observed casually and investigated because, like an adolescent, their story exists one way on the surface, and another at great depth of insight for the ardent observer.

Melissa Ann Pinney has received a Guggenheim fellowship, among other awards and accolades. Her photographs have been widely exhibited and are part of numerous public and private collections. Her most recent book, *Girl Ascending*, addresses the phase of adolescence in a girl's life and is a continuance of themes explored in her earlier monograph, *Regarding Emma: Photographs of American Woman and Girls*.

More images at: **MelissaAnnPinney.com**

"These are the subtle, almost invisible moments in which everything changes."

— Ann Patchett
Regarding Emma: Photographs of American Woman and Girls,
Melissa Ann Pinney, 2003

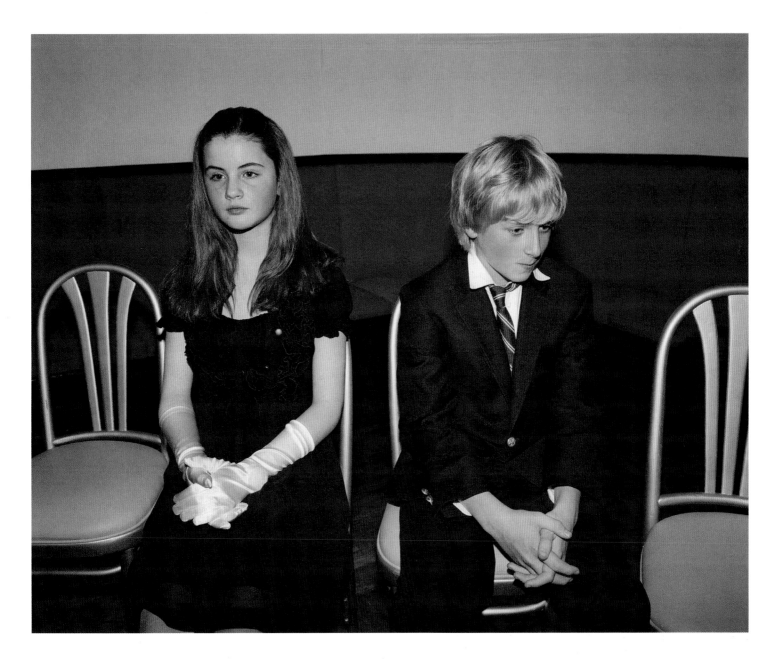

**TEEN COUPLE, BALLROOM DANCE
SERIES, CHICAGO, ILLINOIS, 2008**
Melissa Ann Pinney

Chromogenic print
20 x 24 in.

ROBIN SCHWARTZ *American, b. 1957*

LEGACY

Robin Schwartz's fantastical photography series, *Amelia's World*, was not achieved through pretence or Photoshop manipulation. These are simply portraits of Amelia's adventures, from the heart of her mother. The images capture Amelia and her natural relationships with animals, and are a tribute to the relationship with her mother, as well. To Schwartz, Amelia is more than a muse; she is her legacy in life and photography.

"My mother's death made me see motherhood and being a daughter differently," explains Schwartz. Her father died when she was nineteen and her mother-in-law just six weeks prior to the death of her own mother in 2004. This prompted a resurging dedication to make Amelia her life's focus beyond the necessary time spent earning a living. Schwartz explains unapologetically that "being with my daughter is where I want to spend my time."

It happened almost by accident, then, the images of child and animals. Three-year-old Amelia accompanied her mother on a project to photograph primate portraits of a lemur and chimpanzee. Amelia was drawn to the scene and didn't have fear or hesitation toward the animals; rather, a spontaneous understanding seemed to exist between them. Although it was not the photograph she'd come to make, Robin Schwartz captured this relationship with her camera. This birthed a new series which would span eight years, and counting.

Robin is often asked how long she'll continue the project; after all, Amelia is now twelve years old. Schwartz feels that when Amelia is done, the project will also be done. Yet, instead of winding-down, it has continued as a collaboration between mother and daughter. Today Amelia contributes concepts and goals for many shoots. Since Amelia wants to meet more primates, that's exactly what they've done!

Schwartz creates photographs to hold on to those she loves. She also realizes the gift she's providing for those she will one day leave behind. Robin Schwartz has found comfort in her images when faced with the relentless passing of time. Over the years, a "tween" daughter has replaced the three-year-old from her earlier work. However, in photography she can both hold on to the past and embrace the present. This is the gift and legacy of a photograph. The photographer becomes both a witness and historian, wholly involved in life as it transpires.

To Robin Schwartz neither the animals nor Amelia function as props. Their *relationships* are the substance of the photographs. These photographic moments are, for the Schwartz family, experiences that will always testify to the special world and bond of Amelia and her mother, Robin Schwartz.

More images at: **RobinSchwartz.net**

"I have only accomplished these photographs of Amelia because Amelia has been and continues to be an active participant and partner in this project."

— Robin Schwartz

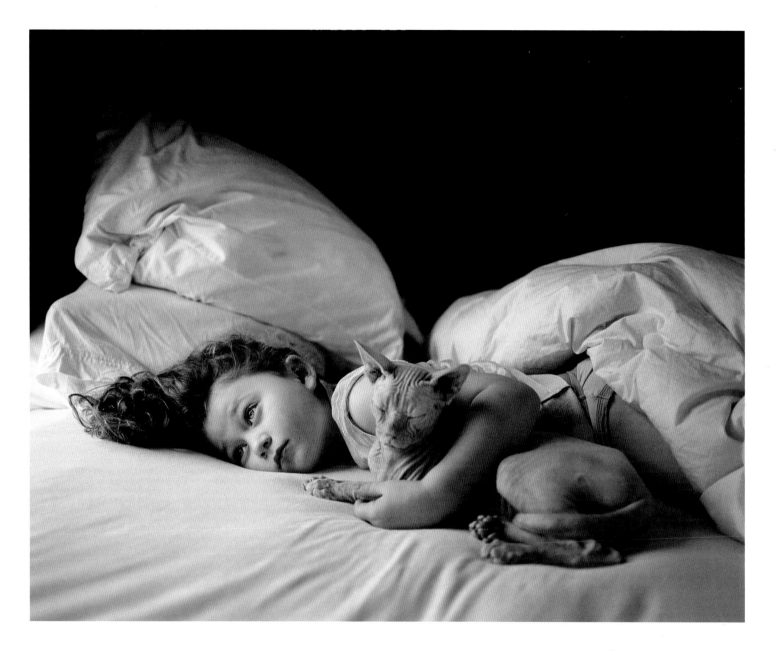

TOWER, 2006
Robin Schwartz

Digital chromogenic print
30 x 40 in
Courtesy of M+B Gallery, L.A.

TAKASHI HOMMA *Japanese, b. 1962*

THE WORLD WE LIVE IN

The work of photographer Takashi Homma is a pop culture document of the here and now. When he photographs, he doesn't do so with an idealized eye or sentimental thought, but through untinted observation of the present. "I always try to remove nostalgia," he says. His photographs are not staged, dramatic, or overly emotional representations of his subjects, by design. Rather, they frame Homma's ability to see what is all around us but often overlooked.

Whether photographing the suburban children and architecture of post-bubble Japan or the iconic sculpture of the Golden Arches of McDonald's worldwide, he offers his viewers the landscape of humanity as it is, without frills. In its plainness, Homma's work exposes the sterilization of our society, which seems to alienate and disregard the variances of the individual, especially among its youth. Although it is tempting to catalogue children as one type, one generation (i.e., Gen Z), they individually possess uniqueness, even within their disaffect.

Homma's ability to capture the nonconformist personalities of what some might term "disaffected youth" derives from his belief that, as a cohabiter of their society, he is disaffected as well. Homma is a kind of a pop culture individualist who is defiantly that way. He lives in ambiguity and doesn't seek to define his work. He's known for showing things as they are, even if uncomfortable to the viewer–he might even prefer it that way. Because of

who he is, he is able to present iconoclastic children with respect born of understanding. Homma simply states, "Disaffected youth are beautiful and valuable people."

Like Homma's work, his child subjects are simultaneously direct and ambiguous. He explains, "It's not about an ambiguous feeling, but the ambiguity of reality (indeed, reality is really ambiguous itself). I'd like to simply photograph the full portrait of an ambiguous reality."

Takashi Homma has over a dozen published books and has garnered awards and acclaim for his work worldwide.

More images at: **betweenthebooks.com**

"...today's children are (to borrow another computer term) 'formatted differently.' They might be able to understand me, but I'll never be able to understand them. Or so it feels."

— Douglas Coupland
Tokyo Children,
Takashi Homma, 2001

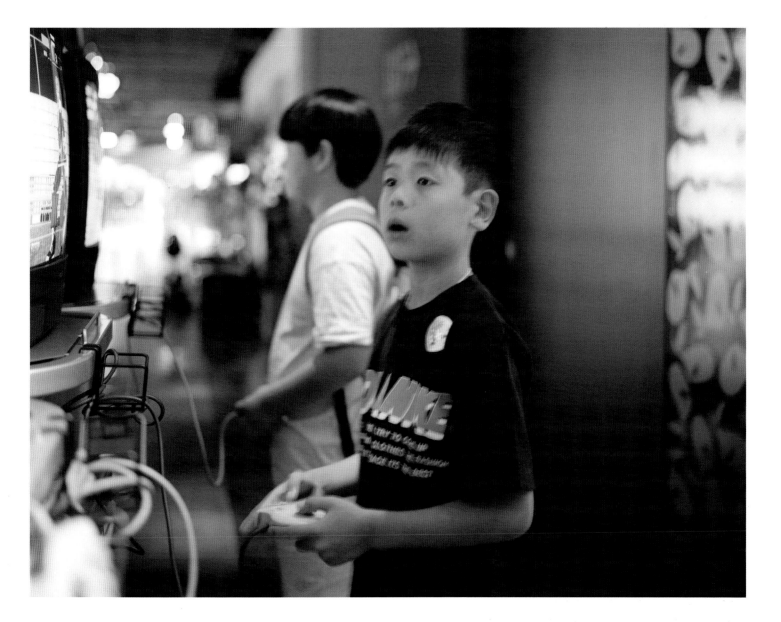

**BOY-2, TOKYO JOYPOLIS,
ODAIBA, 1998**
Takashi Homma

C-print mounted on dibond
46.7 x 56.8 cm
Courtesy of Gallery 360˚, Tokyo

RANIA MATAR *Lebanese-American, b. 1964*

BRIDGING THE GAP

Before embracing photography while pregnant with her fourth child, Rania Matar lived another life–that of a skilled architect. Being able to uproot one life for another was *not* a new experience for her. Born in conflict-burdened Lebanon, her youth took place in the midst of the Lebanese Civil War. Matar, however, didn't feel impacted by the conflict until after she moved to the United States. In Lebanon, it was simply a part of her daily life.

The quickly passing "everyday" moments of her own growing children prompted her to pursue photography as a highly dedicated enthusiast. She took classes and workshops to develop her skills, and she refined her work by experiencing great art and photography. She acknowledges that her interest in photographing long-term projects was shaped by exposure to Artist-Photographers like Helen Levitt, Sally Mann, and Constantine Manos (a Magnum photographer from whom she took a workshop, and who subsequently became her mentor). Her children naturally became her first muses in her earliest work, *Family Moments*. This interest expanded to include the idea of home, the everyday, and the significance of things close to her heart.

In 2002, Rania Matar traveled from her home in Boston to Lebanon. She visited a Palestinian refugee camp ten minutes away from where she grew up. Much about the conditions she saw was distressing, especially with the acquired eyes of a Westerner. Yet, as her eyes acclimated,

there was "much beauty behind the immediate and the obvious." This insight lead her to her second long-term photography project, *Ordinary Lives*.

"I went back again and again," she recalls, "building relationships and aiming to grasp the intimate details." She was struck by how these two projects, of family and homeland, informed and influenced each other. Her work was cathartic and seemed to bridge two worlds: that of child to adult, and Middle East to America. Understanding gained from motherhood allowed her a softness and intimacy when documenting events in the camps. Conversely, her acumen as an outsider in the camps prompted her to step back and view the everyday of her own family life with new and fresh eyes.

Now, as a professional Artist-Photographer, Matar lives for the gift of seeing, propagated by the enthusiasm she has for her subjects. "You have to be passionate about what you are photographing; you have to care and show respect. This is where one can find their voice." She suggests that when photographing ordinary moments, one should learn to acknowledge and see them for what they are, rather then attempting to manufacture them. The humanity of an image is always found within the the everyday and associations made between the seemingly unconnected worlds, she maintains.

More images at: **RaniaMatar.com**

"I photograph them to freeze these magic instants and make them eternal through a collection of images which provide a truthful and intimate documentary of their childhood before they turn into adults and the magic is gone."

— Rania Matar

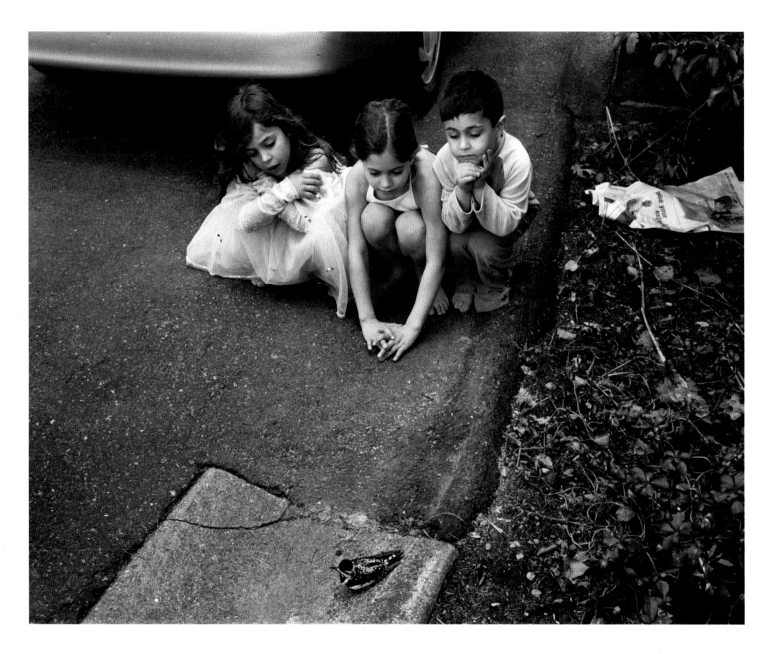

INJURED BIRD, BROOKLINE, 2004
Rania Matar

2004
Archival pigment print, baryta coated
paper
30 x 40 in.

ACHIM LIPPOTH *German, b. 1968*

PRODUCTION

Achim Lippoth is a storyteller. He likes a narrative, be it fact or fiction. He collects books, consumes cinema, and is inspired by historical photographic artists like those of the Bauhaus. All of these inspirations churn with current events and fuse as inspiration for his work. But a story is nothing without a performance, and a performance is nothing without a stage.

The journey from concept to print is a deliberate one. Great care is given to the production of Lippoth's work. Although he has his own production team (consisting of a production manager, production assistant, a casting and location director–plus three people in post production), they focus solely on the organizational aspects of a shoot, giving Lippoth the time and freedom to do the creative work. The primary role of production is not to show how fancy a shoot can be (although it can accomplish this), but rather to clear the path for creative thought and serendipitous moments. Production involves securing the location, wardrobe, and props. But it's also the care given to the children on set through a child-friendly atmosphere, creating an open and honest rapport, and making downtime available as needed.

There is a quality to Lippoth's work that production alone cannot manufacture. This is the authenticity of the children, and one can only set the stage to encourage it. "Of course casting is a very important part of my work," Lippoth explains. "Without choosing the right kids, a shoot can never be successful." In casting he looks for "natural characters who still behave like *real* kids."

After great care has been taken to cast the children, secure a location, provide wardrobe styling and the like, the child is introduced to the scene. This is where Lippoth's creative aptitude and interpersonal ease shine. He provides the children with an idea or concept but balances this with the freedom to be themselves. Through this autonomy potential images are born and "capturing that right moment is always the great challenge."

The level of production in Lippoth's work can seem unobtainable and unrealistic for the aspiring artist-photographer, but it's important to note that in addition to making work that requires a high degree of production, Lippoth has also worked with production that is scaled down. Yet, all his work has the visual finesse that suggests "production value!" Production value is code for a well-thought-out and executed image. It does not always require money, but it does involve forethought, preparation, and care.

Achim Lippoth's diverse body of childhood photographs (and video) have won myriad international awards, notoriety, and acclaim. Still, Lippoth is always in the process of creation, and ready to tell his next tale. He sees each series as a mere challenge to the next, daring him to create something new and extraordinary. And each time he rises to the challenge!

More images at: **Lippoth.com**

"Don't give a speech, put on a show!"

— Paul Arden

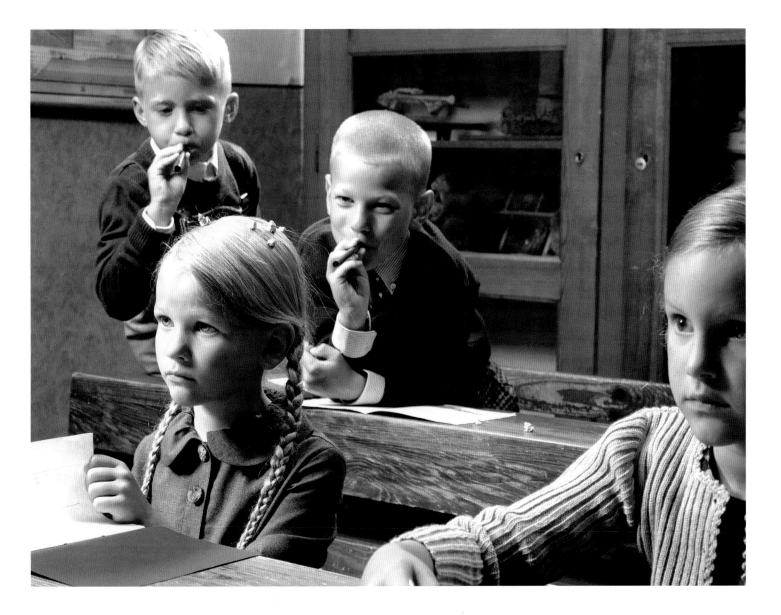

CLASS OF 1954
Achim Lippoth

2006
Digital c-print/lambda/matte
39.4 x 29.5 in. , 100 x 75 cm

ANDERS HALD *Danish, b. 1969*

INTERACTION

We can plan and prep endlessly, yet until the child is before the camera, we simply cannot know of serendipity that will occur. From the moment that the child and photographer come together, all the preparation for the shoot relies on successful interaction between the two. This interaction, not the child's response alone, will either make or break a shoot.

Photographers must conduct themselves so as to have a positive effect on children. There may be pressure to capture the perfect shot (especially on commercial shoots), but this is precisely why Anders Hald creates a rapport that eliminates any pressure that might be felt by his child models. Instead, his team works to create a calm and fun atmosphere. Children will always sense nervous tension and respond to it. Generous production is primarily essential because, at the moment the child steps before the lens, we must shut out all else and focus primarily on that child. We may not have a team of assistants, and stylists, as Hald does, but the objective is the same: putting all else aside and utilizing all our creativity and personality to assure the best capture in that moment.

Hald reflects, "I often have to improvise when I direct the kids. I might have an idea about how to get a child to respond in a certain way, but it may not play out that way, and I will have to come up with new (often playful ways) to get the child to give me the look I am after."

Because Hald is kind, straightforward, and honest with his child models the interaction alone gets him halfway to the successful image. He enjoys the challenge of capturing great photographs of his unpredictable little subjects. He'll mingle and tell stories in the same manner that children instinctively play: "Let's say you are…" or, "Imagine that we are about to…" There is often a photo-worthy narrative waiting for the camera in a simple game of make believe!

Hald's advice? Be respectful and never shout, know your objectives well, maintain a positive interaction, and *always* have a backup (both child and equipment–especially if working commercially). Having a contingency takes the pressure off photographer and child alike. Because we should never force a child to perform, once we have lost a child's interest the shoot is over; if we have a back up, we can kindly dismiss the child and continue to work. If all goes well, we'll simply have more options to choose from when we edit. But if surprises happen, be ready for that too!

Anders Hald directs all interactions in such a way as to manage expectations, be it the client, parent, or child. He brings all his experience and natural artistic prowess to each of his commercial images, assuring that his photographs showcase the authenticity of childhood, and a well-represented product.

More images at: **AndersHald.com**

"If the child is reluctant, I don't get good images… panic will spread like wildfire to the kids, so [it] must be avoided at all cost."

— Anders Hald

EDITORIAL FOR JUNIOR MAGAZINE (DANISH VERSION)
Anders Hald

June 2007
Digital capture and delivery
11 x 14 in.

CUNY JANSSEN *Dutch, b. 1975*

TIME AND PLACE

There is a powerful connection between children and the landscape that cradles them. A child does not exist in solitude, nor does their environment. Rather, there is power that connects child and place. Cuny Janssen captures images of children and the environments they inhabit. Her separate photographs of child and space are exhibited together in galleries and publications. It is the soft candor of *both* subjects that inspires her to pair the two, and subsequently draws crowds toward her images.

At the age of 25, Janssen boldly pronounced that she was going to photograph the children of the world! Now, 10 years later, after travels to India, Japan, South Africa, Macedonia, Iran, and the United States, as well as within her home country, the Netherlands, she continues her quest. Two and a half years into her journey, she felt compelled to include landscapes, the arena of her young sitters. She didn't do this by using a wider lens or pulling back her camera, but by capturing them separately and offering the landscape its own space alongside her thought-provoking portraits. She realized that this essential supplementary information offers an expanded context to the youthful faces of the region.

In her travels she photographs children who live in peace and others who witness armed conflict. "You have no say were you're born," Janssen explains, "All you can do is make the best of it. It's the same in nature; plants will even grow on rocks, and in the shade." In Janssen's photographs the resiliency of circumstance is evident in the eyes of children. Aptly, the same resiliency is found in her portraits of their environment.

Cuny Janssen is a witness and a gatherer of the evidence of existence. "It's all about intuition. I'm not looking for anything, and I'm not trying to prove anything." Although her 4 x 5 film camera mounted on a tripod is anything but discrete, her sincerity allows her to blend in with the surroundings of the young lives before her. She invests time and interest into these little ones and seeks to share their story with the world through her photographs.

More images at: **CunyJanssen.nl**

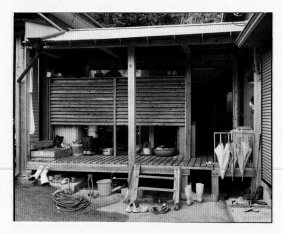

"Photographs of smiles make the viewer feel good, but don't have that much to say. Something about this photograph makes me want to keep looking at it, and it starts to speak to me.

'Don't turn off the lights. Let's talk!'"

— Jurina Sato/2nd grade/ Akakina Junior High School/ Amami-City

AMAMI ISLAND, JAPAN, 2007
Cuny Janssen

(image right)
56 x 48 in
C-print

AMAMI ISLAND, JAPAN, 2007
Cuny Janssen

(image left)
67 x 78 in
C-print

"*Photographers deal in things which are continually vanishing and when they have vanished there is no contrivance on earth which can make them come back.*"

— Henri Cartier-Bresson

TA DA!
LaNola Stone, 2002

STORING, PRINTING & SHARING YOUR WORK

7

NOW WHAT?

The previous chapters provided tools and concepts to facilitate an artist-photographer's capture of authentic and effective childhood images. This final chapter, however, has nothing to do with production; instead, we will talk about various methods of preservation. Since preservation is of utmost importance and rarely done, the next few pages will present a doable and adequate workflow for the "pro-amateur" (as well as many aspiring professionals). This chapter is divided into three categories: storing, printing, and sharing our images.

SOMETHING: BETTER THAN NOTHING

What you can do now to save your images

It takes a lot of work and talent to capture the perfect image. Today's digital technology allows us to instantly see our images on the LCD panel of our cameras so we know, in the moment, that we've captured the perfect shot! The objective of this chapter is to assure that you have the tools to see that shot through to its final presentation, be it digital or print media.

Although one of the best experiences for an artist-photographer is to see the manifestation of our images, one of the worst experiences is seeing that image destroyed or forever lost, never to be seen again. Today a photograph can be lost with a simple accidental brush of the delete key or a dramatic full-scale hard-drive crash. Both scenarios are immediate and devastating. There are, however, sure-fire ways to back up your digital work so that you never need to worry about these situations. Professional photographers utilize them and, though they may be costly and time-consuming, they provide a peace of mind that is unparalleled. Now, I know what you are thinking, "Costly and time-consuming? Seriously?" After all, the scarcest things for most of us are expendable income and time. Luckily, there are both "best" ways to archive, print, and share, and there are "better than nothing" ways.

Better than nothing is a great first step. It starts to move chance to your side. It's better to have a tangible, printed photograph when your hard drive crashes, destroying your files, than to have nothing. It's even better to have both a printed image of your favorite photographs and the digital file to make another print (because you made a backup). It's best to have all, as well as a backup for your backup (preferably offsite), because you just never know!

Better-than-nothing balances, for our image archive, the three universal objectives we all desire: to have _____ (fill in the blank as you wish) done *well, fast,* and *inexpensively.* I am here to tell you that to have all three at once is nearly impossible. Don't get me wrong, all are worthy objectives, but generally we can have no more than two of the three at any given time. Luckily, each possesses its own sliding scale, and if we are willing to give a little on one of the three we can vastly improve one or both of the others. For example, if you want a first class plane ticket for tomorrow, it will cost a lot of money. If you want a first class plane ticket and you have time to put in the effort to conduct extensive research and shop around, you will most likely get that ticket at a significantly discounted rate. And if you will give up your first-class ambitions and settle for coach accommodations on a low-cost carrier, you can get to your destination relatively quickly and spend, comparatively,

The best time to back up your files is now. You may not have the time or money for a perfect system but finding a balance between perfection, time, and cost assures that something is done, rather than nothing.

Shutter Speed: 100
F-Stop: f/4
ISO: Agfa Ultra 50
Camera: 35mm SLR
Lens: 80mm
Light: Scrim diffused daylight

figure 7.1

When setting out to accomplish any task you may be able to have two objectives shown here, but you rarely get all three: perfection, speed, and an inexpensive price point. Even cashing in favors has hidden costs.

little money. So, as you determine your resources (time, money, and high-mindedness or need for perfection), think of the following workflow as a framework for your sliding scale. Which do you have more of and which is the scarcest)? The ultimate objective is to have a system that works for you and your resources.

I won't overwhelm you with the perfect and optimal methods that require a lot of time and money (although I'll provide resources for those who want to delve further), but I will provide a minimal, yet effective workflow with doable steps. It will then be up to you to shape your practice of preserving your images through proper storage, printing, and sharing your work. What is most important is that something be done to preserve your precious images. When it comes to preservation, doing something is always better than nothing.

Between capture and actualization

Latent, in regard to an image, means *capable* of being seen but not yet visible. For example, there are not a lot of printed images of my childhood. It isn't that images weren't taken, although that could be seen as the case since I was the sixth out of seven children, but rather the images (I've been told) are latent on film in canisters. I now have many of these canisters in my possession, but I still have not viewed any of the images that lie undeveloped on the film inside. You see, to develop this film requires a chemical process that is not readily available in today's digital world. In fact, as I wrote this chapter there was only one lab left in the United States that could possibly process the film that holds these latent images, and as of December 2010 they had no more chemistry to develop them. The possibility of these latent childhood images becoming visible is pretty much nil. These childhood experiences in photographs, simply lay dormant on film in canisters, never to be developed and seen.

I don't share this story for any other reason than to instill

a sense of urgency for the preservation and realization of your images. I truly worry that this generation of children will have few to no images of their childhoods, as well. It's not that photographs aren't being taken, but often they are not being printed or saved properly. If they are not saved properly there is little chance the digital files will migrate to new technology as current technologies becomes obsolete. Like the film canisters of Kodachrome that hold my childhood in images, there will come a time when retrieval of our digital files, too, will be nearly impossible if not kept current. Printing is a surefire way to gift these images to the children, proper archiving and preservation is another. The latent image has the potential to be something greater, but until it is developed it is as inactive as a paperweight. Potential is a crazy thing. It seems both valuable and precious, yet without action potential means nothing.

Between the time of capture and tangible creation there are some easy steps to follow to assure that your work will live by being seen and avoid the nothingness of untapped potential.

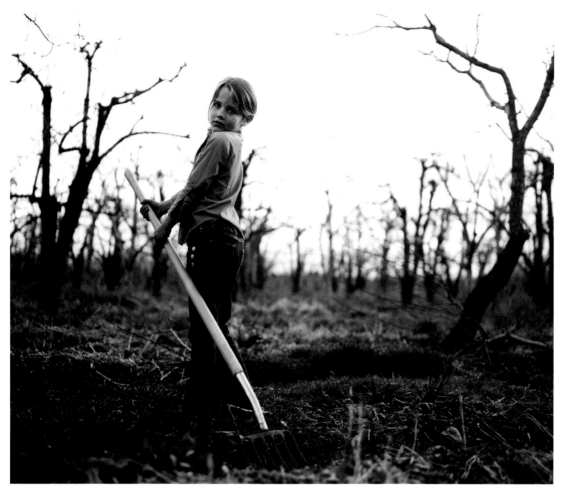

HAVING A PLAN

Having a plan all comes back to that all-important question, "What's the objective?"

If you are reading this chapter, I am going to make a few assumptions: 1) photography is valuable to you; 2) you are willing to do something to protect your photographs; and 3) you need an action plan, from capture to archive, that is doable. These next few pages are about the third assumption. Now, there are numerous books that cover this topic in-depth if you are interested in something more comprehensive than you find here. At the top of my list is the *Digital Photography Best Practices and Workflow Handbook* by Patricia Russotti and Rich-

ard Anderson (2009), also published by Focal Press. It is an all-inclusive text of everything a photographer could want to know about workflow and archiving, and it has a great companion website, dpBestFlow.org. The research behind the publication and funding the website were made possible by a grant from the U.S. Library of Congress because the information contained therein is just that important! It is also endorsed by the ASMP (American Society of Media Photographers), one of the largest associations for professional photographers. Basically, I am saying that there is *a lot* of valuable and pertinent information and I highly recommend that every serious photographer read it. However, since there is a lot of information to process, I feel a simple preliminary alter-

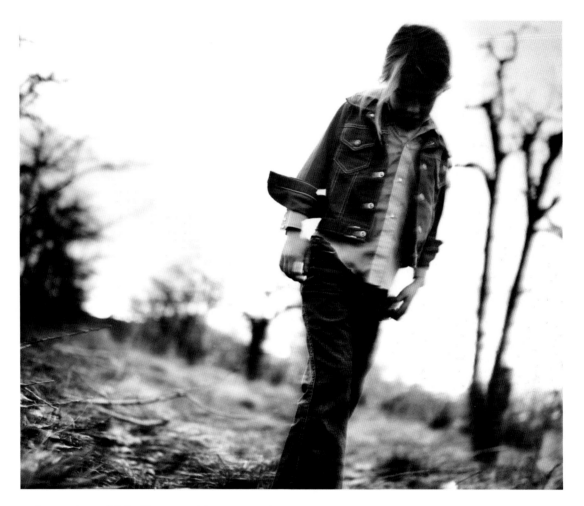

An ounce of prevention is worth a pound of cure.

Step 1 Have the right tools for the job.

Step 2 Have a structure of organization with which to use these tools to achieve objectives.

Step 3 Have a backup plan incase of a failure in the original plan.

native may be useful. I will present only one way to archive your work, manageably scaled down to an effective system that is supported by the complementary theories of DP Best Flow (dpbestflow.org). It is a method that I have used to archive my own work for many years.

My goal is that you *do something,* rather than nothing, to protect your images *now.* This is a more advanced workflow than the "upload the images from your card and forget it method," but with the additional planning comes peace of mind and safety for your images. You'll be less likely to accidently delete an image, or lose all of them after hard drive failure, by following a few simple steps.

Tools

When preparing your workstation it's important to note that for all the hours spent behind your camera, you will most likely spend over 50 times more in front of your computer editing, preparing, and archiving your images (maybe even 100 times more if you count the time spent on Facebook). I only point this out because the faster and more smoothly your computer system works, the more time you'll have to do what you love, take photographs! For a photographer, a good computer system is a fast computer system! The best way to increase the speed of your computer is to have a good processor(s), fast hard drives, and a lot of RAM. Remember all that research you put into your awesome camera? Spend a

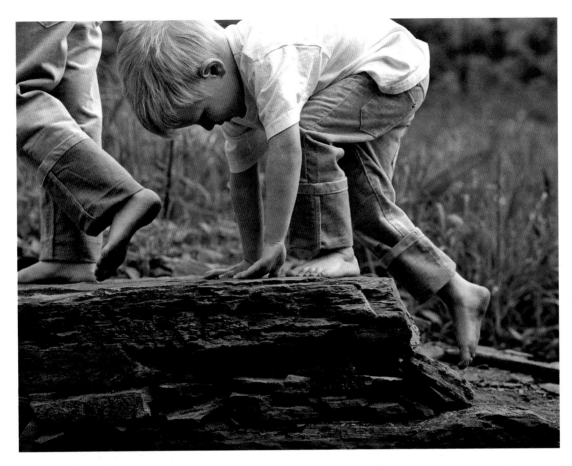

image 7.5

Follow-the-leader is great
when your leader has a
clear direction. Here I pro-
vide a step-by-step path to
a straightforward backup
system.

Shutter Speed: 125
F-Stop: f/4.5
ISO: Kodak 160NC (film)
Camera: Medium format; 645
Lens: 80mm
Light: Overcast daylight

similar amount of time researching the right computer for you (and I reiterate maxing out your RAM is a good idea!). What works for you will depend on your specific needs so I can't lay out for you exactly what you should buy, but here are a few guidelines:

Processors are the worker bees in your computer. Having two is better than one, and having four is better than two. After all, many hands make light work.

RAM stands for Random Access Memory. RAM is much faster than disk-based memory and the more you have, the better your computer's performance. Programs such as Adobe Photoshop and Lightroom work much better if a lot of RAM is available. To run these programs your computer system should have 2 GB of RAM at the very least. To illustrate this point, I have 12 GB of RAM and am looking to upgrade.

Hard drives generally come in two speeds, 5400 rpm and 7200 rpm. The rotations per minute (rpm) describes the speed at which the mechanism inside spins and delivers data. The faster it spins, the quicker the data transfer rate. Please note that hard drives have many working parts and are somewhat fragile. They should not be dropped and must *never* be placed near anything magnetic. Aside from permanent storage hard drives, you should also have portable hard drives that can act as temporary storage bins for your images until they make it to your workstation.

The graphics or video card translates the output of your display. The super high-end cards are great for 3D rendering and gaming. If you are just working with photographs, however, get the card that best suits your needs and the requirements of your display.

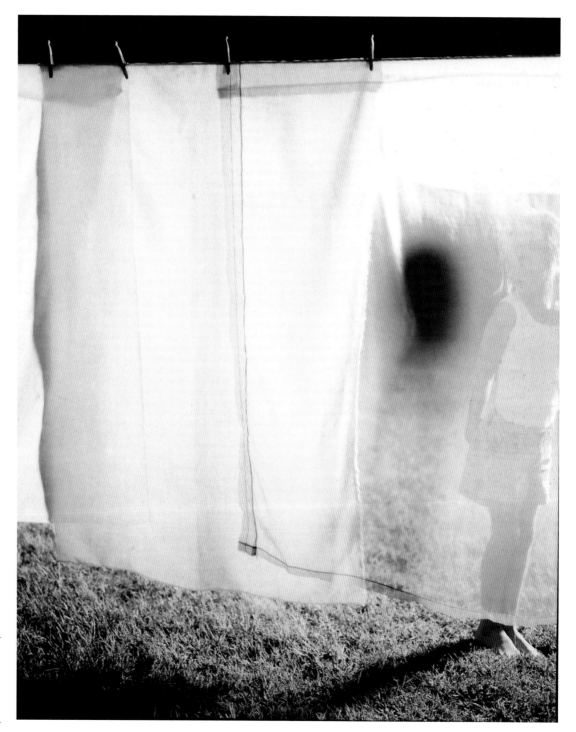

image 7.6

Playing with light and shadow will provide distinctive mood to your images. Here the shadow is as much a subject as the child herself!

Shutter Speed: 125
F-Stop: f/4.5
ISO: Kodak Tmax 400 (film)
Camera: Medium format; 67
Lens: 100mm
Light: Direct strobe

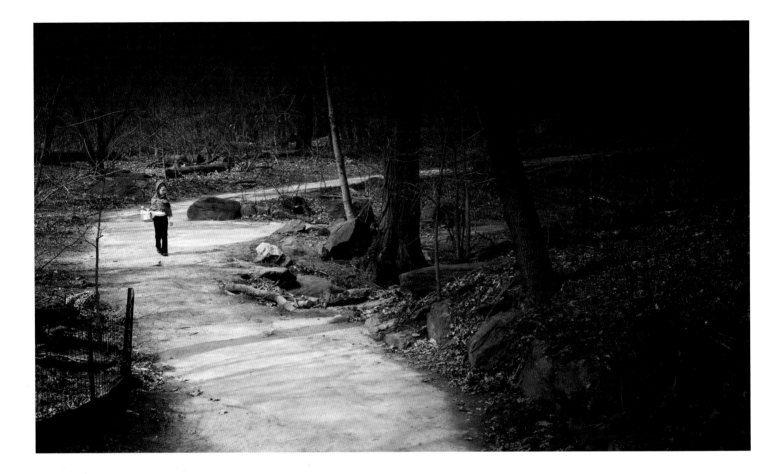

Lastly, I want to quickly touch on the choice of display (computer monitor). The more accurately you would like your screen to represent what is to be printed, the more important it is for you to match the performance of your display to the ability of your printer (or the printers to which you outsource the printing). Displays are lit by red, green, and blue light (RGB, the primary colors of light). They can also mimic a CMYK (pigment-based) color space via profiles for specific printers and papers. Now, I know I am losing a few people with all this tech talk, but this is all to say that there is a vast difference in display models and you generally get what you pay for (brand name notwithstanding). It is important for me that my display have the ability to represent the color space in which I am working, be it sRGB, Adobe RGB

1998, or ProPhoto RGB. Therefore I have a display with a gamut capable of showing all of these color spaces. I also calibrate my monitor often so that it doesn't fall out of gamut. It is just like us—we may be capable of 50 sit-ups a minute, but if we don't stay in shape we will not be able to maintain that performance. The same is the case for the calibration of our displays; frequent calibration keeps them in shape.

If you are interested in learning more about calibration and displays (there is a lot to know), consider the book *Real World Color Management* by Bruce Fraser, Chris Murphy, and Fred Bunting (2004). The x-rite website also has many great articles; xritephoto.com. I will touch on this a bit more on p. 177, as I review the basics of color management for printing, as well.

image 7.7

Finding your images begins with organization from the moment you import. The path will always be clear if your organizational system has a prescribed nomenclature and file structure.

Shutter Speed: 125
F-Stop: f/10
ISO: 100
Camera: 35mm DSLR
Lens: 70mm
Light: Dappled, slightly diffused natural daylight

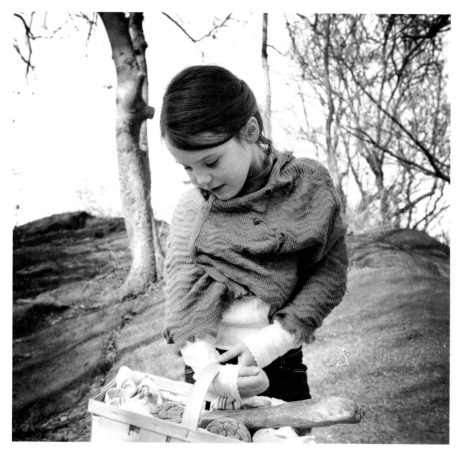

image 7.8

Shutter Speed: 125
F-Stop: f/8
ISO: 100
Camera: 35mm DSLR
Lens: 42mm
Light: Cloud diffused daylight

When considering my workflow, I like to look at the whole process: precapture to archive. Here are my steps from precapture to the doorstep of my archive:

1) Make sure the firmware on the camera is up-to-date. If your camera were a computer, the firmware would be the operating system. Keeping it up-to-date assures that any advances in technology (such as the latest memory cards) will work at their optimal performance even with an older model camera. Keeping our firmware current is the best way to keep our camera current without buying a whole new camera.

2) Format the memory card *in your specific camera* every time before shooting. (Set the camera for RAW shooting when possible.) Formatting the memory card, versus just erasing the disk, not only provides a more absolute way of removing files, but also configures that particular card to your particular camera. It prevents a lot of potential errors as you'll be starting with a clean slate, perfectly suited to your camera, every time. I actually format my cards three times before every shoot to assure they are perfectly clean (although, admittedly, this is probably more superstitious than effective).

3) Prepare a folder for the intake of the files from the memory card. Follow a prescribed nomenclature (file-naming convention/structure) *every time*! Let me pause here to suggest the best nomenclature (in my humble, but correct, opinion).

Always, always place your photography files in folders by the date. In my 20+ years shooting and storing images digitally I have filed them numerous ways, but this is the best. I know that your images fall under many other categories and classifications, and you may be tempted to make folders to reflect these, but don't. Rest assured that you will have the opportunity to virtually place them in those categories when working in your cataloguing software and this category will be stored in the metadata making it easily searchable. (When we talk about collections and metadata we will delve further into categorization.) But for purposes of consistency and avoiding redundancy, the *only* completely unique classification of each of your images is the precise time it was taken by you.

Have hard drives specifically for your photography. Keep them separate from those you use to house your music,

Organization and nomenclature

Organization is essential, especially for creative people. It's the best way to free our minds for other things, like artistic meandering, while feeling assured that the essentials are being taken care of and our images won't be lost or deleted. This is what my mom refers to as "being able to sleep when the wind blows." If you've prepared a strong structure that can handle the elements (whatever they may be), when a storm comes you can rest knowing that all will be well. If your workflow is organic to the way you process things, structured, and predictable (even if the way that you work is not), then you won't have to think about it. Like breathing, you'll just do it. And when things do go wrong, you'll have the tools to fix them, understanding how it first came together.

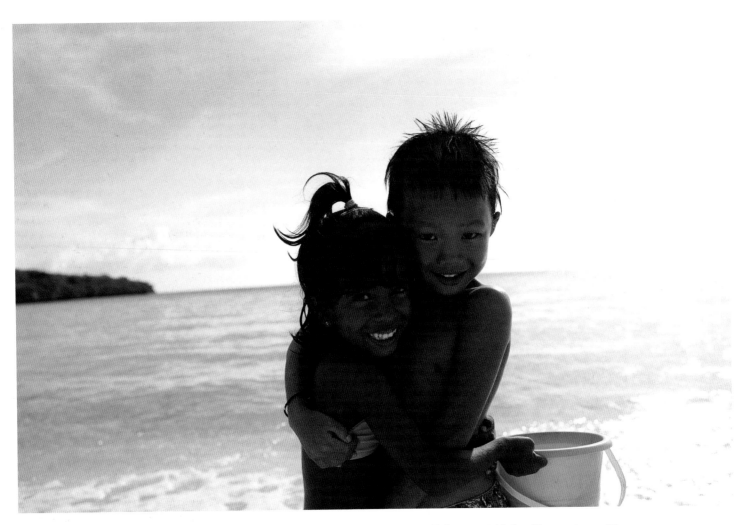

applications, other documents, and the like. I have 1-TB drives and label them Image Files I, Image files II, and so forth. The folder structure on each of these drives is a year range, followed by a specific year. Within the year folder are folders for each day I shoot. That daily folder is labeled with a number constituting a two-digit year, two-digit month, and the two-digit day. I then place an underscore (spaces are never a good idea) and label that dates' file with a signifier (or the client, underscore, and job). In practice, the folder structure looks like this: 2008-2012 > 2012 > YYMMDD_signifer or YYM-MDD_client_job > *then place your images files (with their original names) in this last folder.* As you follow this or-

ganizational structure you will always quickly be able to intake the files from the memory card after capture (see below). Now, on to the next step.

4) Copy your image files from your memory card (with-in the proper folder) to a *temporary, portable hard drive* (some people rename their files, I don't; see p. 173, "File renaming"). For transferring files from the card, I use the drag-and-drop method because it is simple and fast. I am *strongly against this method for backing up your Active Archive files as a whole* (dedicated software is better equipped for complex functions such as that), but at this stage I have found drag-and-drop perfectly acceptable

image 7.9

Happiness is an organized file structure! Also, in regards to this image, when backlighting remember to always directly meter your subjects, *not* the whole scene, to avoid the silhouette.

Shutter Speed: 1000
F-Stop: f/5
ISO: 100
Camera: 35mm DSLR
Lens: 32mm
Light: Backlit with daylight

and have never had a problem. That being said, no file transfer is completely reliable, so be sure to always verify your image files after you move them.

5) Verify your image files with Preview–if they appear corrupted then recopy them, since it could just be a transfer error. *Always verify* that the files you transferred from your card made the trip okay, especially if you plan on reformatting that card right away! This is simply done by viewing the images in Adobe Bridge or with the preview software on your computer.

6) Back up these files on a second drive. **You are so close**

to having nothing if you don't have a backup. An accidental drop of your hard drive, or water spilled, or any other number of potential disasters/mistakes, can cause hard drive failure and immediately erase all your files. At least one backup (stored separately) is required to assure the safe arrival of your photographic work to your computer workstation. Note that backing up your image files on a third drive is the most foolproof approach. Nevertheless, be sure you have *at least* two copies of the verified image files.

7) You are now ready to format your memory card in your camera again, *if you need to*. At this point the files are properly filed and securely backed up. There should be no problem formatting the card for reuse. However, if you don't need to shoot them right away then the memory cards can serve as a third back up of that day's work until you get back to the computer and add them to your Active Archive. Memory cards, after all, are relatively inexpensive these days. I'd suggest purchasing a few extra just to have on hand. When making a memory card purchase, make sure the read/write speed of your memory cards is on par with or better than what your camera can handle, especially when working with children. This prevents unnecessary lag time when you shoot because you'll be utilizing the camera's full ability and recycle time.

Figure 7.2
File structure
HD = hard drive

STORAGE
Assuring the longevity of your archive

You have now organized a proper file structure to house your image files. Still, if these images are not immediately catalogued there is a good chance there will be duplicates and deletes as you work with the files. Working with your pixel-based image files will deteriorate them with each change, as well. For this reason the very next step, before all else, is to place your images in a catalogue, which both actively archives your photographs and allows you to work with them in a nondestructive way. Personally, I have three Lightroom catalogues:

1. Thoughtful camera-based images: The majority of my images are in this catalogue.

2. iPhone images: Low-res camera, yes, but it's always with me and frequently used.

3. Photographs by others: Images that were not taken by me but that I wish to archive and "tag" for personal use. These are images sent to me from others, perhaps from a party or activity we both attended. Lightroom allows us to credit the photograph to the original photographer and keyword the image with names, place, and thoughts of that event. As a teacher, I have a collection in this catalogue that is dedicated to images examples, historical or contemporary, for my various photography classes.

Cataloguing with an Active Archive

An Active Archive workflow requires multifunctioning catalogue software. In fact, the catalogue is the virtual location where you and your images will meet and work together. The catalogue is the home of your Active Archive. Your Active Archive consists of both hardware and software elements. The hardware is the physical location of your archive, the hard drive (defined by its physical place, not a process). The software is the virtual location where you work and interact with your images, or the program, such Adobe Lightroom (defined by its processes, not a place). We touched on the hardware needed when we spoke of tools. Now we are going to focus on the software.

I use Adobe Lightroom as my Active Archive cataloguing and postproduction software. Just for the record, I am not sponsored by Adobe but I am very happy with its product. That being said, other user-friendly programs

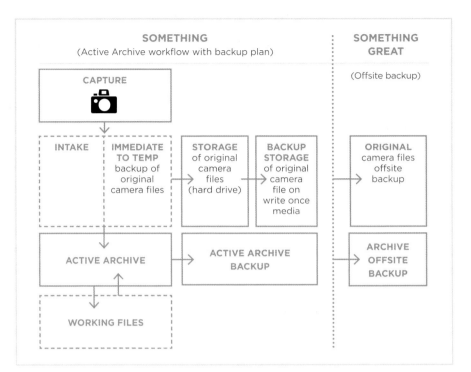

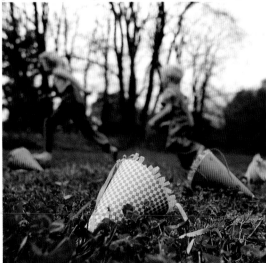

fulfill this same niche, such as Apple's Aperture. Both programs support RAW, JPEG, and DNG formats, as well as master file formats such as PSD and TIFF. They both show you all of your images virtually and maintain your file structure (using your actual files as a reference rather than relocating them).

This assures that all the "development" enhancements to your images, done inside these programs, is "non-destructive" and the integrity of your original file is always preserved! This is achieved through what is called Parametric Image Editing (PIE), meaning simply that instead of making changes to the actual pixels of your image files (as Adobe Photoshop does) PIE edits the image files by recording instructions for the changes and enhancements you've performed in the program. These instructions/enhancements are then saved as metadata linked to your original file, but *do not* change the original file. Even though we see the changes and enhancements, they have not been applied. Until you export the image to a pixel-based format such as Photoshop, the instructions are not applied directly to the image file. When they are applied, the image is "rendered" and the

figure 7.3
Workflow: Image capture to archive to your work with the image files. *Don't forget to backup your image files. One backup is good. Two backups are better. Having three is the best (preferably the last backup is offsite)!

***BACK UP**
A Place and Processes

Onsite: Hard Drive(s)
- Schedule consistent backups of the Active Archive(s)
- Original camera files
- Write once/read only media (DVD/Blu-ray

Offsite: Hard drive(s) and/or write once/read only media such as DVD or Blu-ray.
- Archive (no longer active)
- Original camera files

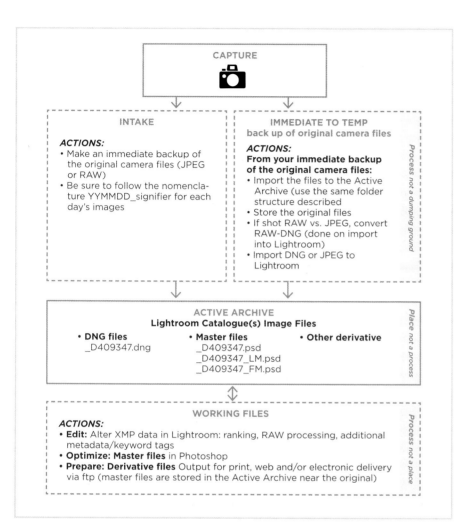

CAPTURE

INTAKE

ACTIONS:
- Make an immediate backup of the original camera files (JPEG or RAW)
- Be sure to follow the nomenclature YYMMDD_signifier for each day's images

IMMEDIATE TO TEMP
back up of original camera files

ACTIONS:
From your immediate backup of the original camera files:
- Import the files to the Active Archive (use the same folder structure described
- Store the original files
- If shot RAW vs. JPEG, convert RAW-DNG (done on import into Lightroom)
- Import DNG or JPEG to Lightroom

Process not a dumping ground

ACTIVE ARCHIVE
Lightroom Catalogue(s) Image Files

- **DNG files**
 _D409347.dng
- **Master files**
 _D409347.psd
 _D409347_LM.psd
 _D409347_FM.psd
- **Other derivative**

Place not a process

WORKING FILES

ACTIONS:
- **Edit:** Alter XMP data in Lightroom: ranking, RAW processing, additional metadata/keyword tags
- **Optimize: Master files** in Photoshop
- **Prepare: Derivative files** Output for print, web and/or electronic delivery via ftp (master files are stored in the Active Archive near the original)

Process not a place

figure 7.4
Workflow details

image 7.10

It can often seem like you are chasing after your images if you don't have a predictable and consistent workflow.

Shutter Speed: 125
F-Stop: f/4.5
ISO: Kodak 160NC (film)
Camera: Medium format; 645
Lens: 80mm
Light: Overcast daylight

program creates a separate file for that particular image (leaving your original image unharmed). The obvious advantage of this is that one image can be processed a plethora of different ways without it being deteriorated, since a new file is always rendered from the original image. Also, until you render the file, the changes made in PIE software don't increase your file size in a significant way, because the changes are only stored as instructions written inside the DNG file, or as a separate "sidecar" file to your RAW images. Whether you use Adobe Lightroom or Apple Aperture, you will have both the advantage of PIE and a powerful cataloguing tool! Both programs are great and, with a little practice, very user-

friendly. Since I work with Adobe Lightroom, this is what I reference here. If you work with Apple Aperture, just replace my general references to Lightroom with Aperture. The main intent of both programs is very similar.

Aside from PIE, all-in-one cataloguing programs also maintain the organizational structure of your archive (Figure 7.2, "File Structure"). When you import the files into Lightroom (File > Import Photos…) there are certain preferences that you are asked to select. Just follow the choices in the toolbar (left to right, then top to bottom).

1. Copy as a DNG "Convert to DNG to a new location and add to catalog": The huge advantages are first that xmp data are housed in the file (whereas sidecar files are their own files and can get separated) and, most importantly, they are converted to a open-source format that will be supported even when your RAW proprietary files are no longer supported by the manufacturer (because its old technology or they've gone out of business, etc.).

2. Select destination: Choose your image hard drive and follow the nomenclature explained above.

3. Size of preview: This is done immediately upon import. "Minimal" previews are rendered faster, whereas "1:1" require more time at the import stage. I choose the middle ground, "Standard," which will still require that a 1:1 preview be rendered when I develop the image, but since I will not be performing detailed work on the majority of the images, this choice allows me to see the images clearly as I edit and rank, and then I'll take the extra time for the 1:1 previews, only for my highest ranked images, at the time I develop them.

4. File renaming: I don't do it; it's just one more step and it's unnecessary at this stage of file handling. Some don't want to have repetitive file names when the camera's assigned numbers roll over, but the original file name will not be repeated in your camera for a very long time, 50K+ images for some cameras, so I don't see this as a real concern (especially since both images will contain very different metadata and subject matter).

5. Metadata: Copyright, URL, and contact information can be added each time as a preset (so you don't have to rewrite these every time you import images). Universal "keywords" for a particular shoot are entered here too

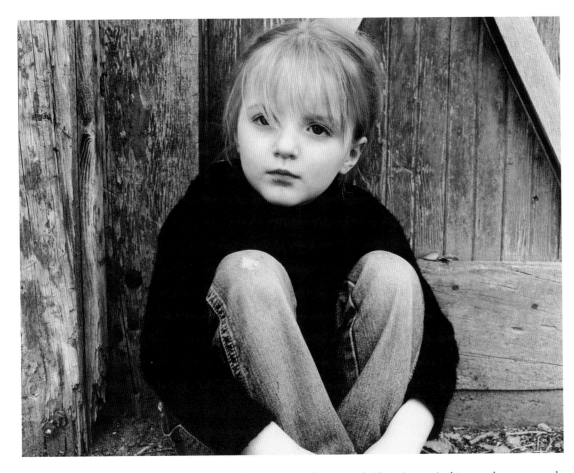

and auto fill will speed up this process as well because it will suggest keywords as you type (based on keywords you've used in the past).

Editing and metadata

In addition to providing a visual catalogue of your images, programs like Lightroom are fantastic for editing and searching your image files.

After importing into your cataloguing software, it is easy to rank and label images quickly so you can pinpoint your top ranked files and work exclusively with them. This may also be a time to do *image specific* keywording that embeds identifying aspects of a particular shot that will help you find that image later (like "Billy," so that when you want to see all your shots of Billy they

will come up). Your Active Archive catalogue not only allows you to view your images, but it can also embed words into the image file that will aid you in a search of your archive. But, to be the most effective, develop a meaningful system for keywording, labels, and collections and use it.

Keyword what all your images from the shoot have in common on import: place (country/city/place/place descriptor—i.e, beach or mountain), client or product, child model(s), conditions (hazy morning, rainy, or evening sunset). Then when dealing with specific images, specific keywords can be added. Lightroom remembers your keywords and auto-fill will help speed up this process each time you open the program.

Labels are the ranking tools that your software provides:

flags, stars, and color. I suggest that each should have a meaning. These are the meanings I was taught to use by a Photoshop master:

Flags offer us three options; to have a flag, to not have a flag, or to assign a black flag. When you edit, flags should be used for *technical issues*. In Lightroom if you want to flag an image you pick it (P). I flag my shots that get a grade of "A" or "B." I unflag (U) or just don't flag my more mediocre shots, (ones that get a grade of a "C" or thereabouts). I reject only my worst images (those receiving a "D" grade) and only keep them around if they can operate as "source files" for that shoot. If a shot is a misfire or there is no hope for recovering the exposure, these qualify as "F" images, which I promptly delete from the disk. Remember before you delete that you are disposing of only the most technically unsalvageable. No use wasting hard drive space for images that will never see the light of day. Be sure you "delete from disk" and not just from the catalogue.

After assigning flags we judge aesthetics. The stars function as a way to rank your flagged or picked images.

figure 7.5
View of the recorded metadata in Photoshop (under the File menu > File Info...).

There is no need to even look at the rest of them, save yourself the time. I assign my stars as follows:

* *(1)"Okay" image, has an appealing quality and it catches my attention, but I don't love it.*

** *(2) Fulfills the objective of the shoot or project.*

*** *(3) Exceeds expectations of the shoot or project.*

**** *(4) Reserved for images I'd be proud to display in an online photo gallery or a portfolio shown to clients.*

***** *(5) "Cream of the Crop" images that I might enter into a competition or display as artwork (be picky here—only a handful of images a year qualify for this rating—these are the best of the best).*

The last label is the color label. I use this label to quickly determine the status of a given image, mainly for derivative files that have been rendered (see "Processing to Rendered" for more detail). For example:

RED (6) Master file in progress (_M.psd)

YELLOW (7) Master file that is finished with all its layers from Photoshop intact (_M.psd)

GREEN (8) Master file that has been "flattened" (_flatM.psd)

BLUE (9) Derivative file for web (_web.jpg)

PURPLE Derivative file for print (_print.tiff)

If you want to sort images across your entire archive then "collections" is the tool. Collections can be anything you'd like it to be. All this information will be stored in the metadata as you save your virtual changes.

Processing to rendered

Once the images are sorted and ranked, it's time to commence the postproduction of your images. This means making any necessary adjustments to your images before you render them. It is best to do this with RAW or DNG images because they haven't been processed and more adjustments are available to you (Lightroom can also modify JPEG images). Remember, for reasons we've already discussed, we want to shoot primarily in RAW and convert to DNG upon import.

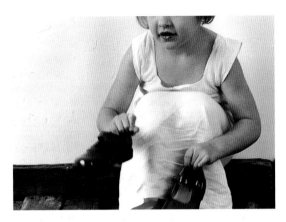

Processing an image through Lightroom is best done following the same rule that applies with all its modules and importing image files: view the modules left to right (Library, Develop, Slideshow, Print, Web) and within each module make adjustments top to bottom. For the Develop module, you will first consider the exposure and white balance, then move on to fine-tuning the tone (recovery of highlights, adding fill to the shadows, increasing or decreasing the qualities of the blacks, and brightness and/or contrast). Then continue down the rest of the sections of the module until you've achieved the look you desire. Remember that all of these changes are nondestructive and can be undone at any time. Don't hold back, experiment and try each of the functions. In fact, a complete history is available in the left column and you can take steps back as needed. Should you want to process an image a variety of ways, just create a virtual copy (or many virtual copies) and you can process each image differently (Photo > Create Virtual Copy). Although two images will show in your catalogue they are both referencing the same original file, so the file to store the instruction data (xmp) is fairly insignificant in size and won't require much additional space from your hard drive. Explore! Adobe has a number of tutorials for Lightroom on its website and there are great books that cover this and other PIEware in depth. But for now you have the know-how to play within Lightroom and achieve great things!

As wonderful as Lightroom is, there will still be operations that can only be done in a pixel-based program such as Photoshop; compositing (combining two images) is an example of this. After you've done all you can

in Lightroom, export your image to Photoshop (Photo > Edit In... > [choose editing program]). Because Lightroom will then render this file, it's important that you consider the settings for the rendering. Under Preferences (Lightroom > Preferences... > [External Editing]) you can choose the settings for the rendering of your file into a .psd (photoshop) image. If working from a RAW or DNG file, export at AdobeRGB (1998) or ProPhoto RGB and with a bit depth of 16 bits. Your resolution should be either 240 or 360 ppi (as these are the native resolutions for all printers).

Whenever exporting outside your archive, be sure to tag your images with your name or initials so they can be quickly identified as yours. Aside from having your identifier in the file name, your copyright should also be recorded in the metadata. Your copyright can be added in the Library module if not done at import, as suggested above.

I keep all my derivative files in the folder with my DNG files. Because they have my name or personal identifier at the front of the file name they will rest at the bottom of the file folder. In Lightroom I sort these derivative files with color labels (as described above). Because of the powerful search function, if I want to see all my print-ready files, for example, I just filter the folder for the purple color label.

BASE FILES: Store the original camera files outside of the Active Archive as "read only" files. They are helpful when you need to use proprietary camera software or to make significant enlargements. DNG files are stored as part of your main Active Archive.

Examples Original: _D409347.cr2
DNG: _D409347.dng

DERIVATIVE FILES: Save all derivative files with your name or initials in the beginning of the file name. Keep these new files in the same folder as the original DNG.

Examples Master file (Status of red or yellow):
STONE_D409347_M.psd

Flattened master file (Status of green):
STONE_D409347_flatM.psd

Web file (Status of blue):
STONE_D409347_web.jpg

File for printing (Status of purple):
STONE_D409347_print.tif

image 7.12

Make what is important to your child the subject of the images. When they are grown these details will provide nostalgia and happy memories. Little girls who love shoes turn into big girls who have a fondness for shoes as well!

Shutter Speed: 125
F-Stop: f/8
ISO: Agfa Optima 200 (film)
Camera: 35mm SLR
Lens: 150mm
Light: 2 head strobe lighting

THE PRINTED IMAGE
The tangible representation of your work

Up until this step we have been dealing with digital files and backlit representations of the final image. But what is far too often overlooked and highly precious is the photograph itself, not merely as an image on our screen, but as an object, a tangible product that you can hold in your hands! Immune to technological failure or lack of electricity, the tangible image survives to tell its story.

Once you choose to print your image there are several considerations and decisions to be made. What paper will you use? What printer? The list goes on… These are personal questions that you alone can answer. Once you have your setup, the framework is universal for printing all images. There are two ways to print your images: as individual pieces, or as a collective body of work in a book. Whatever the output, similar steps need to be taken to assure that the color, sharpness, and resolution are correct for your chosen media.

image 7.13

There are few things as substantive as a printed image, and as slippery as a digital file. Don't forget to make prints in addition to posting your images online.

Shutter Speed: 125
F-Stop: f/4.5
ISO: Agfa Ultra 50 (film)
Camera: Medium format; 67
Lens: 80mm
Light: 3 head strobe setup

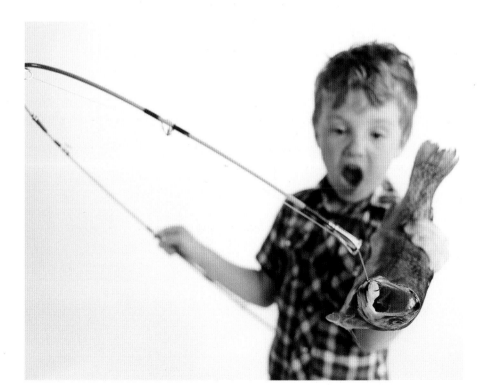

Color management

I am just going to touch on the considerations of color management here, since there is no way to cover all that needs to be covered about this topic in a short chapter, and especially not a small section of a chapter. What is important is that you understand the framework for color management and have the vocabulary to ask further questions. Beyond this, I must again refer you to the *Digital Photography Best Practices and Workflow Handbook* (Russotti & Anderson, 2009) for more detail on color management, as well as sharpening your images and resolution.

The variables for producing a print that looks like what you see on your display are your paper, printer, and display. In order to have all coordinate, they must speak the same language. If our display says one thing to our printer and our printer hears it as something else, no communication has taken place. The secret to color management, as for all successful endeavors, is communication!

The first step to good communication involves you. You want to know that what you see on the display (computer monitor) is accurate. For this to take place, you need to educate your display and give it the tools necessary to show you an accurate representation of your photograph. This happens through calibration.

As discussed earlier (p. 168), it is important to have a display that shows you the same colors (gamut) that your printer produces. If that is not possible then we just want it to be as accurate as it is capable of being. There are tools that can help with this, and they have come down in price significantly over the past five years from thousands of dollars to under $150. They are called colorimeters. Taking that step is a big one but it saves a world of frustration down the line. This may or may not be a step you want to take but unless you do, don't bother reading the rest of this section. Your only option is to be observant and come to know, through trial and error, the variances that your computer produces from what you see on your display. Remember that each substrate (paper) will react differently, so "understand" each paper you use and when you find a paper that works the way you like it to, stick with that paper!

If you are still reading, perfect! You are serious about the

accuracy of the color in your prints. I commend you. Again, I am not going to cover *everything* required to get a degree in color science, but recommend that you research the best colorimeter for you and then use it. X-rite has great, user-friendly products to consider and, as mentioned above, a great website for additional information on color management.

After you know that your display is accurate, you want to assure that your printer and display are speaking the same language. This is achieved through profiles. Profiles are the interpreters that assure accurate communication between your display, printer, and substrate (paper). The better the profile, the better the communication!

To help with this, Epson, Moab, Hahnemühle, and other reputable digital photo paper companies provide profiles suited to your choice of paper media and the printer you have chosen to use (for most common photo inkjet printers). Each combination of paper choice and printer will have its own profile. The profiles are available for free on their websites, so I urge you to take advantage of this gift. Like the firmware for our cameras, profiles instruct the printer in what is required to perform optimally for your chosen paper. Work in a common color space like AdobeRGB 1998 or proPhotoRGB until you print. At that time you will apply the profile to a derivative file and make any necessary adjustments. If you are outputting to the web, convert the color space to sRGB. These options are found in Photoshop > Edit > Color Settings.

Sharp images

All digital files need to be sharpened. An unsharpened image will feel as if it's out of focus. However, sharpening does not fix a lack of focus. When you first process your file in Lightroom you should perform a very slight sharpening, but remember to save the most critical sharpening, the final "output sharpening," for just before an image is exported and it is at its final size! This prevents the look of oversharpened images that seem more like a drawing than a continuous tone photograph. For example, if you sharpen for a large master file and then resize it as a small print, the smaller image will look severely over sharp. To avoid this, always perform your sharpening just before you export that file for print or web publishing.

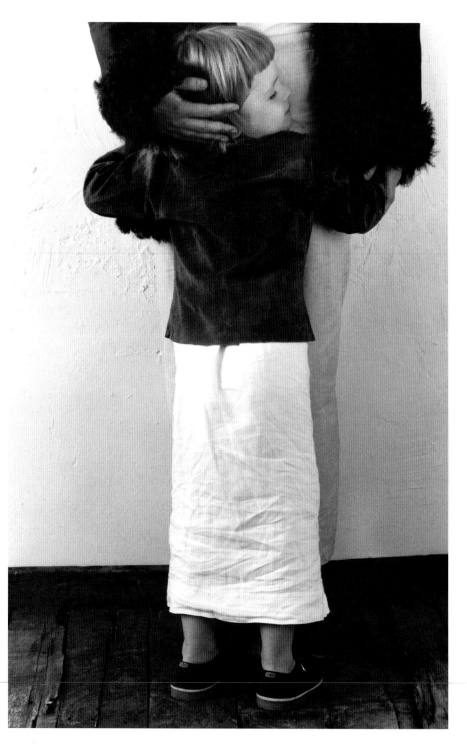

There are two types of sharpening: pixel sharpening and edge sharpening. Pixel sharpening makes the individual pixels crisper, whereas edge sharpening takes into account the shapes within the image as a whole, and sharpens their edges. Pixel sharpening is done with the Unsharp Mask tool in Photoshop. Edge sharpening is subtler and very effective, but is more complicated. Please refer to *Digital Photography Best Practices and Workflow Handbook* (Russotti & Anderson, 2009) for details on that, as well. Finally, always view your image at 50% max when applying the sharpening.

Size does matter

As discussed in Chapter 3, although all megapixels (as camera manufacturers market them) are not created equal, pixels are. A pixel is a pixel is a pixel. Simply put, for adequate coverage you must have the number of pixels required for that space. An image that is one size on Facebook will look pixilated if printed to the same size on paper because the coverage requirements are different. The general screen requirement is 72 ppi, whereas to have the same "look" a printed piece will need at least 240 ppi.

If you choose to enlarge an image, you are enlarging the pixels that make up that image. This is why it is always better to downsize, versus upsize, an image. When you downsize you are in the process of removing redundant pixels, and when you upsize your only choice is to enlarge the pixels that you have; hence the pixilated look (see p. 74).

Always keep your master files at the largest resolution and only downsize derivative files. They should be considered on an individual basis for smaller prints or web images. In the example we discussed on page 177, the print is a temporary, derivative file made from the master file (STONE_D409347_flatM.psd) and would be labeled "STONE_D409347_print.tif". If you are making many prints, you may want to include the print size in the file name. The web image would be labeled "STONE_D409347_web.jpg". Both derivative files should be sharpened just after resizing to their final size and before printing or uploading to the web. The derivative files could be saved or discarded depending on your needs, but *never* discard the master file.

Self published books

From Apple to Blurb, there are many options today for placing your images into a book format. In fact, there is even a Lightroom plug-in for Blurb that allows you to make books from that platform. There is almost no excuse not to see your projects come to life in books or to utilize this format for presenting a portfolio of your work. Blurb even has a marketplace for selling your photography books to friends who want a copy, or visitors to your site or blog, via a link to the Blurb bookstore.

Most likely, you will be using the manufacturer's software to compile your images into a book. This can take a lot of the decisions out of your hands (which can be a good thing or not). Yet you can still control the resolution and sharpening of your images and make them optimal for the final output size. As for color space, if you are working from a calibrated display you have a good chance at getting the color fairly accurate. Companies such as Blurb also provide a "Pro" option, complete with a profile, if you would like to go that route. But always remember to provide images that are sized correctly (height, width, and resolution) to avoid the book publisher's needing to upsize the images itself, resulting in pixilated images.

image 7.14–7.15

The touch or interaction between parent and child contains a story in and of itself. Aside from toys and the like, parents make great props too.

Shutter Speed: 125
F-Stop: f/8
ISO: Agfa Optima 200 (film)
Camera: 35mm SLR
Lens: 150mm
Light: 2 head strobe lighting

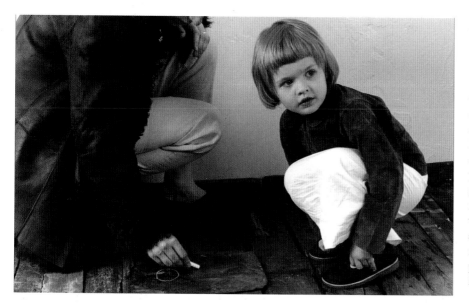

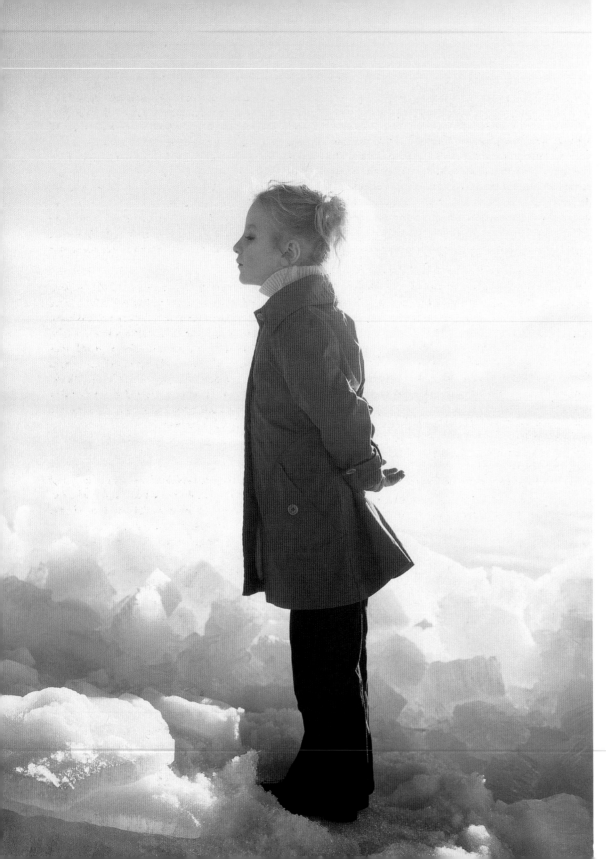

image 7.16

Don't fear flare in your images. It is true that it is somewhat unpredictable, and there are not a lot of rules to control it, but with a little practice flare can add an ethereal quality to your images.

Shutter Speed: 500
F-Stop: f/5.6
ISO: Fuji Provia 100f (film)
Camera: Large Format; 4 x 5 in.
Lens: 150mm
Light: Cloud diffused sunlight

SHARING YOUR PHOTOGRAPHY
A recipe for a legacy in images

We've all heard the question, "If a tree falls in a forest, and no one is around to hear it, does it make a sound?" The very same question can be raised for our images. If they remain on hard drives or even printed as pieces locked in drawers, never shared, does it matter that they exist? If we do not share our images they exist for us alone.

There are many ways to share our images these days through the distribution of prints, scrolling through them on a mobile device such as a phone or tablet, or on the Internet through websites, blogs, Flickr, and social media sites such as Facebook. It is important to note that the experience of the viewer is vastly different with each delivery method. For example, a print of a photograph is more than an image, it is also an object made on a certain substrate (paper) at a certain size. Each variation or edition of that print, be it size or media, will affect the viewer's response to the photograph. Generally speaking, a comfortable viewing distance of a print is equal to the diagonal of that print. With large prints the viewer stands back and with smaller prints they get closer. One viewing distance supports a very different experience from the other. Also, if the photograph belongs to a numbered edition, it feels precious simply because it is limited. This also affects the viewer's experience with the print. We should think about these considerations as we share our work, however we may do it, simply because each delivery method has its own features and benefits and the viewing of our work will be impacted by these characteristics. Still, no matter the method, it's important to share our work. When all is said and done, we, as artist-photographers, want our photographs to exist beyond ourselves, and sharing them, no matter the approach, will secure our legacy in images!

Print

There are two ways to share a printed photograph, individually or collectively. We can gift or sell the print(s), we can display them as artworks hung on walls or held in hand, or we can compile them and arrange them in books. In any case, the printed piece is a technology that requires very little from the viewer. They need not have a computer, access to the Internet, or any other type of contraption to have an experience with the photograph. This low-tech approach to photography makes the photograph accessible to every vision capable person who comes in contact with that print. It is easy to get swept up by technology and forget the simple pleasure of the printed piece. I feel that forgetting to make prints is a mistake. Without taking anything away from other approaches to share our work, the printed piece is real and tangible–there is nothing virtual about it. There is an authenticity that comes from occupying physical space on the planet, and in this way a printed photograph is authentic.

I encourage all artist-photographers to include the print as a form of their expression. With inexpensive photo-quality home inkjet printers (with highly archival inks), and the accessibility and ease of self-published books, there is almost no excuse not to make prints of one's work. There is even the possibility to sell the books you've created to others through outlets like the "Bookstore" at Blurb.com. Check it out and remember that when considering sharing your work, never overlook the power of the printed photograph.

Mobile devices

The great thing about mobile devices such as smart phones or tablets is that they travel well and hold a lot. Whether sharing your work mid-flight on your phone, or presenting it formally to a potential client on your tablet, hundreds of images and various uploaded galleries can be accessed in an instant with the tap of your finger. This is an incredible way to explain in images who you are as an artist-photographer. This presentation method may not have the inherent qualities of a printed piece, but they do help artists communicate in a quantity and at a pace that is suited to the interaction. As you share your work on your tablet or phone, the viewer has the added benefit of having the artist present. They can ask you questions that feed their understanding of the work and you, in turn, gain an understanding of others' impressions of your work.

One last note, whenever rendering derivative files for digital display, be it phone, tablet or computer, always export these images as jpgs in an sRGB color space and with 72ppi at your desired height and width.

Web

The Internet provides many ways to share your work. You can register your own domain and create a website with a unique URL, or you can utilize available blog sites like Wordpress or Blogger, and be assigned a URL under their domains. Additionally, you can share your work on Flickr or social media sites. Each has its own qualities and all are effective ways to have your images available 24/7 to anyone in the world that has access to the web.

It's easy to think that when *you* are not viewing your images they are not being viewed by anyone—but we must never forget that whatever we put on the web (especially without password protection) is completely available, to everyone all the time. This can be a blessing if you are happy with the content you've posted, and a curse if you are not. Remember that it's always a good idea to "put your best foot forward" when uploading content onto the web. Of course, expectations will differ depending on the format you choose to present your work; for example, there is an expectation that a personal portfolio site houses only your best work. Because of this, great care should be given to editing and presentation of your work on that site, whereas a blog has a connotation that the images presented are more of a work-in-progress than a final product and they are generally accompanied by text that reinforces this point. The expectations of social media sites, on the other hand, vary greatly and you will set the atmosphere for those pages by making them fan pages, or friend pages, and by the quality of work you choose to share. Consider which style best fits your objectives when presenting your work to the world!

My best piece of advice for web-based images is that you *always* embed your copyright information in the metadata of the image. Once your images are on the web and copied and referenced and dragged-and-dropped onto personal computers, and so on. it's nice to know your credit will always be associated with that image. Be aware that some sites will strip this information during compression, but it's always a good idea to do what you can to assure that people who may want to contact you about your photo, perhaps to purchase it, know who to make the check out to. If you did the work you should get the credit.

Social media

I've made a separate section for social media because its presence on the web is a sphere unto itself. As of this publication, there are over 500 million active users on Facebook, and 50% of them log onto Facebook in a given day. Just to give you an idea, there are 312 million people in the United States of America and continuing its proven growth rate, the number of active Facebook users will be double the population of America in less than two years. Love it or hate it, Facebook is a force to be reckoned with.

When considering the amount of images we, our friends, and our family upload to Facebook, it behooves us to remember a few things. First, always tag you images with your copyright. Second, don't use Facebook as an archive for your images; at upload they are compressed and do not generally have the proper resolution to make reasonably sized prints. Be sure to have a backup of all the images uploaded there. Third, Facebook has a feature that allows you to make a copy of your posts and images. For many, Facebook is like a journal of their lives (especially the lives of our children). Backing up your account (the backup results in a PDF that you can print) assures that that record of your Facebook life is preserved. Lastly, Facebook does not allow you to back up images friends have posted of you or your children. I would advise asking friends to send you a quick email of images of your family members that you wish to preserve. Properly credit these images with the original photographer/source in the metadata and add them to your family image archive!

There are so many ways to share your work these days that there is no excuse not to. Be as proactive in sharing and preserving imagery as you are in creating it!

Now you have the knowledge and tools to organize, preserve, and share your images. Apply this organization to your creative fortitude and you will be free you to do what you love best, photograph and spend time with children. Enjoy.

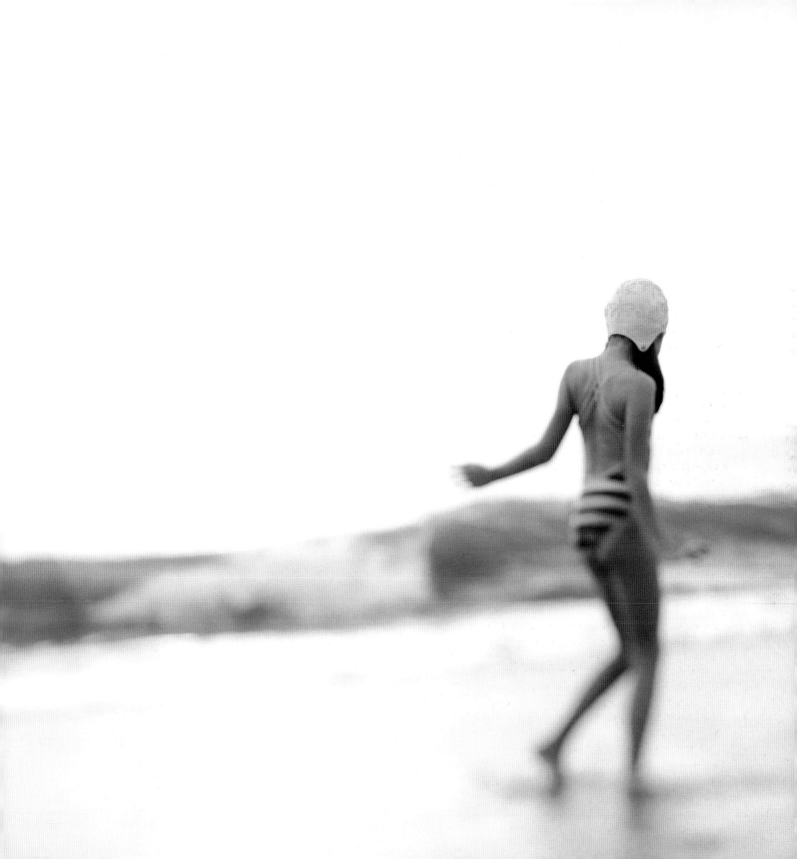

GLOSSARY

Albumen

Egg whites. Circa 1850 egg whites were used as an emulsion to hold salt that was later sensitized and dried onto sheets of paper. This was one of the earliest forms of printing paper and was often used in contact printing with glass plates. During this time more eggs were used in photographic printing process than for any other reason (including baking).

Aperture

A hole or an opening through which light travels to expose film or a digital sensor. The aperture size is adjusted by "f-stops." The aperture setting controls the amount of depth of field in a given image. A "wide open" aperture, such as f/2.8, provides a very shallow depth of field, whereas an aperture opening of f/32 provides a wide depth of field.

Archival Pigment Print

An inkjet print made with archival inks such as the Epson™ Ultrachrome K3® ink which resists fading under normal light compared to c-prints and other lesser quality commercially available ink sets not made for high-end photographic printing.

Archive

Long-term storage with a goal of preservation.

Aspect Ratio

The difference between the height and length of an image.

Backup

A system of cloning digital assets (such as image files, applications, and other documents) that assures preservation of these files in the event of original file damage due to hardware or user error.

Bit Depth

Refers to the quantity of bits of tonal or color data are associated with each pixel. 1 bit per pixel provides the option for either black or white for each pixel (2 two to the 1 power), whereas an 8 bit image has the option of 256 grayscale tones or colors for each pixel (2 to the 8th power). Interestingly enough, the average person can see 8 bits and won't detect the differences in a higher bit file, making it acceptable to output and deliver an 8 bit file. Still, it is better to do retouching work on higher bit depth images so as not to risk falling under 8 bits, as pixel information is lost (gaps develop in the histogram and the image quality is visually poorer).

Bounce light

When light hits one surface and reflects onto another surface.

c-print

See *Chromogenic Print*.

Calibration

Adjusting the behavior of a monitor or printer (or other such device) to make it conform with a know specification or state. In color management, monitor calibration is the first step to assuring what you see on the screen is what you will see in print.

Camera RAW

Unlike the JPEG capture format, Camera RAW files are uncompressed and allow the photographer to determine what information to keep and what to discard. Because of this, extra data RAW files can be as much as 2–3 times larger than their JPEG counterparts but afford the photographer the power to modify images and make adjustments based on his or her creative objectives. Also see *Raw Files*.

Catalogue

The itemized display and categorization of image files that allows for easy search and an organized archive.

Chiaroscuro

Art and photography that is characterized by a strong "fall off" of light, which results in a stark relationship between light and dark values.

Chromogenic Print

A full-color photographic print, typically produced from color negative film or digital image, that has been printed with the RA-4 chemical process (verses inkjet). A Chromogenic print is also known as a *c-print*.

Clipping

The point, either black or white, where there is no information for the histogram. The histogram represents 0–255 and everything

below 0 is clipped to pure black and above 255 is clipped to pure white.

Colorimeter

A device used to compare or measure colors and their intensities on a digital display and aid in the proper calibration of a given display device.

Color Management

An ordered and systematic procedure to assure color integrity from digital display through the printing process of an image.

Color Profile

See *Profile*.

Color Space

A geometric representation of colors that are capable of being produced by a color model (RGB or CMYK) and ultimately by a particular device.

Color Temperature

See *White Balance* and *Kelvin*.

Compression

The process of re-encoding digital information using fewer bits than the original. Some compression, such as JPEG will discard information in a "lossy" way and others seek to preserve all information and encode in a "lossless" manner.

Contrast

The difference between the col-

or and light of various parts of an image to other parts of the same image.

Daguerreotype

The first commercially successful photographic process, which resulted in a positive image with extreme fidelity of detail made in the camera.

Depth of Field (DOF)

The depth of perceived focus on either side of the actual focus set for a given image (what apears in focus). A "shallow" DOF is attained by the use of large aperture openings like f/2.8.

Derivative Files

Files created from an original source or "master file." Many derivative files have a particular purpose, be it print or web display.

Digital Noise

Undesirable color or luminance variations (artifacts) in pixel information. This results in poor of image quality. Noise is common when using high ISO settings on a digital camera.

Display

Commonly known as a computer monitor.

DNG (Digital Negative)

The public, royalty-free, open source archival format for digital camera RAW data developed)supported by Adobe Systems).

dpi (dots per inch)

The number of dots of ink laid down, per inch, when making an inkjet print. The more dots per inch the higher the resolution of the print, which results in better image quality.

Edit

The process of selecting, ranking, and organizing images to determine further involvement with them.

Exposure

When light strikes a sensor or film and an impression is made or data collected. Digitally, and "underexposed" image did not collect enough light to make an image without digital noise and shadow clipping. An "overexposed" capture happens when too much light was collected (resulting in highlight clipping and blooming). A proper exposure balances shadow and highlights with a full range of information in-between. Exposure is controlled by three camera settings: aperture, shutter speed, and ISO.

File Format

How digital information is stored or encoded. Popular file formats are JPEG or TIFF for image files and PDF for written documents.

Fill Light

Additional light added to the shadows of a scene to draw out

more detail at the time of exposure.

Flash

See *Strobe*.

Gamut

The range of color (as well as density and tonal values) that is capable of being represented in a particular capture or output device or represented in a color space.

Gelatin Silver Print

Commonly known as black and white prints. The name comes from the process used to make printing paper (suspending silver salts in gelatin, and coating this light sensitive emulsion onto paper or other substrate). This is the most common and commercially available type of black and white printing paper.

Graflex camera

Graflex was a manufacture of early twentieth century hand held press cameras that typically used 4x5 film or glass plates.

Grain

Random optical texture of processed photographic film due to the presence of small particles of a metallic silver.

Histogram

A graphical representation of the tonal distribution in a digital image. From deep shadows on the left to the bright high-

lights on the right, it plots the number of pixels for each tonal value in an image.

ICC Profile

See *Profile*.

Image Capture

Using cameras and scanners to input the information presented (from light reflecting off an object) and record it in a digital format. The file is further processed into a final pixel based image or left as RAW image information.

In-camera meter

A device built into the camera that reads the reflective luminance given off by a given object. The camera uses this data to suggest an exposure setting (or determine it when the camera is set on auto). An in-camera meter always assumes 18% luminance or middle gray for any given scene and consequently will determine the exposures for fully white and fully black objects the same: middle gray. The use of a gray card (as provided in the inside covers of this book) can provide the photographer with a fairly accurate exposure reading when using an in-camera (reflective light) meter because it provides the camera data to match its assumptions. If the camera is then manually set to the exposure the camera determined for a gray card, a proper exposure would be obtained when the card is removed.

Interpolation

The process of resizing an image by the addition or removal of pixels. As a general rule it is better to resize to a smaller image than to add random pixels when upsizing.

JPEG, JPG (Joint Photgraphic Experts Group)

The most common image format used by digital cameras and for images on the Internet. The degree of compression can be adjusted, allowing tradeoffs between storage size and image quality disruptions.

Kelvin

Light emits different colors at specific temperatures recorded in degrees Kelvin. Think of the light from a candle as a relatively cool temperature, 1000-2000 degrees Kelvin (reddish) and the appearance of a blowtorch flame, which is much hotter and blue.

Key Light

The main light source that illuminates a scene.

Keyword

Descriptive words added to and stored in the metadata of an image to aid in the searchablity of that image.

Latent

Capable of emerging and being seen or developed but not yet visible.

LCD

(Liquid Crystal Display) Thin, flat electronic visual displays that are often used on the back of cameras and in laptop and computer displays.

Light ratio

The difference between highlights and lowlights in a scene.

Lossless Compression

Data compression algorithm that allows original data to be exactly reconstructed from the compressed data. The TIFF file format is an example of this.

Lossy Compression

Data compression algorithm that does *not* allow original data to be exactly reconstructed from the compressed data, meaning that data will be discarded and lost. It is used to decrease the storage size of a file. The JPEG file format is an example of this.

Luck

A force for good or bad influenced by preparation and/or experience aligning with opportunity.

Master File

A rendered file that is the high-resolution representation of the original source file/captured image. This file has been fully processed, rendered, and retouched. All other derivative files are made considering individual needs and output requirements.

Megapixel

One million pixels. Also used as a term for the number of pixels in an image, and also to express how much pixels information that a digital camera's image sensor can collect.

Metadata

Data about data: information embedded in a file that provides further information about the file. Some is inherent to the file and other is added after the fact by the author or end user.

Metering

Using tools such as in-camera or hand-held incident meters to measure the amount of light in a given scene. Photographers use this information to apply their creative vision through the settings that control exposure: Shutter Speed (which controls movement), Aperture (which controls Depth of Field), and ISO (which determines the integrity of the digital image file).

Middle Gray

Characterized by 18% luminance, middle gray is the value that all in-camera reflective meters use as a basis for their exposure reading. It assumes an average of dark and light values in an average scene.

Nondestructive Editing

See *PIE*.

Operating System (OS)

Software that provides an interface for the user and his or her interaction with the computer hardware and applications.

Output

The end use of a digital file.

Output Sharpening

The final sharpening of an image based on the end use (size and substrate). This sharpening is saved as a derivative of the master file.

PIE (Parametric Image Editing)

PIEware is software that edits image files by user actions that write instructions to the metadata allowing nondestructive changes to an image because the underlying image data is never altered. These PIE instructions are stored in an .XMP sidecar file near the original image file, or as with DNG are saved in a reserved segment of the actual file.

Pixel

A single point in a graphic image arranged in rows and columns. In high-resolution images the pixels are close together and appear as a solid image. Pixel is short for *picture element*.

PPI (pixels per inch)

A pixel based measurement of image resolution that defines the size an image will be on a screen or in a print (depending on the required resolution for the output device).

Processing, Image

A series of technical and creative decisions, which will be rendered (upon export from PIEware), to create desired pixel based images (JPEG, TIFF, or PSD) from an original RAW image file. The procedure of transforming image files to desired user specifications.

Profile

Color or ICC profiles define the color output of a device such as a printer or display. Profiles interpret the color language, from one device to the next, in a target color space.

Proof Sheet

One piece of photographic paper with thumbnails of various images from a digital photo shoot.

Proprietary Format

File formats that are protected by patent, copyright, or other licensing agreement and have "hidden" elements to them that only the original manufacturer's software can access to protect intellectual property or trade secrets.

RAW files

Unprocessed linear data recorded by digital cameras. When shooting with a JPEG setting this information is processed and compressed whereas with a RAW setting the information is left untouched so that the photographer can process the image to his or her personal specifications.

Recovery

An image-processing technique to correct improper exposure in shadows and highlights. When performed on a RAW file the recovery process is nondestructive because the additional information is available in the original capture file.

Reflector

Flat cards, expandable disks, or any object of any size that reflects light back into a scene. Commercially available reflectors come in colors of silver, white, and gold (or a combination of these).

Render

The process of generating a pixelated image from a set of instructions or actions applied to a RAW or original file.

Resolution

The Specific detail in an image (how it looks when displayed or printed at various sizes). Each device has an optimal resolution that must be met or the image detail will not be well-represented. Most displays require 72 PPI and printers require a resolution of either 240, 360 PPI.

RGB

Red, green, and blue—otherwise known as the primary colors of light that are used to electronically display an image on an LCD or other backlit display.

Sharpening

Emphasis of the contrast around the edges of pixels or object edges (comprised of multiple pixels) in an image. All digital images are slightly soft (not out of focus) and require some level of sharpening. Sharpening does not increase the focus of an image and over-sharpening is undesirable.

Shutter speed

The set time a camera's aperture is open and allows exposure light to its film or sensor. The shutter speed setting controls the amount of movement recorded at the time of exposure. A fast shutter speed will "freeze" movement, whereas a slower shutter speed will show movement as a blur.

Sidecar File

An XMP text file that contains metadata associated with the file of the same name. A sidecar file and its parent file must remain next to each other (in the same folder in the finder). When the XMP file is apart from its parent file it cannot be "found" by PIEware applications, such as Lightroom or Camera RAW, and all changes recorded in this file will not be seen.

Strobe

Lighting equipment used to produce predictable and measurable flashes of light with which to illuminate a scene wholly or in part. A camera flash is a small strobe light. The color temperature of a strobe is near or equal to daylight (5500 degrees Kelvin) and works well with daylight balanced film.

Substrate

The material onto which an image is printed (generally paper).

Thumbnail Image

A small, low-resolution image used as a preview or representation of a larger image or file.

TIFF, TIF (Tagged Image File Format)

An open standard file format that is specifically for images and is well-suited for lossless compression of high-quality image files (able to save layers from Photoshop files). As well, DNG is based on a subset of the standard TIFF format. Adobe Systems owns the copyright for both TIFF and DNG but maintains each as free and open standards for public use.

Tonality

The balance of light, middle, and dark values in an image.

Tone Curve

The tone curve is a graphical representation of shadows, highlights, and the values in

between. It offers the adjustment of the brightness, contrast, and even saturation of these values through movement of the curve line.

Wet Collodion Negitive

The collodion process was the first widely used photographic process that produced a negative image on a glass plate. The glass plates had to be both exposed and developed while the chemistry was still wet (as the name suggests).

White Balance

Establishes the color balance or neutrality of an image by determining the light source that is illuminating it, be it, be it flash, daylight (cloudy or in shade), tungsten, or fluorescent Each light source has a specified "color temperature," recorded in degrees Kelvin, which provides the overall color cast to a photographic image.

Workflow

The sequence of actions taken that achieves a final product. A well-established and efficient digital photographic workflow will save time and minimizes the occurrence of costly mistakes and loss of, or redundancy in, data storage and handling.

XMP (Extensible Metadata Platform)

An open standard for safely embedding metadata to a large variety of file formats. It can accept

existing metadata schemas such as IPTC but can also grow to support emerging technologies, as it did/does with PIE instructions and proprietary metadata. Developed by Adobe Systems.

Zone System, The

Formulated by Ansel Adams and Fred Archer in 1939–1940: A photographic technique and system for determining, as well as understanding, optimal photographic exposures.

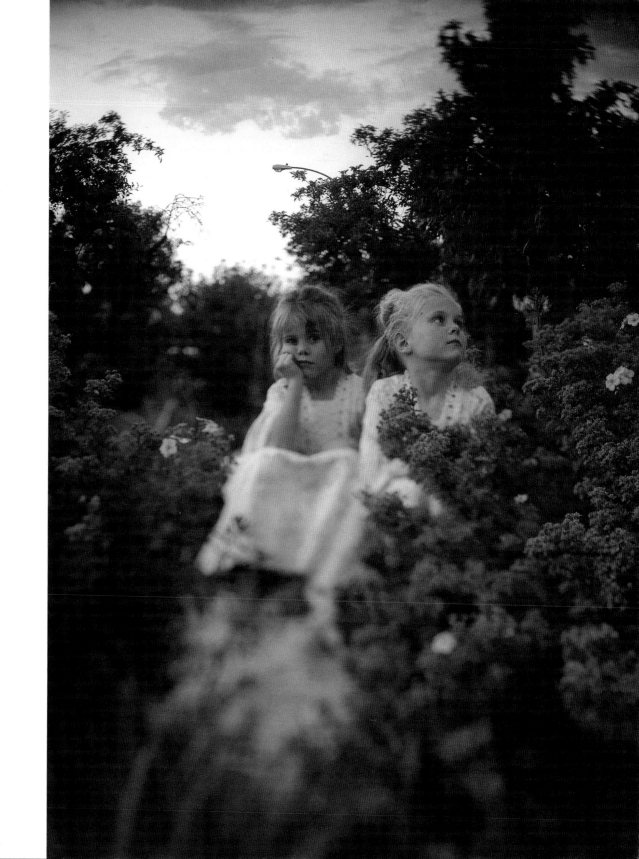

INDEX

ACKNOWLEDGMENTS
A big ol' thank you

There are a number of people I would like to acknowledge as I reflect back on the creation of this book. First and foremost I would not have had the opportunity to work with the wonderful people at Focal Press if it was not for Katrin Eismann. Katrin, your support of my work and ideas is a true blessing. To the publishing team of Cara St.Hilaire and Stacey Walker at Focal Press, thank you for your patience and freedom to create. This book would not have been as beautiful were it not for the design genius of Matt Simpson at Studio Suba in New York, nor have concepts as fully developed were I not able to work through my theories with my editor, Davian Roberts-Ogilvie. You two are amazing!

Of course I have to acknowledge the photography greats on whose shoulders I stand, and especially the contemporary photographers (and their representatives) whose work grace Chapter 6. Thank you for your time speaking with me about your work and allowing me to share that insight with my inquiring readers. To you I give great appreciation: Emmet Gowin (Josiah Cuneo, Pace/MacGill Gallery), Sabastião Salgado (Robert Pledge, Contact Press Images), Joyce Tenneson, Melissa Ann Pinney, Robin Schwartz, Takashi Homma (Miyuki Sugaya), Rania Matar (Miriam Romais), Achim Lippoth (Emily Kolibius), Anders Hald, and Cuny Janssen.

Lastly, but perhaps most importantly, I would like to thank my friends and family for their support (especially my mother Dr. Joyce Summerhays Stone). As well, I must express gratitude to the many children I have collaborated with over the years—a lot of you are grown and even married, yet your childhood continues to live in photographs! May the wonder and magic of childhood forever live in the hearts of each of us, regardless of age.